THE VIEW FROM ABOVE

THE VIEW FROM ABOVE

THE SCIENCE OF SOCIAL SPACE

JEANNE HAFFNER

THE MIT PRESS

CAMBRIDGE, MASSACHUSETTS

LONDON, ENGLAND

MIT Press books may be purchased at special quantity discounts for business or sales promotional use. For information, please email special_sales@mitpress.mit.edu or write to Special Sales Department, The MIT Press, 55 Hayward Street, Cambridge, MA 02142.

Set in Engravers Gothic and Bembo by Toppan Best-set Premedia Limited, Hong Kong. Printed and bound in the United States of America.

Library of Congress Cataloging-in-Publication Data

Haffner, Jeanne, 1973–
The view from above : the science of social space / Jeanne Haffner.
p. cm.
Includes bibliographical references and index.
ISBN 978-0-262-01879-1 (hardcover : alk. paper)
1. Space—Social aspects. I. Title.
HM654.H34 2013
304.2'3—dc23
2012029843

10 9 8 7 6 5 4 3 2 1

This book is lovingly dedicated to my father, Alfred L. Haffner Jr. (1925–2000), whose personal recollections of the Great Depression, World War II, and the Cold War always made these historical moments feel strangely familiar to me.

CONTENTS

"Just look," goes the refrain. Galileo, we learn in school, told the princes to look through the telescope, and they stubbornly refused; Robert Koch fought for years to get his generation to look at the bacilli through the microscope, until microbe hunting became the royal road for a generation of medical work. But whether through sketching or photographing, and whether through radio telescopes or functional magnetic resonance imaging, there is no "just looking." The centuries-long battle over scientific observation in and outside science has shown that time and again. Since the 1960s if not earlier, philosophers of science have insisted that there is no way to exclude theory completely from our observations. It is, they taught, a pipe dream to pursue pure sense data. But even talk of "theory ladenness" fails to get at the depth of the issue. (On the theory ladenness of observation, see Thomas S. Kuhn, *The Structure of Scientific Revolutions*, University of Chicago Press, 1962 and 1970; Russell Hanson, *The Concept of the Positron*, Cambridge University Press, 1963 and 2010.) Scientific seeing involves more than the smuggled assumptions of high or low theory. To see a particular way involves more than just partitioning the world in particular ways (with special instruments or careful object preparation). Equally important, scientific sight involves the self-conditioning of the scientist.

Vesalius and Albinus made their anatomical atlases not by dutifully sketching every bit of the scenes before them, but by learning and developing a form of sight that aimed beyond appearances, to the ideal reality behind the body of this or that criminal's mortal remains. This was a moral as well as an epistemic injunction. Goethe polemicized *against* drawing what was before the artist—variations, damage, bad conditions of observation could all make nonsense of this particular flower found behind that

lot on a particular day. So the scientific depiction required a kind of genius or sage, someone able to part the curtains of the merely here. When objectivity came to be seen as the best kind of right depiction, the aim was for the scientist to interfere as little as possible, and to let nature speak for itself as the scientist traced, inked, or photographed it. Getting an objective grip on the image of the natural world was the flip side of scientists' teaching themselves a kind of self-restraint. Self-abnegation became the order of the day—not genial intervention. These two moments in the systematic depiction of nature clash, and from that ethico-epistemic clash we learn about the history of forms of scientific sight. We now know something of how forms of sight work in the natural sciences, but until now we have known next to nothing about how to proceed in the social sciences. (On forms of sight, see Lorraine Daston and Peter Galison, *Objectivity*, Zone, 2007.)

Jeanne Haffner has contributed importantly to the history of technology, the history of urban planning, and the history of the social sciences, extending and developing scholarly sight in the social sciences as it developed in the years between World War I and 1970. Her interest: the historicization of the *vue d'ensemble*. Perhaps one should say that she has found a way to use the concept on itself. For years we have known pieces of this puzzle. From earlier studies, we know something about the effect of balloon observations of France by the Montgolfier brothers, and about how such work affected mapping and painting. We have known from good work by historians of aviation about the heady enthusiasm for "air-mindedness" that avidly mixed technology, utopianism, nationalism, and popular religion. We have known, too, about reaction against the all-too-visible as French structuralism of the 1950s and the 1960s turned away from observation and focused on rules of combination—"algebras" of everything from psychiatry and linguistics to Marx and Freud. (See Charles Gillespie, *The Montgolfier Brothers and the Invention of Aviation*, Princeton University Press, 1983; Joseph J. Corn, *The Winged Gospel*, Johns Hopkins University Press, 2002; Martin Jay, *Downcast Eyes*, University of California Press, 1994.)

Haffner has identified the development of the *vue d'ensemble* as a set of practices, honed in the ferocity of World War I, that left a generation of scholars trained to combine aerial views with cultural practices. The military trained its analysts to take those photographs and to combine them

with what was known of German practices—as one manual that Haffner quotes put it, the good analyst should "see [the enemy's actions] written on the landscape, even before the pattern was fully visible."

After World War I, the same techniques pointed elsewhere. During the war, the order of the day was to assess bomb damage, find camouflaged trenches, and locate bridges under construction. Between the wars, a wide range of scholars began asking questions differently. Anthropologists, archeologists, sociologists, and geographers all learned to see through these new schools. Look at Cameroon villages from the air, the anthropologist advised, combine that overview with what was known about culture (such as child rearing and extended family structure), and you could develop a new way of grasping the world of the colonized.

At one level, Haffner tracks this world of sight practices—the diffusion of aerial photographic interpretation, and the skills and instruments used to parse the images This is already an important and innovative move. At another level, Haffner digs into the complexities of individual thinkerv s, including Claude Lévi-Strauss, André Leroi-Gourhan, Marcel Griaule, Pierre Gourou, and Marc Bloch. Reading this book, we see them all arranged rather differently than in the usual disciplinary histories of anthropology, archeology, ethnography, geography, or history. Perhaps the centerpiece of this second, more granular history is Haffner's close analysis of the work of Paul-Henry Chombart de Lauwe and Henri Lefebvre. Chombart—sculptor, aviator, and ethnographer—celebrated the combination of a view from above (literally) and a view from below (a street-level sociology), setting the whole of the project in the frame of a progressive (but not radical) "social Catholicism." Lefebvre, explicitly Marxist, never quite acknowledged Chombart as either friend or foe, though he made intensive use of the central concept of the *vue d'ensemble*. Chombart wanted a new form of sight; Lefebvre used the novel way of seeing, but demanded that it be embedded in socially redemptive planning, not scholarly picturing. Again we see a crossing of the moral and the epistcmic.

Attentive to instruments and arguments, Jeanne Haffner has given us a *vue d'ensemble* of the *vue d'ensemble*. And that is a valued contribution to our understanding of social scientific sight.

Peter Galison

This project began with a desire to historicize a collection of social theories concerned with the intersection of social organization and spatial organization, a notion that was encapsulated by some authors in the usefully ambiguous term "social space." I was fascinated by the work of David Harvey, Edward Soja, and Henri Lefebvre, who were driven by the question of why capitalism (and the social inequalities produced by that mode of production) had persisted for so long after the end of the Industrial Revolution. Their consideration of this question led to a reconceptualization of the connection between space and society. Modes of production, social structure, and economic relations, these and other scholars suggested, were embedded in the physical world, in the organization of space at various scales, whether urban, suburban, regional, or even global. Therefore, a successful social revolution could never take place without a parallel revolution in spatial relations.

I didn't, therefore, set out to study aerial photography and other techniques of vision. Yet as I began investigating the genesis of this way of analyzing spatial relations, I noticed that the airplane was ever-present in early-twentieth-century accounts of spatial organization in various fields. The Africanist Marcel Griaule, for instance, used aerial photography to understand the relationship between the form of Dogon agricultural fields in West Africa and the social structure, values, and cosmology of the Dogon. Understanding Griaule's studies of spatial organization in French colonies in the 1930s led me to the work of his student Paul-Henry Chombart de Lauwe, who used aerial photography to critique spatial segregation in Paris after World War II. The "social space" (*l'espace social*) of Paris and its outlying areas (*banlieues*) seen from the air, Chombart contended, did not reflect the egalitarian values of the French revolution.

On the contrary, it illuminated the depths of socio-spatial segregation in France. My story came to focus more and more on the practice, rather than the aesthetics, of aerial photography—the new ways of "seeing" it inspired, how it changed over time, how it was used for different purposes, and how it was interpreted differently at different historical moments.

For those interested in recent developments in urban planning, examining the history of "social space" provides insight into the potential for citizen participation that will be made possible by the universal access to new mapping and mobile tracking technologies such as Google Maps. As this book shows, combining aerial visions with a "street-level" perspective is not new. The top-down technique of aerial photography was seen as a bottom-up tool of observation from the very beginning, even though its adoption was tied to the technological apparatus of aviation, colonial administration, state-controlled urban planning, and the French military. This inspires us to wonder: what new conceptions of space will emerge in the late twenty-first century as a result of technologies being developed today, and their direct use not only by researchers but also by urban residents themselves?

No work of scholarship is ever created alone, and I am deeply grateful to the many colleagues, friends, librarians, and archivists who contributed to the making of this book in various ways. The Graham Foundation for Advanced Studies in the Fine Arts provided generous funding that allowed me to bring the work to completion. Anonymous readers provided very helpful feedback on the initial manuscript. Juan-Andres Léon and Anna Darice Miller read multiple drafts and provided substantive editing. Sylvie Tissot read drafts, engaged in numerous discussions based on her own rich work on the Paris suburbs, and housed me several times during my trips to Paris. Sophie Rosenfeld, my dissertation advisor, offered feedback in the early stages as well as much support and encouragement along the way. Archivists, including Arnaud Dercelles of the Fondation Le Corbusier, Marie-Dominique Mouton of the Laboratoire d'ethnologie et de sociologie comparative at the University of Paris-X (Nanterre), Alexandre Ragois of the Institut français d'architecture, and Frédéric le Bourhis of the Ministère de l'Écologie, du Développement durable et de l'Énérgie, provided assistance during the course of my research in Paris. At the MIT Press, Marguerite Avery supported the project from the beginning and Paul Bethge edited the manuscript.

I have been exceptionally lucky to have had the opportunity to work with Peter Galison, who was on my dissertation committee and for whom I have worked as a research assistant. His own work, and that of other scholars in the history of science to whom he introduced me, deeply inspired me and shaped the way I thought about this project. I would like to thank Peter Galison for numerous discussions, feedback on drafts, and constant encouragement from beginning to end.

I owe so much to numerous great friends who offered support and encouragement, especially Be Birchall, Mark Theunissen, Juan-Andres Léon, Roxana Vicovanu, Cristian Bota, Jennifer Mack, Sylvie Tissot, Daniel Gillard, and Carrie and Sean Bettinger-Lopez. My deepest gratitude goes, however, to my marvelous family: Dolores Haffner, Cathy Haffner, Steve Rier, Anne, Larry, Kieran, and Dillon Sullivan, and Mary Beth, Steve, Ashyln, Riley, and Andrew Perry, without whom this book would never have been possible.

FIGURE I. I
The *grands ensembles* housing projects of Sarcelles, northeast of Paris, 2009. Photo
by the author.

In *The Aerial Discovery of the World*,[1] an interdisciplinary work on aerial photography published in 1948, the French Africanist ethnographer Marcel Griaule began his contribution with an air-minded metaphor. He imagined a parachuter descending from the sky to the ground. From a high altitude, Griaule wrote, looking down at a vertical angle, the land below initially appeared to be "inhuman." Through the clouds, the earth resembled a map, laid out, flat, and scattered with geometrical lines. But as this skydiver approached the earth, the topographical form of the terrain suddenly appeared as the outline of human civilization. Not only had the parachuter dropped from the sky to the ground; in ethnographic terms, he had changed from an "outsider" to an "insider."[2]

After World War II, the connection between the "social" and the "spatial" described by Griaule was encapsulated in the term *l'espace social* ("social space"). This coupling of two analytical categories defies any single definition; it has been used by multiple scholars in multiple ways. "Social space" can, however, generally be understood as the notion that the outline or *form* of space at various scales—from a small rural community to a large urban metropolis and its surroundings to entire geographical regions across the globe—reflects the social structure, cultural values, and mode of production of the society that produced it. At the heart of this notion is *practice*, entailing the practices of everyday life and the imprint of habitual behaviors, feelings, and values on spatial organization.[3] Most broadly, the concept implies that it is impossible to understand the "social" without exploring its spatial dimension, and vice versa.

When discussing socio-spatial relations, scholars working in a wide range of social-scientific fields—among them urban planners, architects, social geographers, anthropologists, sociologists, and even literary theorists—

often refer to the work of the Marxist urban sociologist Henri Lefebvre. In the mid 1970s, while based at Nanterre University, located just outside Paris, Lefebvre published a book, titled *The Production of Space*, in which he devoted an entire chapter to the concept of "social space" and its implications for urban planning, social-scientific research, and French society.[4] Space at various scales—local, regional, national, global—was "produced" in everyday life, he argued; it was a "concrete abstraction of the mode of production" and as such could clearly illuminate social exploitation, alienation, and domination. Lefebvre defined social space as a "new science" that was "no less complex than the sciences of abstract space (geometry, topology, etc.) and physical space (from physics to cosmology)."[5] Just as physicists and mathematicians before Einstein had focused on understanding absolute or abstract space, Lefebvre contended, late-twentieth-century social scientists should devote themselves to investigating "social space." Lefebvre hoped that the formation of this new academic discipline would change urban planning practice. Instead of privileging the distanced expertise of architects, planners, and government officials, planners, informed by social-scientific work, would instead allow for the active participation of urban residents—the "users" of urban space—in the decision-making process. "The understanding of social space," Lefebvre noted in 1978, "is the theoretical aspect of a social process that has, as its practical aspect, the "users" movement."[6] There was much to learn, this leader of the French New Left insisted, not only about the connection between social relations and spatial relations but also the consequences of this late-twentieth-century phenomenon on everyday life in urban environments. "Knowledge of (social) space," Lefebvre wrote in 1976, "is now being established as a science, even though it is still in an early stage."[7]

HISTORICIZING THE NEW SCIENCE OF SOCIAL SPACE

This book traces the origins, the development, and the effects of the "new science" of social space as it emerged in France from the interwar years (especially the Depression of the 1930s) to the early 1970s. In particular, it seeks to illuminate the role of aerial photography—a novel twentieth-century technique of observation and representation that was closely associated with the French colonial state and military—in the emergence of this new way of conceptualizing socio-spatial relations. For Griaule, or for

his student the ethnographer and urban sociologist Paul-Henry Chombart de Lauwe (the main figure of this book), the view from an airplane was crucial for connecting the "social" with the "spatial." Yet just a few decades later, proponents of the "social space" concept—not least Henri Lefebvre—expressed much suspicion of the aerial perspective, calling it the "space of state control."[8] In contrast to qualitative research methods, such as personal interviews with residents, quantitative methods such as cartography and aerial photography only served to "flatten" the complexity of social life. They were, Lefebvre contended, used by a centralized state to "rationalize" and colonize French cities in the same way that the State had taken control of colonial areas. "That which is merely *seen*," Lefebvre wrote in 1974, "is reduced to an image, to an icy coldness. . . . By the time this process is complete, *space has no social existence*."[9]

Tracing the emergence of "social space" as an intellectual category and an object of scientific research, especially its connection to the deployment of aerial photography analysis and interpretation (best expressed, as we will see, in Chombart's work), can help us to understand why the "social" and the "spatial" came to be conceptually linked in postwar French social-scientific research and urban planning. It will also illuminate broader trends in twentieth-century French social, intellectual, and urban history. These include the influence of the colonies on the metropole in the postcolonial era, the application of sociological expertise to the study of the built environment in postwar France, and the development of a spatially oriented critique of capitalism in the French New Left in the late 1950s and the 1960s.

Moreover, recounting this story helps us see more clearly how the novel twentieth-century technique of aerial photography affected the emergence of new ways of conceptualizing the old problem of housing in France. Utilizing the notion of "social space," Lefebvre and other proponents of this concept suggested that the problem of the *grands ensembles* housing units was not located in the architecture of these modernist buildings themselves but rather in the organization of space of cities across France. In other words, the concept inspired Lefebvre and others to recast the problem of the *grands ensembles* as that of the modern *banlieue* (suburb).

As the riots that occurred on the outskirts of French cities in 2005 and 2007 have clearly demonstrated, the "problem" of the French suburbs, and of spatial segregation more generally, has not gone away. On the contrary,

it has accelerated, and it continues to be the central political problem in France today. Former President Nicholas Sarkozy's Le Grand Paris project, initiated in 2007, aimed (in rhetoric, at least) to better integrate the suburbs with the center of the city and to facilitate travel from one suburb to another. Reconnecting the idea of "social space" to aerial photography and other techniques of representation can help us understand how and why the *banlieue* became an object of social-scientific investigation and public policy in late-twentieth-century France in the first place. Much like nineteenth-century cartography,[10] Chombart's use of aerial photos to examine the "social space" of Paris and other cities and to critique the *grands ensembles* by focusing on the spatial segregation of cities across France helped to make the *banlieue*—and its residents—into an object of investigation that could be studied, analyzed, theorized, and ideally transformed by "experts." It is thus part of a much longer tradition of expertise and technocracy in France.[11]

ORIENTATION

Although most of this book will be concerned with the 1950s, the 1960s, and the early to mid 1970s, when the conception of "social space" emerged and began to take hold in urban planning and social-scientific circles in postwar Paris, the first two chapters will go back to the interwar period. Chapter 1 will explore the transformation of aerial photography into a systematized technique during World War I, when teams of experts interpreted aerial views on a large scale. Among them would be a whole generation of social scientists, including Griaule and the human geographers Jean Brunhes and Pierre Gourou, who would adopt aerial photography in their work. Chapter 1 will also examine the symbolic meaning of the airplane in the interwar period, when the machine became a powerful symbol for Fascists, Nazis, socialists, high modernists, and others. Chapter 2 will build upon that story to show how the very same technique was used in ethnography, in human geography, and in history as well as in urban planning and architecture (in the work of Marcel Lods, Le Corbusier, and others) in the 1920s and the 1930s. These parallel stories, as we will see in chapter 3, began to merge during World War II. Aerial photography helped to bring social scientists such as Chombart, government officials such as Paul Delouvrier, and architects and planners such as

Robert Auzelle together within Vichy-sponsored institutions. During the era of postwar urban reconstruction, these wartime connections continued and directly impacted concrete urban planning programs in cities across France. Chapter 4 will explore the role of "social space"—as both a novel discourse urban space and a new field of study for urban sociologists—in helping sociological expertise become seen as applicable, even indispensable, to urban planning practice in 1950s France.

Chapter 5, which examines the work of Lefebvre, the urban sociologist Raymond Ledrut, and others, addresses what happened when the scale of both urban planning and aerial photography changed during the politically infused era of the 1960s. In the wake of the atomic bomb, the Algerian War, and the first satellite views of Earth, the view from above assumed new meaning. As the technique itself became more distanced from human life on Earth than ever before and was used in new ways, perceptions of aerial views underwent a radical change. Unlike Griaule's parachuter, whose unique verticality provided special insight into the depths of social structure and the human psyche, the airplane and the satellite now seemed incapable of penetrating social life on the ground. Consequently, the "social space" concept promoted by Lefebvre, Ledrut, and many others, originally inspired by the view from above, now stood only for the view from below.

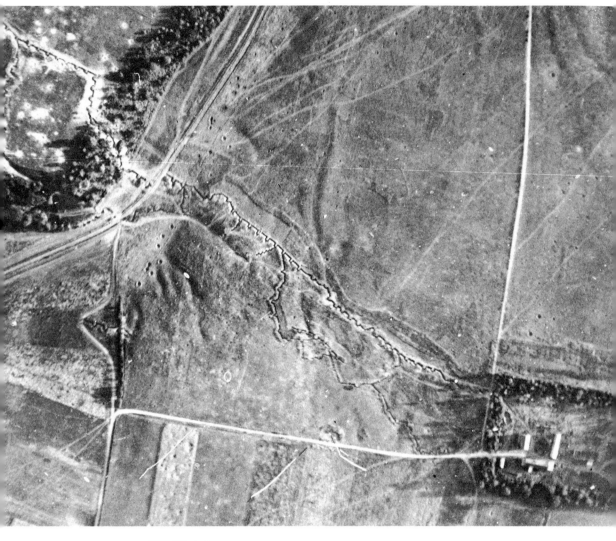

FIGURE 1.1

Aerial photograph of the Somme, 1916. Réunion des Musées Nationaux / Art Resource, New York.

1 FROM ENTHUSIASM TO EXPERTISE: AERIAL VISION FROM BEFORE THE AIRPLANE TO THE AFTERMATH OF WORLD WAR I

Techniques for capturing the Earth on a photographic plate from above had been part of the pioneering work of nineteenth-century photographers such as Nadar (Gaspard-Félix Tournachon). Their early successes inspired a first generation of enthusiasts to adopt such techniques for use in scientific research. In a handbook published in 1890, the photographer Arthur Batut suggested that this method of observation would lead to major discoveries in a range of fields.[1] However, a tradition into which the techniques fitted more readily was military reconnaissance. As the historian Albert Garcia Espruche has insightfully noted, "it is difficult to separate the history of the aerial photograph from the history of war."[2]

In France, the Western Front was the first entity whose existence and evolution were systematically followed "in real time" from above. Many of the originators of the "new science" of social space first came into contact with the practice of aerial photography while serving as aerial interpreters for the French military; as we will see, the centrality of this method to the war effort (both real and perceived) determined how the practice would be adopted by researchers in the years that followed. We begin this story of how a novel method of data collection gave rise to a new discourse about urban space, therefore, with World War I, in which the practice of aerial photography came into maturity.

EXPERT AIR RECONNAISSANCE DURING WORLD WAR I AND THE *VUE D'ENSEMBLE*

The military applications of bird's-eye views had already materialized by the turn of the nineteenth century, when aerial reconnaissance by balloon

was used in the French Revolutionary Wars.[3] The importance of air recon-
naissance was marked by the establishment, during the Revolutionary era,
of a group of *aérostiers* whose job it was to sketch the contours of the
battlefield from a balloon and then transfer them by cable to officers
waiting on the ground.[4] The position of *aérostier* was a prestigious one.
Contemporary accounts, foreshadowing those of aerial photography ana-
lysts during World War I, emphasized the qualities and personal virtues
that were required for work in balloon surveillance. *Aérostiers* were usually
highly educated scientists or engineers, praised for their patriotism and for
the potentials of their craft to contribute to the progress of humankind.
As one former member of this group recounted in 1889, they were "not
common soldiers."[5]

During World War I, the French military's use of aerial views was radi-
cally transformed. The pressures of trench warfare and the need to locate
and track well-camouflaged troops across the French landscape precipitated
rapid developments in the technology of aerial photography itself and also,
crucially, in the formation of new interdisciplinary teams (*équipes*) of
"experts" to interpret these photos. This demand for expertise in reading
and interpreting aerial photos was recognized by Captain Eugène Pépin,
one of the pioneers in aerial surveillance practices in France. "The study
of an aerial photograph," Pépin wrote in 1917, "must be confided to spe-
cialists. . . . Interpretation requires good sense, method, and a certain
knowledge of German theories and practice. . . . When thoroughly
exploited [aerial photography] enables us to penetrate into the life and
even the intentions of the enemy."[6] Pépin and others hailed the benefits
of aerial photos. In particular, these views from above provided a compre-
hensive picture of the landscape—a *vue d'ensemble*—that allowed military
officers to locate troop movements, camouflaged artillery, and trenches at
a glance. Aerial photography, in other words, was to be used, at least ini-
tially, for the purposes of surveillance, not bombardment.[7] *Observateur*
Pépin, who had been an amateur aviator before the war and who had
studied archaeology, history, geography, and telegraphy at the Sorbonne,
helped guide the advancement of aerial reconnaissance within the French
Army during World War I. He and his group, which included photogra-
phers, architects, and artists, traveled around the Front in a mobile pho-
tography laboratory.[8] Using a specially designed airplane and camera, they
captured hundreds of images, when assembled back in the laboratory,

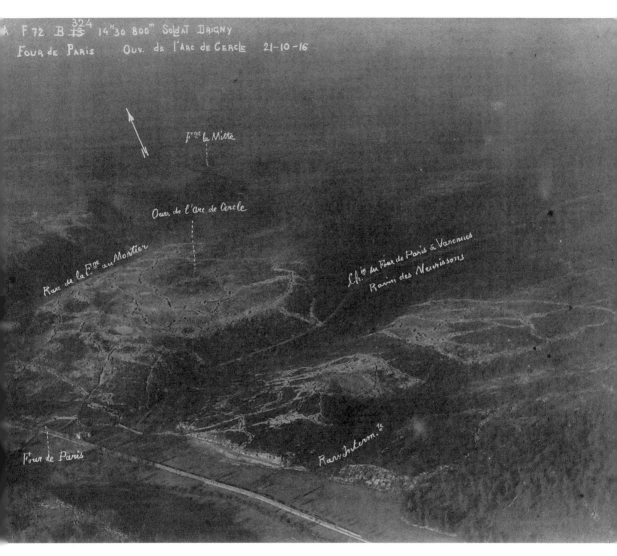

FIGURE 1.2
Aerial view of the Marne, 1916. Réunion des Musées Nationaux / Art Resource,
New York.

provided a "totalizing view" that offered clues to the enemy's defense positions and future plans.

It was the nature of World War I itself that made aerial photography more important to military strategy than ever before. For the first time, as German philosopher Peter Sloterdijk has pointed out, the main target "was no longer the body, but the enemy's environment."[9] For much of the war, of course, that "environment" was none other than the French landscape; consequently, France devoted more resources to the development of aviation than any other nation involved in this conflict.[10] It became clear to French military commanders such as Paul-Louis Weiller that maps were obsolete—not only were they outdated, but the landscape was changing so rapidly and dramatically that cartographers could not keep up. At Weiller's insistence, systematic aerial surveillance over enemy territory entered army operations at every level.[11] By 1918, French aviation officers were recognized in Britain and America for their great precision, skill, and innovation in using this still embryonic method of observation.[12]

Aerial surveillance alone, however, was not enough. Photos of the battlefield from above had to be verified. They were examined in conjunction with other types of information, including on-the-ground exploration and information gained by interrogating prisoners. Soldiers often sketched maps on the palms of their hands. When soldiers who had such maps were first captured, the maps would be compared with aerial photos of the area. Likewise, the itinerary of each prisoner, noted in detail during interrogation sessions, was mapped and collated with aerial photographs. The itineraries of prisoners, noted in detail during interrogation sessions, was mapped and collated with aerial photographs.[13] Such information was vital for interpreting aerial views of the battlefield. As one of the first French photographic interpreters during World War I, André Carlier, explained in a manual written in 1921, "the technique of aerial photography is one of the principal sources of information, but used alone it would never be sufficient to allow a military commander to form an opinion, with absolute certainty, of the intentions of the enemy."[14]

Carlier emphasized that the task of information gathering and analyzing could never be achieved without productive and efficient cooperation between various sectors of the army. The process of interpretation was so complex that one person could never do it alone, and military personnel at all levels were trained to read the photos. In other words, the

"non-elitist" nature of the task was considered essential to its success. One never knew, for example, whether a simple drawing on the hand of a German prisoner by a low-ranking soldier might indicate the location of a command station. Everyone involved needed access to aerial photographs in order to participate in the enemy's defeat.[15] As a result, men of various ranks, from foot soldiers to generals, were taught to read aerial photos.[16]

The consequences of the use of aerial photography during the war, accordingly, went beyond technological advancements in aviation, photography, and visual techniques for interpretation. The wartime application of aerial photography also led to the complete restructuring of the French Army. At the beginning of the war, in 1914, the French Army was barely prepared to undertake aerial reconnaissance and navigation on a large scale. Yet just one year later, each section of the French army had created its own aerial photography unit.[17] This was no easy transformation; it required intensive recruitment of citizens with skills in photography, spatial recognition, and graphic interpretation, including designers, architects, photographers, and artists, and the creation of a new phase of exhaustive "observation training" for all recruits, no matter what section of the army they belonged to.

As the war progressed, army officials created new positions to facilitate the process of taking, developing, and interpreting aerial photos. Some French army officers, for instance, trained as "reconnaissance observers" who took photos from kites or balloons; others became aviation officers who photographed the Front from airplanes.[18] These officers then brought the films to a mobile photographic laboratory, where they developed and labeled each of the thirty to forty photos of that section of the terrain and completed a first-level "technical interpretation" by comparing the new photos against earlier photos of the same section of the landscape.

Across the front, multiple aerial photography teams supplied hundred of photos to the newly established Second Bureau (deuxième bureau), which was responsible for second-level "tactical interpretation." At that stage, aerial photographs were read not for details, as they were in the first-level interpretation, but rather for the more crucial purpose of devising military strategy. The Second Bureau was composed of aerial photography specialists from each section of the army. Teams of designers, artists, architects, and other specialists assembled "photographic mosaics" of sections of the Front, then schematized the terrain so as to be able to locate

various features as quickly as possible.[19] Abstracting the outline or form of different sections of the front was especially important. A stereoscope allowed officers to obtain a ground-level, three-dimensional perspective on the battlefield. Using a stereoscope, interpreters from the Second Bureau were able to locate trenches hidden deep within the French landscape, to differentiate between natural brush and the results of camouflage tactics, and to find subtle traces of troop movements. This abstract view was then compared to previous drawings of the same portions of the landscape at other times. The result, Carlier explained, was a "holistic" view of the battlefield—a "vue d'ensemble" such as could not have been obtained from ground-level excursions alone. According to Carlier, analyzing the "form" of the terrain, with the assistance of other visual techniques such as the stereoscope, provided interpreters with insight into the "reality" of the battlefield. Aerial spotters and navigators had to be able to recognize broad topographical patterns and to see how they changed over time. Officials based at the Aeronautical Intelligence Service (Service de renseignements de l'aéronautique) in Paris then used this "holistic view" to position troops and locate communication networks, munitions depots, and other military operations.

OBSERVATION TRAINING

Obtaining an overall perspective was central to the "observation training" of future officers of the Second Bureau. New recruits learned to ignore meaningless details in aerial photos and instead grasp the "totality" of the situation. "He will try," Carlier wrote, "to obtain a holistic impression."[20] During observation training, future tactical interpreters learned how to distinguish among oblique, panoramic, and vertical photographs, how to assemble multiple aerial photographs into a "mosaic map," how to read panoramic photos with the aid of a stereoscope, and thus how to trace the outline of the terrain.[21] They also learned to understand the "form and nature of the terrain occupied by the enemy": the form was revealed through study of relief maps and use of the stereoscope, while the "nature" of the terrain was understood through careful geological study made by other sections of the army.[22] Interpreters were expected to "discipline their imagination" so as to be able to read aerial photos as "objectively" as was possible. In his manual, Carlier described the ideal interpreter as someone

who should have "a good eye, [who could] be systematic, rigorously conscientious, not give in to his imagination, and be willing to surround himself with all sources of information, ignoring none."[23]

Most importantly, new recruits to the Second Bureau were trained to connect *visible* topographical information obtained from photographic surveys with *invisible* knowledge of German defense practices and customs. They were trained to "see" far below the surface of the French landscape, which was now a battlefield, in order to discern camouflaged troops, buried trenches, and subtle movements across their own national terrain. According to Carlier, the best interpreters were architects, photographers, or other artists who could "discipline their imagination" according to a deep understanding of the German system of defense. They should know the German system so well, he asserted, that they could "see it written on the landscape, even before the pattern was fully visible."[24]

French interpreters were able to connect German customs and intentions with the topography of the Front because each German offensive was preceded by a predictable series of movements: new roads and bridges were built, weapons were stockpiled, communication networks were set up, and mobile hospitals established. Most of these activities were, of course, camouflaged extensively and performed under the cover of night. Yet the comparison of daily aerial surveys of the same portion of a particular landscape could reveal traces of enemy intentions—a pending attack, a retreat, a change in direction. It was simply a matter of noting what had existed before versus what had just appeared. The successful interpreter could deduce future actions from such comparisons, much like a tracker following the signs left upon the landscape by a fleeing animal.

As the novel technique of aerial photography developed during World War I, then, so too did new networks of expertise that were required to successfully carry out the various tasks of taking, reproducing, distributing, and analyzing the photos. The process of interpretation required a well-organized system involving a wide range of specialists; this, in turn, demanded great coordination, teamwork, long hours, and the creation of new army offices and positions.

Developments in aerial photography, and in aviation more generally, did much to determine the war's outcome. "Aerial photography," the man who had led the first aviation division of the French army during the war wrote several years after the armistice, "was the eye of our armies. . . . Everyone

has seen aerial photos taken on our battlefields, but very few know the conditions in which this mode of work was pursued and the importance it had in obtaining victory."[25]

AIR-MINDEDNESS, TECHNOLOGICAL UTOPIANISM, AND NATIONALISM AFTER WORLD WAR I

Considering the contribution—both real and perceived—of aerial photography to military triumph in World War I, it is no wonder that the airplane became central to so many developments in art, science, and social science in the 1920s and the 1930s. The literal ability of the airplane to provide a distanced, holistic outsider's perspective—not only a new visual angle but also a novel outlook on the world—inspired a wide variety of intellectual and political movements throughout Europe. After the war, enthusiasm for the airplane and aerial photography evolved into what people at the time called "air-mindedness," a phenomenon that historian Joseph Corn has defined as "believing in [the] potential [of airplanes] to better human life."[26] Aviation may have owed its rapid technological development to World War I, but, in the 1920s and the 1930s it became generally perceived as a promising tool for helping humankind progress further than ever before—the basis, it seemed, for a veritable twentieth-century Enlightenment project.

The optimism attached to the airplane can certainly be understood as part of a broader trend of "technological utopianism" in the 1920s and the 1930s.[27] Throughout the 1920s, numerous photographers, architects, painters, and other artists across Europe sought to put the skills they had learned in aerial reconnaissance during World War I to creative new use. Many at the time expressed astonishment at how this technology offered a new way of seeing the world, and a novel way of seeing space that was not Euclidean but relative.[28] The artist Laszlo Moholy-Nagy remarked that such a distanced perspective on the earth, and on urban environments in particular, was "disconcerting." It provided an escape from "worn out" conventional perspectives passed down from the Renaissance.[29] The aerial photograph, Moholy-Nagy maintained, was "an invitation to re-evaluate our ways of seeing."[30]

Much like Carlier in his discussion of "observation training" during World War I, Moholy-Nagy and other photographers and painters emphasized the importance of ignoring details in aerial photos and instead

grasping the totality of form that this perspective made visible. In the caption of one of his very first aerial photographs, for instance, Moholy-Nagy remarked that "the charm of the photograph lies not in the object but in the view from above and in the balanced relationships."[31] Like his contemporaries Kasimir Malevich and Alexander Rodchenko, Moholy-Nagy was deeply inspired by the surprising juxtapositions and optical illusions present in an aerial photo, where the relationships between objects became more interesting than the objects themselves. The unexpected patterns and abstract forms that became perceptible in aerial photos inspired a variety of artistic developments after World War I, among them Constructivism and the New Photography.

But the interest in aerial photography and the abstract views this technique brought to light was not limited to the world of the arts. In the 1920s and the 1930s, aerial views saturated the public sphere. Public enthusiasm for airplanes and aerial photos in Europe and America soared when Charles Lindbergh flew solo across the Atlantic in 1927. This trip signified the "coming of age" of aviation, and furthered the quasi-religious fervor surrounding air-mindedness through the 1930s.[32]

In the 1920s and the 1930s, right-wing political movements across Europe seized the opportunity to build upon aviation's perceived advantages for human society, which had been espoused by leftist social progressives such as Nadar since the middle of the nineteenth century.[33] Mussolini, most notably, argued that aviation was essential to the task of bringing about a revolution in Italian society; the "chaos" of politics and society could finally be made "orderly" with the aid of an outsider's perspective. For Mussolini, aviation was the ultimate symbol of modernity, leadership, technological progress, optimism, and citizenship—all the essential qualities of a future Italian state as he and other fascists imagined it. Flying over the Italian territory symbolized the task of rising above the weight of the nation's traditions. To lead it toward a new level of civilization, Mussolini contended, the Italian nation needed someone who could literally rise above the confines of present conditions and steer them toward a new social, political, and economic order. "Not everyone can fly," he once wrote. "But everyone must want to fly. . . . All good citizens, all devoted citizens must follow with profound feeling the development of Italian wings."[34] No other machine seemed to better represent the "divine" Italian nation's spirit of sacrifice, and its eventual redemption from mediocrity.

The various interwar developments involving aviation did not, of course, emerge out of thin air. They grew out of a century-long tradition of thinking about aerial vision in science, the arts, and governance that had been developing since the nineteenth century. The unique traits of aerial photography—most notable among them the technique's capability to abstract from everyday details, revealing an overall form or outline of societies below—made it useful in the development of "high modernist ideology," which anthropologist James Scott has defined as "a strong . . . version of the beliefs in scientific and technological progress that were associated with industrialization in Western Europe and in North America from roughly 1830 until World War I."[35] Scott argues that a variety of scientific methods, including cartography, statistics, demography, and aerial photography, aided states in grasping and maintaining control over local populations through various social engineering programs that were not explicitly political. The ideology assumed, for instance, that societies that *looked* orderly *were* orderly, and that tradition and history prohibited nations from progressing.

Moreover, praise for aerial photography's ability to capture a "totalizing" view of the landscape and battlefield recalls the enthusiasm and utility for "bird's-eye views" that various figures, including artists, urban planners, cartographers, and geographers, had expressed long before the twentieth century. In the fifteenth and sixteenth centuries, for instance, Leonardo da Vinci and Albrecht Altdorfer drew or painted bird's-eye views of rural and urban landscapes, drawing attention to surface and geometric patterns. Their interest in pattern and surface anticipated the later developments in abstraction that came to characterize modern art in the late nineteenth and early twentieth centuries, especially Cubism and Futurism.[36]

The development of new forms of spatial representations, in turn, inspired novel conceptions about the ideal relationship among humans, landscapes, and technology.[37] In the discipline of urban planning, the new techniques of representation helped create the planner's subject of study (the "city") and shaped hopes for its improvement. As the historian Antoine Picon has demonstrated, the various topographic maps of Paris produced in the nineteenth century were not simply methodological tools but, in fact, constituted an entire system of representation that inspired new ways of seeing and understanding the city. "The system of cartographic genres to which these representations belonged," Picon writes, "was

permeated by the ambition to transform the French capital into a scientific object. . . ."[38] This was a political and social project as well as a scientific one. French administrators often gathered data for the production of atlases, which were often used to aid the geometric fantasies of order that had permeated the French state since the early modern period. "Understanding how the city was organized and above all how it functioned," Picon explains, "seemed to be a precondition for its pacification."[39] These atlases, which held on to the metaphor of the city as a living organism even as their abstracted perspectives inspired new hopes of efficiency and control, eventually paved the way for the Baron Georges Haussmann's massive public health and urban modernization program.

As we will see in the next chapter, World War I sparked the emergence of a new understanding of the role of space in society. Culturally, the disillusionment with modernity brought about by the war inspired many social scientists in the 1920s and the 1930s to study "primitive" societies that were uncontaminated by the ills brought about by the tragedy of modern warfare. Aerial photography was one scientific means, among others, to gain unparalleled access into the inner workings of these societies, overcoming numerous linguistic and cultural boundaries. If reading landscape forms with the assistance of aerial photography had provided insight into the minds of German enemies during the Great War, in the interwar period it offered a means of grasping the "mentality" of colonial areas as well as rural communities in France.

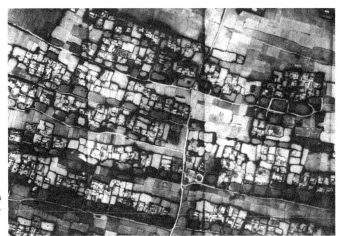

**22. — Thăn Đầu
(c. Thăn Huống, p. Thái
Ninh, Thái Bình)**

Village de cordon littoral;
maisons alignées en étroites bandes
parallèles séparées par des rizières.
(Cliché Aéronautique militaire.)

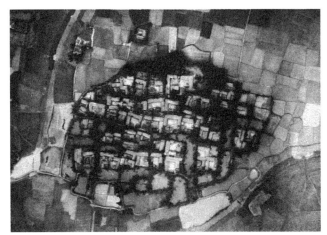

**23. — Village du type Thành
Liêm Phương Vỹ (hameau
Chuật Thôn, c. Mỹ Xá, h.
Thanh Liêm, Hà Nam)**

Pays plat et bas. Village serré;
maisons rigoureusement orientées
au sud. Dans certaines maisons les
dépendances et le corps principal
ont un toit continu, signe précurseur
de ce que l'on verra souvent en
Annam. Un puits au sud-est. Voir
Figure n° 47.
(Cliché Aéronautique militaire.)

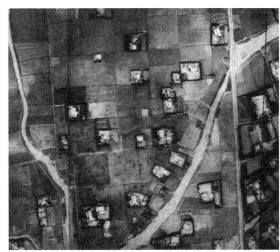

**24. — Trinh Cát (c. Tân Phong, h.
Tiền Hải, Thái Bình)**

Peuplement dispersé, dans une région mari-
time récemment occupée. A droite de la photo-
graphie commence le peuplement organisé
typique de Tiền Hải.

The northernmost area of Vietnam in the 1930s, then known as the Tonkin Delta, was relatively isolated from the major urban centers of Haiphong and Hanoi. The rice fields that stretched along its densely populated landscape were cultivated by impoverished villagers. A French colonial protectorate, the Tonkin Delta was neither exploited for its natural resources nor settled by French emigrants. Instead, the region was created by the French state solely for administrative purposes, especially tax collection. As a result, villagers had very little contact with the Western world.

It was precisely this remoteness that made the Tonkin Delta so attractive to the young French human geographer Pierre Gourou, then a professor at the University of Indochina in Hanoi. Influenced as a student by the great French geographer Paul Vidal de la Blache, Gourou believed that natural landscapes were "humanized" by local populations, and therefore that the study of the former promised to provide insights into the latter. Although Vidal's own work had focused on the French countryside, Gourou was eager to test his ideas on non-Western areas. He saw the "tropical region" of northern Vietnam as an ideal laboratory for such an experiment.[1]

Yet even though he wished to obtain an intimate portrait of everyday life in the Tonkin region, Gourou chose to position himself at a distance from the ground on which village society took shape. Besides distributing questionnaires and interviewing village leaders, Gourou utilized aerial

FIGURE 2.1
In *Les Paysans du delta tonkinois* (1936), the geographer Pierre Gourou utilized aerial photography to link the spatial form of villages in this remote region of northern Vietnam with social, economic, and political structure and levels of sociability on the ground.

photography, a technique of observation that had only been fully developed during World War I. Viewed from the air, he argued, each of the chaotic and overpopulated villages of northern Vietnam assumed a distinct and abstract form. For instance, the Thành Liêm Phu'o'ng Vỹ village, with its close-knit houses situated on a low, flat plain, differed from the dispersed dwellings of the Trinh Càt type (figure 2.1).[2] In his widely read study titled *The Peasants of the Tonkin Delta*, published in 1936, Gourou juxtaposed aerial photos obtained from the French Air Force with a schematic diagram indicating the close correlation between topography and the outline of local villages as seen from above (figure 2.2).[3] He asserted that such abstract forms revealed the autonomous nature of political, economic, and social life on the ground. They also led Gourou to conclude that, although daily life in these villages appeared chaotic, it was in fact extremely well ordered. Northern Vietnamese peasants were much more sociable and content than their rural counterparts in France, Gourou claimed, because the diverse areas of their lives were "harmoniously" integrated. With the aid of aerial photos, therefore, Gourou came to link natural topography with social, political, and economic structure, with levels of sociability, and with human happiness.

Illuminating these topographical forms also provided, for Gourou, a medium for thinking about social life in France. This French colony had much to teach its colonizer. Rural villagers in northern Vietnam were much "happier" and more sociable than their counterparts in France, according to Gourou, because the diverse areas of their lives were harmoniously integrated. The unity between Tonkin villagers and their surrounding environment precipitated a corresponding synthesis in political, economic, social, and cultural life. Gourou's aerial study of the Tonkin was intended, in part, to open the eyes of French citizens to the artificiality and emptiness of life under consumer capitalism. Tonkin villagers thus offered Gourou a model for the West; they presented an example of how to live according to human values, not economic profit. Gourou was not alone. In the 1920s and the 1930s, aerial photography—now widely perceived as having been instrumental to the Allies' success in World War

FIGURE 2.2

A relief map in Pierre Gourou's 1936 book *Les Paysans du delta tonkinoi* demonstrating the close connection between the form of human habitation and geography in the Tonkin region of northern Vietnam.

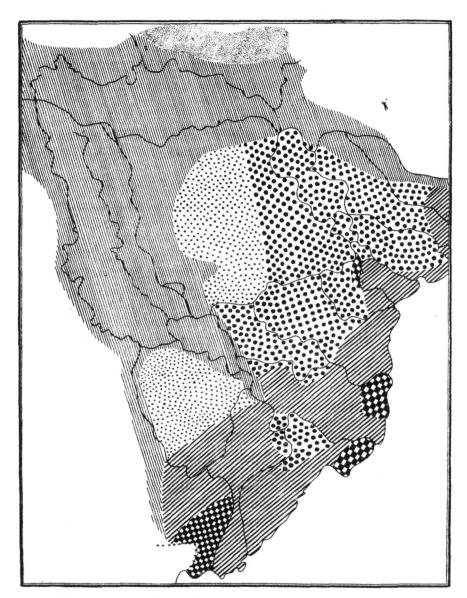

Les types de villages du Delta TonKinois

1. Villages de relief du haut Delta (bourrelets fluviaux, bordure de collines, bourrelets abandonnés). — 2. Villages de terrasses. — 3. Villages de cordons littoraux. — 4. Villages de lais de mer. — 5. Villages disposés sans ordre, du type Kim Thành. — 6. Villages disposés sans ordre, du type Bình Giang à l'est du Fleuve Rouge et du type Thanh Liêm à l'ouest du Fleuve rouge. — Les villages de lit majeur n'ont pas été indiqués sur cette carte.

Échelle : 1/1.000.000ᵐᵉ.

FIG. 46

I—became a tool of observation and research in the social sciences as well as a tool of urban planning and architecture. Having gained expertise in aerial photography interpretation and analysis, social scientists working in a wide range of fields, including human geography, history, ethnography, urban planning, and architecture, were enthusiastic about the technique's promise to offer new insight into the study of humankind and its relationship to the environment: The very same technique that had been used in war was now employed extensively in social-scientific research, in combination with many other methods.

This was not, however, a purely scientific endeavor. Embedded within researchers' interests in the study of topographical space, and in the use of aerial photography (in addition to other research tools) to illuminate various forms of human habitation so that they could be compared on a global level, were a complex set of political and social concerns, as well as hopes about the future of human society with the aid of new technologies. Especially during the Great Depression of the 1930s, the study of the countryside in the colonies as well as in France, with the aid of aerial photos, served as a medium for reflecting upon capitalism and the French state.[4] Exploring the varied use of aerial photography in the social sciences, architecture, and planning in interwar France will illuminate the airplane's contribution to the emergence of a spatially oriented critique of capitalism and modernity—a critique that, as we will see, later became focused on the problem of housing and the suburbs in postwar France.

READING SPACE: AERIAL PHOTOGRAPHY IN INTERWAR HUMAN GEOGRAPHY AND HISTORY

By the 1920s, the regional tradition of French human geography, spearheaded by the geographer Paul Vidal de la Blache at the elite École normale supérieure in Paris in the late nineteenth and early twentieth centuries, was already firmly established. Its roots, as historian Marie-Claire Robic and others have pointed out, can be traced in large part to the national crisis that followed the Franco-Prussian War of 1870 and the French Commune of 1871. After 1870, there was a general feeling within the national education system, headed by Minister of Education Jules Simon, that knowledge of geography not only would improve the conditions of the country but also would foster nationalist sentiment.

Geographical knowledge of the French territory would, it was hoped, serve national regeneration efforts. At the same time, as the historian David Livingston has explained, interest in the "particularities of place" via the study of humanized regions held within it the possibility of reinvigorating the spirit of local areas, providing a focus beyond the centralized administration of the state. Vidal himself argued, in a highly influential report titled "Régions françaises," that the field of human geography—assisted by methods of analysis such as cartography and aerial photography—could help bring to light the "true" France, providing an alternative to the supposedly artificial administrative division of France into *départements* (a product of Napoleonic centralization in the early nineteenth century). Vidal and his students made detailed studies of the characteristics of the landscape, including its botanical and ecological traits and of the "character" or personality of the human groups who resided there—what Vidal called *genres de vie* (ways of life). Their aim was to reveal a correlation between the two. As Vidal wrote, "the study of the ground will contribute . . . to clarify for us the character, customs, and habits of the inhabitants."[5]

Aerial photography, as well as street-level photography, was crucial to Vidal's regionalism. Only aerial views of a particular region, Vidal argued, would allow human geographers to grasp the abstract *form* of a particular area. This outline, in turn, would shed light on the "character" or personality of the people who lived there. Vidal even began his 1903 *Tableau de la Géographie de la France*, one of his most significant works, with a balloon photograph of the center of Paris.[6] Although concerned with human action, Vidal asserted in *Tableau de la Géographie de la France* and in other books that natural topography should remain the most important element of the analysis. In this way, his utilization of aerial photos, cartography, and other methods of observation served to connect Vidal's human geographical studies with the work of the neighboring, and much more established, scientific discipline of ecology. Like the human geographers Vidal and Gourou, ecologists also required a "holistic" view (*vue d'ensemble*) of the human and geographical landscape in order to uncover patterns and to view the interrelationships of various elements within the same "ecosystem." Vidal and many other great human geographers of this time (including Albert Demangeon, Emmanuel de Martonne, and Jean Brunhes), while interested in the human and social, referenced the work of ecologists and

other specialists in the natural sciences (zoologists, climatologists, geologists, botanists, hydrographic surveyors) extensively. This interdisciplinary interest was necessary in a field that encompassed no less than the entire surface of the globe and humankind's actions within it. No study of human geography would ever be complete, it seemed, without detailed analyses of the soil as well as types of human habitation. When one looks beyond this often-cited reason for its connection to the natural sciences, however, the symbolic dimension of this association becomes apparent. Cartography and aerial photography were not simply useful ways of studying human landscapes. Their methodological association with the natural sciences served to help define the new field of human geography as a "science"; these and other tools of vision offered a means of removing the bias of oneself and one's senses from the object of study, providing a powerful mode of interpretation at this time that the historians of science Lorraine Daston and Peter Galison have termed "mechanical objectivity."[7] These methods were considered "scientific" for other reasons too—for example, because the abstract forms they produced became the basis for a global comparison of regions.. De Martonne, one of Vidal's most eminent students, noted this in his *Traité de géographie physique* of 1927: "The geographical study of a phenomenon requires constant preoccupation with analogous phenomena . . . from other parts of the globe. For example, characteristics of the coast of Brittany become geographically significant when compared with similar coasts . . . to show how its particularities are explained by general principles of the evolution of coastal forms."[8]

In the aftermath of World War I, such global comparisons became extremely important not only for promoting the "science" of human geography but also for developing humanistic and political concerns. One of the best examples was Jean Brunhes, a former pupil of Vidal who shared his teacher's enthusiasm for both the natural sciences and photographic techniques, especially aerial photography. A social Catholic, Brunhes had studied history and geography at the École normale supérieure under Vidal but also worked closely with renowned ecologists and geologists. One of his colleagues even described Brunhes as "a natural scientist deeply concerned with social issues in the contemporary world."[9] The developing discipline of human geography was, for Brunhes, a medium for discussing his humanist concerns as much as it was a scientific undertaking. Just before World War I, Brunhes joined the banker and

philanthropist Albert Kahn in his ambitious "Archives of the Planet" project, an endeavor to create a photographic atlas of the entire world in order to show the unity and diversity of humankind.[10] The purpose of the archives project was not only to provide scholars with details about how human populations all over the globe live. It would also, Kahn hoped, make people more aware of the world's diversity and thus promote understanding across cultures, an ambition shared by practitioners of the budding field of ethnography. This ambitious venture aimed to use photography to document the relationship between humans and their environments in every corner of the world, and then re-assemble them into a photographic atlas.

In a letter asking Brunhes to direct the project, Kahn's associate described it as "a sort of photographic inventory of the surface of the globe as it is occupied and managed by mankind, such as it is presented at the beginning of the twentieth century."[11] Kahn's invitation provided Brunhes with an opportunity to explore his long-term interests in geography, photography, and social progress. It also led to a prestigious chair at the Collège de France, which provided the necessary resources for him to master photographic techniques. In an effort to make the directorship as appealing as possible, Kahn promised Brunhes all the equipment his endeavors required: "We will give him everything necessary in terms of photographic devices and operators, and everything he will need, one of my houses in Boulogne will serve as a laboratory and a conservatory: stereoscopic photography, projections, and films above all. . . ."[12]

Brunhes took full advantage of this opportunity. In the decades that followed, he developed the use of all sorts of visual techniques in his work, among them aerial photos. Influenced, like many of his contemporaries, by the French phenomenologist Henri Bergson, Brunhes taught his students that direct observation, with the aid of street-level and aerial photos, was indispensable to the work of human geography.[13] Aerial photos were particularly important because they brought abstract forms to light. Like aerial spotters and navigators during World War I, Brunhes instructed young students of human geography to "read" the landscape and to quickly locate human settlement patterns such as villages, houses, and agricultural fields. "You must learn how to read the land," Brunhes exclaimed in a textbook he published in 1926, "as one reads a great open book."[14] In this instructional manual for young students of human geography, Brunhes

rewrite use of color during AP US teaching us how to interpret primary sources

juxtaposed aerial photos of different regions of France and asked his readers to consider questions such as the following:

What do you have before your eyes? What shocks you at first glance on the photograph? What do the different tints represent? How are the spaces of human habitation divided? Are they grouped or isolated? How are the houses placed in relation to the highways and roads? Is this land heavily populated? Where are the borders of the houses? What does the white line around the island represent? Are the inhabitants agriculturalists? How do you think they make their living?[15]

Gourou's work followed the same tradition, but applied it instead to the study of the non-Western, tropical region of northern Vietnam.[16] Reflecting on several decades of work in the 1980s, Gourou explained that his interest in northern Vietnam was, in part, a response to World War I. As was true of many other scholars and artists working in the 1920s and the 1930s, the war had undermined Gourou's faith in the European ideals of modernization and rationality, and he had turned to the study of non-Western societies in search of alternatives to Western values, ways of life, and modes of production.[17] Born in Tunis, Gourou studied human geography at the University of Lyon before assuming teaching positions at secondary schools (*lycées*) in Tunis in 1923, in Saigon in 1926, and Hanoi in 1927. His study of the Tonkin Delta, completed after years of weekend excursions to villages in the area, provided the basis for his dissertation at the Sorbonne in Paris, which he defended in 1936.[18]

Like Brunhes and Vidal, Gourou made abundant use of aerial photos, which he acquired from the French Air Force, in his published works, especially his highly influential 1936 study.[19] Views from above, he argued, gave him special access to "geographical reality," which he defined as the projection of thought onto the exterior world.[20] Gourou marveled at the ability of aerial photos to shed light on the "unity" of Tonkin villages and on the distinct correlation between each form of habitation and their natural surroundings. From the air, each of the chaotic and overpopulated villages of northern Vietnam assumed a distinct and abstract form. Looking down on Tonkin villages from above, he explained, one might think that there was no order in their arrangement: "At first glance, one is shocked by the incalculable multitude of black spots which represent the villages and by the very important area that they occupy. . . . It first appears that these spots are thrown in a disorderly fashion, like haphazard traces by an

LEÇONS DE GÉOGRAPHIE

COURS MOYEN

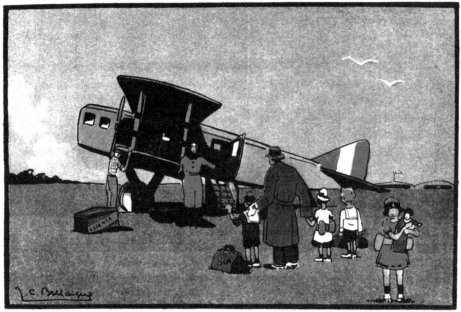

Fig. 1. — Partons en avion...

PREMIER EXERCICE D'OBSERVATION

Étudier la **Géographie,** c'est voir et connaître, puis réfléchir et comprendre[1]. Offrons-nous d'abord l'incomparable joie d'un beau voyage ; essayons d'apercevoir et d'expliquer quelques-uns des paysages si divers de notre France, et même des régions d'outre-mer sur lesquelles flotte le pavillon français.

Nous allons nous faire enlever et transporter par le moteur et sur les ailes d'un avion, et, très vite, ardents à tout voir, nous irons aux *quatre coins du pays,...* plus loin encore.

Il vous faut savoir **lire sur la terre,** quand vous la dominez ainsi, comme on lit en un livre tout grand ouvert.

Tournez la page : vous avez au-dessous de vous des figures vraies de la réalité terrestre. Découvrez et déchiffrez. Ce sera là votre premier exercice de géographie. Et comme on aurait dit au temps où l'on énonçait en cadence les plus importants préceptes :

Avant toute leçon que vous devrez apprendre,
Voici donc, pour vos yeux, images à comprendre.

FIGURE 2.3

A page in Jean Brunhes' 1926 book *Leçons de géographie. Cours Moyen.* "To study geography," Brunhes wrote in this 1926 text for young students of human geography, "is to see and to know, then reflect and understand. . . . You must know how to *read the land* . . . as one reads a great open book."

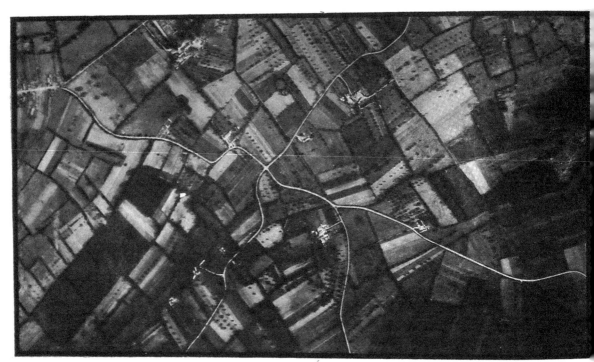

Fig. 2. — Un paysage de la France de l'Ouest. — Environs du MANS (Sarthe).

Qu'est-ce qui vous frappe à première vue sur la photographie ? — Que représentent les différentes teintes ? — Voyez-vous des arbres ? — Qu'est-ce qui entoure les champs ? — Comment sont réparties les habitations ? — Sont-elles groupées ou isolées ? — Comment sont placés les villages ou les fermes par rapport à la route ? — Que pensez-vous des routes ? — Le pays paraît-il riche ? — De quelle sorte de richesse ? *Voir l'emplacement du Mans sur la carte de la fig. 72, p. 59.*

FIGURE 2.4

A page from Brunhes' *Leçons de géographie.* In teaching young geography students how to "read" the landscape with the aid of aerial photos, Brunhes asked them to consider these questions: "What shocks you on first glance in the photograph? What do the different tints represent? Do you see trees? What surrounds the agricultural fields? How are the spaces of human habitation divided? Are they grouped or isolated? How are the villages or farms situated in relation to the roads? What do you think of the roads? Does the country appear wealthy? What sort of wealth?"

insect which had dipped its legs in ink."[21] Yet a closer look revealed the pattern embedded within this apparent chaos. "Very quickly, direct lines appear; the study of human habitation will consist of making sense of these direct lines and to determine the different types of villages."[22]

Gourou broadened this study of spatial form to connect with Tonkin politics and social life. He asserted, in particular, that such abstract forms revealed the autonomous nature of political, economic, and social life on the ground. He pointed out that one of five distinct regions in Vietnam, the Tonkin, constituted a political unity, but that this unity predated the French colonial presence and was linked to the topography of the region.[23] Gourou posited that at the basis of this unity was the topography of the region, which served to foster political and social cohesion and to maintain the vitality of village life. "The natural unity of the Delta," he wrote, "has contributed greatly to the creation of human unity. Natural uniformity and human uniformity, in aiding one another, have created a remarkably homogeneous country and a perfectly coherent nation."[24]

In his concluding remarks to his 1936 work, Gourou praised the "beauty" of the harmony and homogeneity of the Tonkin region. "The population of the Tonkin delta lives in need," he reflected, "but not in despair. . . . The peasant lives in a moral and social world which provides him with a thousand interests and satisfactions."[25] In contrast to "more developed countries," such as France, the peasants of the region lived in complete harmony with nature. Everything about the Tonkin, from the structure of their houses to the dull colors of their clothing, reflected this harmonious socio-spatial relationship and accounted for their happiness and stability. Gourou was especially fascinated by the vitality of daily life in Tonkin villages, a characteristic that he attributed to the well-balanced relationship between villagers and their natural surroundings. Contrasting the robustness of communal life in Tonkin villages with the dreariness of individualistic society in France, he wrote that "the peasant is not an isolated, random citizen of a community in which he only participates from afar, as is an inhabitant of the French countryside. On the contrary, the religious, political, and social life of the Annamite community is intense and embedded in everyday life, and all the peasants participate in it with faith, with ardor, with the ambition of playing a larger and larger role in it."[26] Aerial views thus led Gourou to link the physical structure or form of the Tonkin community with sociability and happiness.

If, as we saw in the case of Vidal, the visual technique of aerial photography served to connect human geography to natural sciences such as ecology, it also bridged the discipline with neighboring ones in the human sciences. In history, for instance, the outline or form of human settlements as seen from above inspired Marc Bloch, one of the founders of the *Annales* School. The *Annales* School aimed to go beyond the study of spontaneous events and uncover deeper historical structures, which adherents referred to as the *longue durée*. As was the case with Gourou, Bloch's interest in aerial photography stemmed largely from his experience during World War I. Although early on in the war Bloch had been stationed deep within the Gruerie Forest, after a bout of typhoid fever he was promoted and made responsible for providing "reports on aircraft, cartography, and topography."[27] After the war, Bloch began experimenting with the use of these military techniques in the non-military discipline of history.

As a professor of medieval history at the University of Strasbourg in the 1920s and the 1930s, before moving to the Sorbonne in Paris in 1936, Bloch encouraged his students to consider the landscape as a historical document. If written texts provided a view into conscious historical processes, topography, he suggested, provided valuable insight into phenomena that were unconscious and invisible, such as social, economic, and political structure. Bloch described rural history as a "vibrant human interaction with the soil."[28] Studying the form of agricultural fields as seen from an airplane, he contended, provided insight into the society that had produced them. Bloch demonstrated these connections as he took his students on field trips into the countryside near Strasbourg to see the elongated fields of Alsace, which he considered to be characteristic of all of northern Europe. According to Bloch, students of history could best understand historical processes by looking at historical processes that were still very much alive.

Bloch published these findings in his 1931 book *French Rural History. An Essay on Its Basic Characteristics*.[29] After discussing rural customs in France in the Middle Ages, he quickly shifted to analyzing how these customs corresponded to current patterns in the form of agricultural fields in different regions of France. One could see from the air, he explained, that the territory of France was divided into three types of agricultural fields: parallel open fields in the north, irregular fields in the south, and enclosed fields in the center and the west. Each of these patterns reflected

both a series of technological practices and a set of social customs. For instance, the "open and elongated fields" of the north indicated "a society of great compactness, composed of men who thought instinctively in terms of the community."[30] Bloch examined the form of agricultural fields alongside more conventional historical records, including legal treatises. In reviewing the evidence, he drew upon work in an array of academic fields, including human geography. For example, his bibliography includes Albert Demangeon's *La Plaine picardie* (1905) and Jules Sion's *Les Paysans de la Normandie orientale* (1909), among many other studies.[31]

Although Bloch pointed out that the type of plow used to till the soil influenced the form of agricultural fields, his argument was not one of technological determinism. On the contrary, Bloch placed heavy emphasis on the role of ideas, and on customary practices of land division. "Thus, less ambitiously," he wrote, "let us limit ourselves to noting that as far back as we can go, the plow, mother of elongated fields, and the practice of a strong collective life join together to characterize one very clear type of agrarian civilization; and the absence of these two criteria, a completely different type."[32] In contrast to two other contemporary works on similar topics, the historian Gaston Roupnel's *Histoire de la Campagne Française* (1932) and the geographer Roger Dion's *Essai sur la formation du paysage rural française* (1934),[33] Bloch's study was distinctly sociological in focus. For instance, although Bloch claimed that there was a correlation between the form of agricultural fields and the type of civilization that produced them, he also emphasized the complexity of this relationship, and he did not base his analysis strictly on geographical factors.

At the University of Strasbourg, Bloch presented this pioneering research in interdisciplinary workshops and colloquia with scholars such as the geographer Henri Baulig, the ethnographer Maurice Halbwachs, and the geographer-turned-historian Lucien Febvre, who also taught at the University of Strasbourg. Much like Brunhes and Durkheim, Bloch aimed to bring together data from various disciplines and to develop comparisons on a global scale. He encouraged the use of interdisciplinary methods in historical research by founding, with Lucien Febvre, the *Annales* historical school. In the first issue of the journal produced by this group, Bloch urged historians to pay more attention to geographical space, the "setting of social life." "Although, in Germany . . . in England, in Belgium, analogous plans have long been exploited by historians," he wrote, "French

cadastral plans . . . have hardly ever been studied. It is urgent to call upon the attention of professionals, and notably of researchers preoccupied with regional or local history. . . ."[34]

While Bloch encouraged the use of aerial photos in historical research, he nonetheless was aware of the expense of this technique (which made it "subject . . . to limited usage"[35]), and he argued that it should never be used alone. Aerial photography, for Bloch as well as others, was just one technique among many that could facilitate historical research. For instance, in the second issue of *Annales*, Bloch reviewed *Air-Photography and Economic History: The Evolution of the Corn Field*, a book by the British archaeologist Cecil E. Curwen.[36] Curwen, Bloch explained, employed the military technique of aerial photography for scientific research. Views from the air "[made] visible elevations on the ground which are hardly visible, at least in their totality, at ground level."[37] Bloch admired the book's intentions, but criticized Curwen's reliance on aerial photography, arguing that he should have used it in conjunction with other methods, such as a thorough comparison of cadastral maps and, even more important, observation of local customs. "Aerial photos may be admirable documents. . . . It would be keenly wished that in France as well they are put to use in the history of territorial occupation," Bloch explained. "But, for the love of God! Let's not compromise the use of this new instrument of investigation by absorbing it non-stop."[38]

ETHNOGRAPHY FROM THE AIR

Aerial views thus drew the attention of human geographers and historians to humankind's physical mark on the Earth. Yet it was above all in ethnography, a field devoted to the study of culture, that—with the aid of aerial photography—the social aspects of space came to the fore.[39] One of the first ethnographers to use the technique in anthropological fieldwork was the Africanist Marcel Griaule, who was based in Paris at the Musée de l'homme and the Sorbonne. Griaule learned aerial photography during World War I, where he served as an aerial spotter and navigator. After the war, Griaule often lectured at the Sorbonne in his military uniform. He also endeavored to use a variety of military techniques in ethnographic fieldwork, including teamwork, interrogations of local inhabitants, and aerial photography, in order to obtain results that he described

as "scientific" and objective. Griaule surmised that if aerial photos could help him to see trenches hidden deep within the landscape, they could also aid in bringing to light the invisible aspects of cultural, social, political, and economic organization.

Using aerial photos, Griaule attempted to add a new and more technical element to the work of other ethnographers, namely Marcel Mauss, Maurice Halbwachs, and Émile Durkheim, who had already suggested links between spatial organization and social organization in non-Western societies.[40] One of the most exemplary studies in this regard was Mauss' early-twentieth-century study of spatial organization in Eskimo society, which he completed without leaving France.[41] Mauss argued that the seasonal migration of Eskimo groups could not be explained by geography alone; the form of their habitation during summer and winter was also influenced by social, economic, and political structure, as well as cultural values. To this ongoing concern with understanding the complex relationship between spatial organization and social organization in so-called primitive societies, Griaule introduced the military technique of aerial photography. Although Griaule described ethnography as an interdisciplinary endeavor—in his words, a "body of sciences" (*corpus de sciences*) with a corresponding "body of methods" (*corpus de méthodes*)[42]—he placed special emphasis on the "scientific" method of aerial photography.

The special place of this technique in Griaule's work stemmed, in part, from its practical utility. Aerial photos could scan large areas in a short amount of time, and track changes over time. In Griaule's eyes, only aerial photography could provide a "realistic" and objective "vue d'ensemble" of the societies under investigation. Yet, according to him, they also were useful in *verifying* ethnographic information, which, in turn, made ethnographic data more "scientific." Griaule often warned that information provided by local informants could not be trusted, especially in societies as "secretive" as those in which he worked.[43] The ethnographer who uses the "science of observation," Griaule asserted, has the "advantage of administering proof by confrontation with various sources. . . . The words of an informant are confronted with those of another interview, a document . . . [and] the observation of concrete facts. . . ."[44] Moreover, ethnographic information that could be verified with the assistance of observation techniques could be viewed as more scientific than analyses that did not use such methods.

This claim was tremendously important in the 1930s, when the field of ethnography (African ethnography in particular) was just emerging. Much as in human geography, aerial photography helped to infuse this new sub-discipline with an air of objectivity by bringing it closer to the realm of the natural sciences. Since the late nineteenth century, there had been a close connection between the natural sciences and the social sciences; the Darwinian physical anthropologist Paul Broca exemplified that trend.[45] Through aerial photography, Griaule continued this trend, aiming to make the study of African culture "scientific" and firmly grounded in the physical world.

It was in his fourth "mission" to Africa, the 1936–1937 Mission Sahara-Cameroon, that Griaule first experimented with the use of aerial photography in ethnographic fieldwork in the colonies. Funded by the Colonial Minister, the Ministry of National Education, the Ministry of Air, the High Commission of Cameroon, and the Institute of Ethnology at the Museum of Mankind in Paris,[46] the research team included the ethnographer Paul-Henry Chombart de Lauwe, the ethnographer Jean-Paul Lebeuf, and the pilot Georges Guyot.[47] Their aim was to document the lives of the various tribal groups of the region of northern Cameroon through photography, aerial photography, interviews with local inhabitants, and the collection of art objects. Griaule and his team took more than 600 aerial photos.[48] Although they began their fieldwork among the Foulbé tribe, they soon became interested in that tribe's chief enemy, the Dogon.[49]

At the time, the Dogon, who inhabited the cliff region of the western part of northern Cameroon, were best known for their supposed secrecy, particularly in matters of religion, and their reputation as superior agriculturalists. As he later stated in the mission's reports and in articles published in the *Journal de la société des africanistes*, Griaule found aerial photography an essential technique. From the air, Griaule noticed the distinctive checkerboard pattern of Dogon agricultural fields (figure 2.5). Then, on the ground, he discovered this same geometrical pattern on the facades of sanctuaries, painted on rocks, and weaved into funerary blankets (figure 2.6). This observation led him to argue that the Dogon had an integrated cultural system in which the various spheres of their lives were "harmoniously" integrated (figure 2.7). "It is true," he explained, "that in the Dogon unconscious, these [signs] are linked; the crop of the field is always placed side by side with prayers, with offspring; the fertilizing power

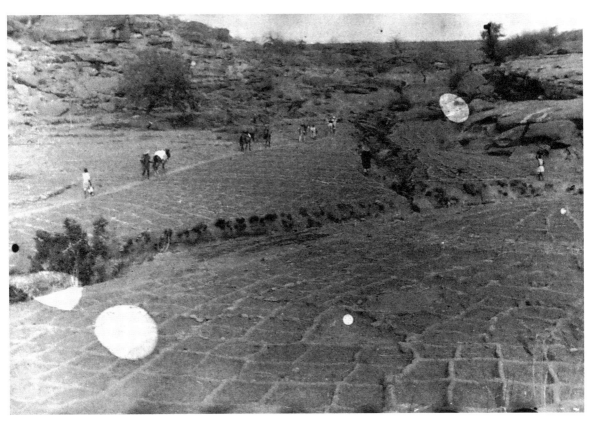

FIGURE 2.5
A photo of Drogon agricultural fields showing the checkered pattern that Griaule
saw from the air. Fonds Marcel-Griaule.

of the funerary cult is perfectly conceived; it is thus not astonishing that
the blanket, important symbol of this cult and a sign of wealth, which
sometimes replaces the corpse, is tied to men and to agricultural fields."[50]
The airplane, Griaule asserted, had allowed him to plunge into the "mental
life" (*vie mentale*) of the Dogon and to see unconscious connections
between disparate cultural phenomena. In various articles, he emphasized
that this "scientific discovery" would never have been possible without the
aid of the airplane.

Griaule also used aerial photography in numerous subsequent researches.
For example, in 1937 and 1938 he studied the form of villages of a group

FIGURE 2.6
On the ground in Dogon territory, Griaule noticed that the same checkerboard
pattern was painted on rocks, woven into blankets, and sketched onto the facades
of sanctuaries. Fonds Marcel-Griaule.

FIGURE 2.7
Griaule concluded that the checkerboard pattern linked various aspects of cultural life within the Dogon unconscious. Marcel Griaule, "Blasons totémiques des dogon," *Journal de la société des africanistes* VII (1937): 69–79.

known as the Saô in Chad. The Saô's built environment, for Griaule, provided a clear example of how African myths were inscribed in the physical world. Informants had recounted for him the myth of legendary giants arriving near the river after a long journey, and how each village in the region bore the mark of the body of one of these giants. Aerial photos of the abstract layout of Saô villages reflected this origin myth, and thus, for Griaule, helped reveal the unconscious connections between the Saô's system of cosmology and the spaces they inhabited.[51]

One of the members of Griaule's team was Paul-Henry Chombart de Lauwe, then just 22 years old and a student at the École des Beaux-Arts, where he completed a certificate in ethnography under Marcel Mauss and Paul Rivet.[52] In the early 1930s, Chombart began to pursue studies in the then-burgeoning field of ethnography. While studying under Mauss and Rivet, Chombart met Griaule and was invited to accompany him on

various ethnographic "missions" in West Africa in the 1930s, including the fourth one.[53]

During his trips to the field, Chombart learned not only the practice of aerial photography but also the value of the study of topography in understanding the cultural and social significance of spatial organization in colonial areas. In 1937, for example, Chombart reported on the fourth Griaule mission to the prestigious Geographical Society in Paris, describing the mission's importance for understanding the social life and culture of the Dogon and neighboring groups. In a manner reminiscent of Charles Lindbergh's accounts of the dangers of aviation, Chombart first discussed how difficult it was to fly to this African region, with a plane intended for tourism, before moving on to a description of the roughness of the territory itself and the complexity of the tribal groups who resided there.[54] The fact that there were many social groups in a territory the size of Belgium, each with its own customs and dialects, made it impossible to carry out an intensive study without the assistance of the colonial administration. "Teamwork," Chombart stated, "is indispensable . . . for establishing a collaboration . . . between the colonial administration and the ethnographers was one of the mission's primary objectives."[55] Studies of the outline of residential areas were also crucial to capturing an accurate understanding of such groups, because these abstract forms reflected patterns of social organization and cultural values. Describing the form of one village, Chombart commented that from the air the roofs of particular houses and the groups of houses in sections and villages resembled mushrooms and clusters of mushrooms.[56]

In 1939 Chombart expanded upon his description of the correlation between natural topography, social/familial structure, and cultural values in "Schematic Map of the Populations of Cameroon," an article written in conjunction with the Chief Administrator of the Colonies, J. Deboudaud.[57] Much like Gourou's study of the Tonkin, published three years earlier, Chombart began by describing how clearly definable each tribal territory was from the air, as each was situated within a different type of terrain. He even used Vidal's term *genre de vie* to explain this phenomenon: "Each

FIGURE 2.8
Paul Henry Chombart de Lauwe, with Chief Administrator of the Colonies, J. Deboudaud, made a schematic map of villages in northern Cameroon, much like Gourou's map of Tonkin villages in northern Vietnam.

FIG. 44. — Carte schématique des populations du Cameroun.

region corresponds to a different way of life [*genre de vie*]. . . ."[58] Even though this region of northern Cameroon seemed to be a crossroads of various cultural groups, he explained, all the groups maintained distinct personalities within defined patches of territory.[59] Chombart and Deboudaud argued that various groups in northern and southern Cameroon could be mapped onto distinct topological regions, just as the territorial zones of animals or insects might be outlined by a biologist.

After the Mission Sahara-Cameroon, the anthropologist Paul Rivet invited Chombart to conduct a two-year aviation and ethnography mission in northern Vietnam—among, no less, the Tonkin of northern Vietnam, where Gourou worked—but sickness and military service prevented Chombart from accepting Rivet's offer.[60] Nevertheless, after World War II Chombart found another way to further his interests in ethnography, aviation, and geographical space: rather than applying the theories of spatial organization that he developed in Africa to the study of another colonial area, he instead employed them to shed light on contemporary trends in France.

TRANSFORMING SPACE: AERIAL PHOTOGRAPHY IN INTERWAR ARCHITECTURE AND URBAN PLANNING

While Gourou, Griaule, and multiple other social scientists were experimenting with aerial photography in their work to "read" the landscape and its history in the 1930s, architects and planners were using the technique to develop plans for *transforming* urban space in the metropole—or, more specifically, the metropolis. Paris was growing, but not in the locations where one might expect. Its periphery, rather than its center, was growing more rapidly than ever before. The population of Paris' suburbs grew by more than a million, and many of the new residents were immigrants seeking employment in the many new factories constructed there after World War I.[61] In the 1920s and the 1930s, observers often remarked upon the "chaos" and "disorder" of these peripheral areas.[62] Georges Lacombe's 1928 film *La Zone* highlighted the stark contrast between the wealthy center of Paris and the poverty of the periphery, just minutes away by train.[63]

As the historians Marc Desportes and Antoine Picon argue, this phenomenon should not be understood simply as the realization of the nineteenth century writer Émile Verhaeren's nightmare of the *villes tentacu-*

laires applied to Paris. At the root of the problem, rather than urban growth alone, was the absence of any development of an "urban framework" (*l'armature urbaine*) through planning.[64] Unlike many other European cities, pre–World War II Paris lacked a clear system of territorial management. The laws created in this direction in the aftermath of World War I—the *loi Cornudet* of 1919 and the Sarraut and Loucher Laws of 1928[65]—were bold efforts in this direction. But these initiatives lost steam during the economic crisis of the 1930s. Additionally, the business of land speculation flourished within the unregulated context of the 1920s. Ready to take advantage of the high hopes and dreams of young workers, speculators offered *lotissements* (large estates that were financed by saving syndicates). Many workers, especially immigrants, lived in houses with dirt floors and no plumbing, with little or no public transportation network around them.

While rural areas and the center of Paris remained largely unchanged during the 1920s and the 1930s, therefore, the Parisian *banlieues* were in the midst of a dramatic transformation. The population of the suburbs had grown, by the 1930s, to 5 million, while that of central Paris was less than 3 million.[66] Because land was cheaper on the outskirts than in the center of Paris, 92 percent of the houses built between 1914 and 1943 were constructed in outlying areas of the city.[67] In 1928, a new organization, La Comité supérieure d'aménagement et d'organization de la région parisienne, was created to develop an organizational plan for Paris.

Aerial photography played a central role in interwar efforts to restore public health and family structure in the *banlieues*. The architect Marcel Lods, who had studied at the École des Beaux-Arts and who later became its director, was a major figure in this effort. Having learned to fly during World War I, Lods became an enthusiastic aviator. In the interwar period, the disorder of the Parisian suburbs became a laboratory for Lods to experiment with new and supposedly more rational technologies and construction materials, including concrete and pre-fabrication.[68] Yet what is most significant (at least for us) is the way the aerial perspective drew Lods' attention beyond architecture to the broader problem of urban planning—or, rather, the absence thereof in interwar Paris. According to the historian Pieter Uyttenhove, "Lods' first projects in the *banlieues* of Paris revealed to him the suburban disorder against which he enthusiastically revolted. . . . It was, for him, the beginning of an awareness of the very large city and, as a result, of the importance of urbanism."[69]

An avid photographer, Lods took photos of everything around him: the pollution visible from the air above Paris, where automobiles and industry were beginning to boom; the chaos of the outskirts, where there was little or no government regulation or planning; and the miserable state of the people who lived in these chaotic areas, often in shacks made of cheap materials and with no running water. Even the production site itself, which was often showcased in aerial photos, was intended to be an efficient and organized site of assembly, made specifically for fostering a particularly modern form of housing, one that would finally solve, or at least ameliorate, the lodging crisis.[70] Lods also used aerial photos to document environmental pollution.[71] Interestingly, Lods did not use military aerial photographs to analyze the chaos of the shantytowns (*bidonvilles*) on the outskirts of Paris. Rather, he flew and took aerial photos himself, and let them stand alone without interpretation.[72]

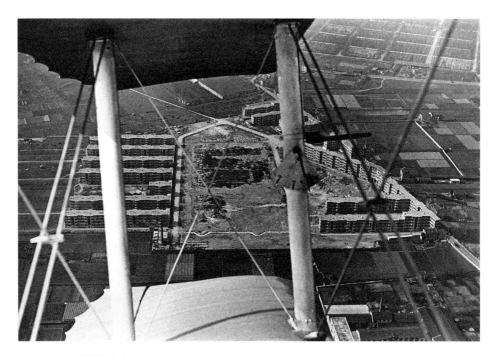

FIGURE 2.9

In the mid 1930s, Marcel Lods took aerial photographs of the construction of the Cité de la Muette, a housing complex he and Eugène Beaudouin had designed. Fonds Marcel Lods. Académie d'architecture/Cité de l'architecture et du patrimoine/Archives d'architecture du XXe siècle.

The airplane also played a symbolic role for Lods. During an era when most members of the French elite were concerned with "planning," (mainly economic planning), the "God's-eye view" put him on a par with other "experts" and reinforced his authority. As the historian Nicole Toutcheff has remarked, aerial views served to confirm, for Lods, the notion that architects and planners were deities.[73] He also used aerial photos to try to incite government officials, architects, planners, and the public to "take action," by which he meant implementing government-sponsored planning programs to gain control of the disorderly suburbs of Paris. The unregulated, private, chaotic *banlieues*—were to be replaced with an organized building program that was directed by the state. This private, disorderly space was to become a model of rationality.

The Cité de la Muette, a government-subsidized residential complex that was designed and constructed by Lods and the architect Eugène Beaudouin in the early 1930s, provides a perfect example of the program for Parisian suburbs that Lods envisioned. Situated in a northeastern suburb of Paris presided over by a Communist mayor, the Cité de la Muette was constructed in direct opposition to the main type of housing that existed in the suburbs at that time: Instead of shack-like individual dwellings or *pavillons*, the complex was composed of multiple rows of fourteen-story towers laid out geometrically. Lods had high hopes for this novel residence, which he expressed at an exhibit at the Museum of Modern Art in New York in 1939: "This will be a complete community with its own schools, church, athletic fields . . . *financed by the State*. The well-spaced skyscrapers assure their tenants light, air and privacy. . . . This scheme shows an important type of housing solution unrealized else-where."[74] Prefabricated and devoid of any "exterior signs of material effort," the Cité de la Muette was a precursor to the *grands ensembles* of the postwar period, which became the central target of social-scientific studies of "social space."[75]

Lods drew inspiration for the Cité de la Muette and other architectural projects from the work of the Congrès Internationaux d'Architecture Moderne, a group founded in 1928 by the architect Le Corbusier for the purpose of defining the contours of "modernist architecture." Central to Lods' program was a prescription for dividing a city into four main functions, based on supposedly universal needs: living, working, leisure, and circulation. The principles of rational planning, though largely

developed during the 1930s, were published in the Athens Charter of 1943.[76] In 1934, after finishing plans for the Cité de la Muette, Lods joined the CIAM chapter in France. Even after World War II, he remained an adherent to notions of "rational" urban planning as outlined in the Athens Charter.[77] Throughout the early twentieth century, Le Corbusier himself was developing bold solutions to the problem of housing conditions in the Parisian suburbs. In 1925 he proposed a "Plan for A City of Three Million Inhabitants" (also known as the Plan Voisin) that addressed the issue of expansion by building up rather than out.[78] For Le Corbusier and other "high modernists," the disorderly domain of urban planning could be cured with rational, state-run urban planning programs. The Plan Voisin called for bulldozing the chaotic center of Paris and constructing high-rise towers for work and living. The idea was that visual disarray, as seen from an airplane, could be made orderly and geometrical with the aid of modern building techniques, a series of experts, and, most important, a centralized state. "Human needs," James Scott writes, were scientifically stipulated by the planner. Nowhere did [Le Corbusier] admit that the subjects for whom he was planning might have something valuable to say on this matter or that their needs might be plural rather than singular."[79]

Yet, beginning in 1930 with plans for The Radiant City (*La Ville Radieuse*), Le Corbusier began to reconsider his approach to city planning—and his admiration for large capitalist cities in general.[80] Le Corbusier's rethinking of design principles coincided with an airplane trip to Rio de Janeiro with the poet and pilot Antoine Saint-Exupéry in 1929, the year of the stock market crash. If Gourou and other social scientists had begun to question the advantages of capitalist modes of production at this time, and used the practice of aerial photography to support their critique, so too did Le Corbusier. In contrast to the abstract and geometrical forms that Cubists and others had, in the early twentieth century, seen from above and praised for their revolutionary potential,[81] in the 1930s Le Corbusier saw only unstructured chaos when he looked down upon Western cities. For him, aerial views, combined with the unique political-economic context of the 1930s, engendered the impression that the West was in a profound cultural crisis.

In a series of lectures published as *Precisions on the Present State of Architecture and City Planning,* Le Corbusier recounted how aerial views of Brazil

had affected his thinking about urban planning and architecture.[82] The winding path of the Amazon and other rivers as seen from the air had inspired him to rethink his former emphasis on straight lines and geometrical order, and to envision an alternative conception of order rooted in organic and irregular forms. There was, Le Corbusier argued, an inherent logic in the curved line, which he described as the "law of the meander."[83] Le Corbusier was thus inspired by the detached view of the earth from an airplane to look to nature, rather than industrial techniques, to solve the problem of growth in modern cities. It was only in nature, climate, and topography, he wrote, that humankind could find unity, harmony, and true happiness.

Beginning in 1931, Le Corbusier attempted to articulate this new vision, and employ the "law of the meander," in a series of plans for Algiers. Le Corbusier's focus on the capital of Algeria, which lasted from 1931 through 1942, coincided with his political involvement with regional syndicalism, a movement that placed primary importance on action, rejected capitalism, and called for "cultural and spiritual regeneration as much as economic and social reform. . . ."[84] Le Corbusier chose Algiers in part because of its role as a Mediterranean and colonial center. If successful, Le Corbusier hoped to use his new schemes to help connect the Mediterranean world and colonial societies more generally with European cities such as Paris and Barcelona. The city was, therefore, as important in the development of Le Corbusier's new approach to planning as it was for his ideological and humanist aspirations, to bring humankind together through architecture and the reorganization of urban space.

Le Corbusier's newfound fascination with organicism, which developed during his airplane trip to Brazil, was reflected in his first plan for the city of Algiers, "Obus A," which he presented to the city's mayor in 1931. According to the historian Mary McLeod, the project aimed "for a spontaneous and total symbiosis of man, architecture, and the landscape."[85] The aerial perspective on the world thus provided the very basis for Le Corbusier's new vision of town planning and his political commitment to regional syndicalism during the economic depression of the 1930s. As in *Preludes*, this call for a return to nature was intended as a remedy to the grave sickness that afflicted Western capitalist cities. In his 1942 book *Poésie sur Alger*, Le Corbusier wrote: "Urbanism is exactly the expression of the vitality of a society. Across the entire world, the unambiguous spectacle is

that of disorder, of unconsciousness, and of disarray. Mediocrity of days and of lives, cities without hope, in Europe as in America. . . . Cities are sick like the plague."[86]

In the early 1930s, Le Corbusier was invited by a London publishing house called The Studio, Ltd. to write a book on the airplane for a series titled The New Vision.[87] Le Corbusier replied, after some delay, that he understood that by "the aeroplane" The Studio meant "aviation, that is, the phenomenon . . . that opens entirely new horizons."[88] Le Corbusier decided to take this opportunity to express a critique of Western capitalism through a comparative analysis of urban form in non-Western and Western areas.[89] The most important contribution of the airplane to the development of Western civilization, Le Corbusier argued, was that it allowed the modern world to clearly *see*—and therefore recognize—the chaos of its present situation, spurring citizens to action. This new vision would spur the process of regeneration and spiritual renewal that was so desperately needed to bring about a new social, political, and economic order. "With its eagle eye," wrote Le Corbusier, "the airplane looks at the city. It looks at London, Paris, Berlin, New York, Barcelona, Algiers, Buenos Aires, Saô Paulo. Alas, what a sorry account! The airplane reveals this fact: that men have built cities for men, not in order to give them pleasure, to content them, to make them happy, but to make money!"[90]

In *Aircraft*, Le Corbusier contrasted the misery of capitalist urban environments with the "organic, harmonious, and beautiful" layout of non-Western cities such as M'Zab in Algeria. Describing the desert community, he wrote:

Behind the blind walls of the streets were laughing houses, each opening with three ample arcades on an exquisite garden. The women had dashed under the arches on hearing the noise of the engine. The whole town was under the arcades, watching the airplane make its spiral: then there were signs of joy and surprise when we passed like a whirlwind just above the roof level. The lesson is this: every house in the M'Zab, yes, every house without exception, is a place of happiness, of joy, of a serene existence regulated like an inescapable truth, in the service of man and for each. Up in the air this can be clearly seen.[91]

Thus, with the onset of economic depression in the 1930s, Le Corbusier's faith in industrialism and science began to crumble. The airplane inspired both a new vision of the world and a novel approach to urban

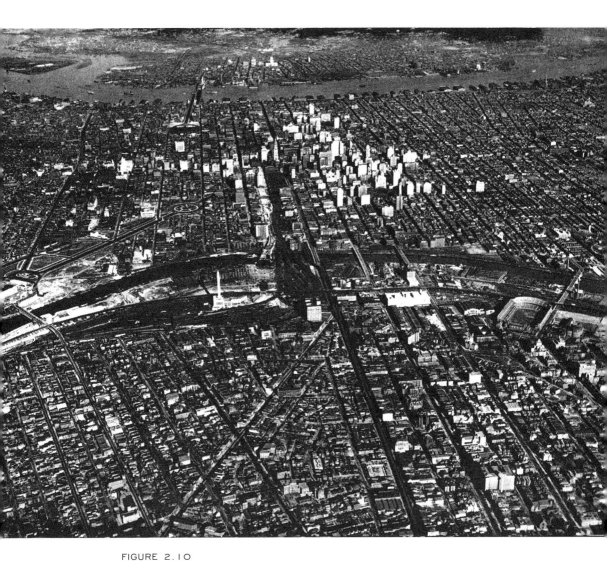

FIGURE 2.10
In *Aircraft* (1935), Le Corbusier contrasted the centrality of the financial district in Western cities such as Philadelphia with the "organic" organization of non-Western cities, where people, according to Le Corbusier, were "happier" and more sociable.

FIGURE 2.11

Le Corbusier was inspired by the view from above to develop a new approach to urban planning. Called "organic town planning," this approach privileged the curvature of the Earth's natural topography over the geometric right angles of the cube. From *Aircraft* (1935).

planning. The view from above drew Le Corbusier's attention to the importance of climate, topography, and geography, and brought to light, in what he perceived to be a scientific way, the "chaos" of Western capitalist cities. In articulating this aerial critique of capitalism, Le Corbusier was joined by other planners, architects, and urban critics—among them Lewis Mumford, who rebuked the "shapeless giantism" of large cities as seen from the air. Le Corbusier's estimation, therefore, was emblematic of a much wider trend.[92]

Le Corbusier's ambitious plans for Paris were, of course, never realized. But those of another influential architect and urban planner, Henri Prost, affected the future planning of the city. Like many other architects of his era, Prost began his career in the colonies. In 1914, three years after

starting the Société Française des Urbanistes, he was appointed director of the Service Spécial d'Architecture et des Plans des Villes in Morocco, where he worked alongside the military governor Hubert Lyautey to develop plans for that country's major cities. The experience marked Prost profoundly and had a direct influence on the Plan for Paris that he developed in the 1930s for the Comité supérieure d'aménagement et d'organization de la région parisienne.

Prost contributed to planning in all of Morocco's largest cities, including Rabat, Fez, Casablanca, Meknès, and Marrakesh. But in Casablanca, the historian Jean-Louis Cohen explains, Prost found a unique challenge. Unlike the cleanly divided cities of Rabat, Fez, and Meknès, which had already been redesigned by Lyautey, Casablanca had developed "organically," on its own, without an overall plan. As a result, it appeared much more chaotic than other Moroccan cities. In addition, after the formation of the French Protectorate in 1912, Casablanca began to expand even more, making the project of "managing" its growth a priority for Lyautey. Prost, working under Lyautey, felt that his job was to "[contain] damages" of this wild urban space[93]—a sentiment that reflected his nostalgia for the state-run urban planning programs of the past, such as that of Haussmann.[94]

Having been inspired by developments in urban planning in Germany and Switzerland, Prost focused his attention in Morocco on achieving a sense of "morphological homogeneity."[95] That is, instead of simply designing a plan for the location of buildings, streets, and other aspects of the city, he also concentrated on composing urban forms that would preserve the beauty of the city while replacing apparent "chaos" with functionality and order. This approach, for Prost, had roots in the view of a city as a living organism, which had been promoted by the Austrian planner Camillo Sitte in the late nineteenth century. In Casablanca, Prost aimed to create a "new city," one that was far from the median in both geographical distance and form. He "vertebrated" Casablanca's growth with two large axes, one from north to south and the other from east to west. He also designed open spaces, public squares, and instituted an administrative center.[96]

Prost returned to Paris in the early 1920s. The chaos of the suburbs, largely the result of land speculation in the 1920s, was, as we have seen, beginning to be viewed as a very serious social and political problem as

well as a public health hazard. When President Raymond Poincaré created the Comité Supérieur de l'Aménagement et de l'Organisation Générale de la Région Parisienne in 1928, the historian Rosemary Wakeman points out, it signified the growing perspective within governmental circles that the problem of Paris was "a national crisis that reflected mounting social tensions and the growing presence of communism."[97] Minister of Interior Albert Sarraut appointed Prost as Chief Urbanist of this organization, whose task it was to modernize and organize the Parisian region. "The suburbs," Wakeman explains, "would be converted into an ordered, regulated, more politically docile landscape."[98] Prost's task was immense: the population around Paris from 1926 to 1931 had grown an average of 10 percent each year, resulting in urban sprawl and a lack of adequate housing.[99]

In Paris, while working on his regional plan for the city in the 1930s, Prost was involved with the Insititut d'Urbanisme de l'Université de Paris, an interdisciplinary research group of socially minded planners at the Sorbonne. The IUUD had close ties to the Musée Social, which had made social housing a major left-wing issue since the late nineteenth century. Gaston Bardet and other IUUD planners were interested in aerial photography because they thought it promised to provide a more accurate picture of the "reality" of urban problems.

Prost's regional plan for Paris made use of aerial photos taken by the Institut Géographique Nationale, formerly the geographical service of the French Army. Most significantly, Prost presented a new way of thinking about the suburbs of Paris: rather than discreet places on the outskirts of the city, they should, Prost argued, be viewed as part of a holistic Parisian *agglomeration*. Here Prost was applying the notion of "morphological homogeneity," which he had developed in Casablanca, to Paris. Working with the engineer Raoul Dautry, Prost attempted to bring order to the suburbs by making them a part of the existing anatomy or biology of Paris.

FIGURE 2.12

From Plan d'aménagement de la région parisienne et autres études sur la région parisienne: carte générale de l'aménagement, 14 mai 1934. Académie d'architecture/ Cité de l'architecture et du patrimoine/Archives d'architecture du XXe siècle.

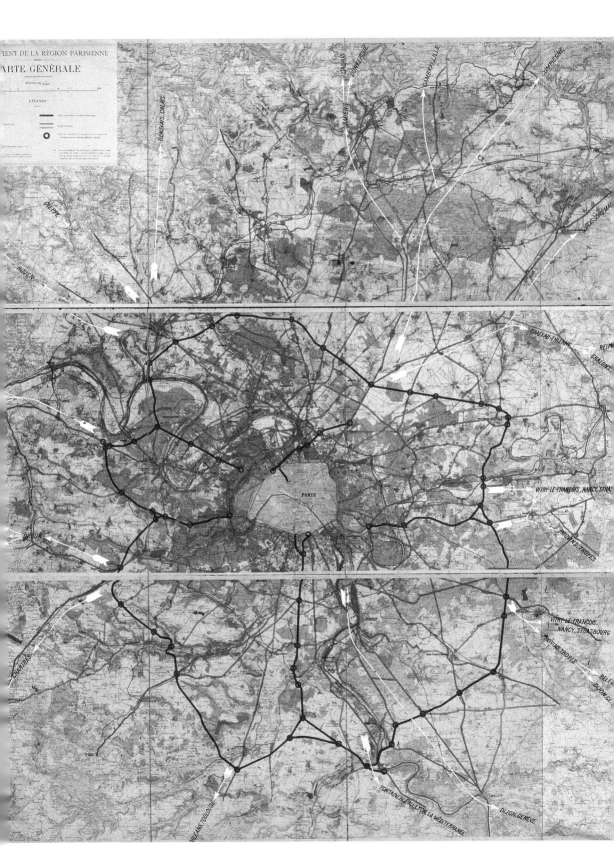

Closely associated with "morphological homogeneity" and the creation of the "Parisian agglomeration" was the practice of zoning. What better way, Prost reasoned, to reverse the chaos of suburban housing than to designate certain areas for residential living? "All housing," Prost argued, "is a fragment of the agglomeration . . . [which is] a whole . . . an organism in need of cohesion."[100] If Lods had used aerial photos to develop plans for the first *grands ensembles*, Prost utilized this technique, along with many others, to lay the groundwork that would make actual construction of the *grands ensembles* possible in the postwar era.

Using Institut Géographique Nationale maps, Prost never lost sight of the *vue d'ensemble* of the metropolis. Aerial photos brought Prost and Dautry's attention to the reality of the existing city and its organization. From this concrete point of departure, rejecting abstraction, they developed plans for the "new city," especially housing, preservation of green space, and circulation. "The realism and pragmatism of the plan," wrote Louis Dausset, director of the Comité Supérieur de l'Aménagement et de l'Organisation Générale de la Région Parisienne, "is highlighted. The plan is attentive to facts, to realities, to possibilities."[101] For example, in designing plans to increase circulation within and around the city, Prost began by locating points of constructed and unconstructed space, and finding areas where various spaces could be linked in a rational manner. The regional plan that he and Dautry presented in 1934, with the assistance of aerial photography and many other techniques of observation, defined the boundaries of the Parisian agglomeration until the 1960s, when they were redrawn.

Thus, the holistic view from above (*vue d'ensemble*) seemed to offer benefits for human geography, for history, for ethnography, for architecture, and for urban planning. The use of this method, considered by many at the time to represent the ultimate qualities of "objectivity," fostered desires for "interdisciplinary" research across fields, including such social sciences as human geography, history, ethnography, urban planning, and architecture and such natural sciences as biology and ecology.[102] In the late 1930s, however, these two stories were still parallel. The use of aerial photography to explore human habitation in the social sciences had not yet become fully integrated into urban planning and architecture.

In the 1940s this began to change. What brought social scientists, architects, and planners into each others' purview was a question posed by

World War II: What should postwar France look like? By presenting the problem of postwar reconstruction, World War II offered people in various academic and practical domains the opportunity to interact and share ideas. Although notions about the most "natural" and "organic" relationship between humans and geographical space were certainly percolating during the interwar period, mainly from studies conducted in French colonies by Griaule, Gourou, and others, the prospect of postwar reconstruction provided an opportunity for social scientists to put these ideas into action.

FIGURE 3.1
Studying everyday life in rural French communities was an important aspect of getting back in touch with "true" French values at the École des cadres d'Uriage. Archives départementales de l'Isère, Grenoble. Fonds de l'École des cadres d'Uriage 102 J 177.

"You think you know your country," wrote Chombart in a 1941 article for his students at the elite École des cadres d'Uriage,[1] a pedagogical institution created by the Vichy regime for the purpose of instilling future leaders of France with the values of the National Revolution, as captured in the 1941 slogan "Work, Family, Country." "But in fact, you tend to see the same everywhere. . . . These excursions [into the French countryside] are intended to help you to see France with entirely new eyes and . . . to rid ourselves of preconceived ideas."[2] The article was accompanied by an aerial photo of the village of Le Petit Dauphinois, near Grenoble, where Chombart led his small group of students. It was at Uriage that Chombart first had the opportunity to apply the anthropological theories he had developed in African colonies with Marcel Griaule during the 1930s to France. With his ethnographic eye, Chombart attempted to examine France as if it were a foreign country.

At Uriage, Marshal Henri-Philippe Pétain's maxim that France would have to "return to the land" in order to thrive again was no abstract metaphor. Students were taken into the French countryside to witness "true" French values of work, family, and nation. These values, Pétain and others argued, had been overshadowed by excess and wealth, and this was one of the reasons behind the defeat of France in 1940. The only way of returning to France's core, Pétain and others maintained, was by reconnecting all French citizens with the land (*la terre*), not only figuratively but literally.

At the same time, at another wartime institution, the Délégation Général de l'Equipement Nationale (Vichy's central urban planning department), government officials began to develop a large-scale plan to decentralize industries throughout France. The motivations for this project were rooted

in concerns over both national defense and social welfare. Decentralization promised to alleviate the effects of aerial bombardment and to equalize economic resources across France. This endeavor, however, was much more complicated than it appeared at first glance. DGEN officials quickly discovered that redistribution involved more than a simple dispersal of factories. Recognizing that decentralization would have profound social consequences, especially in regard to workers' housing, they sought advice from experts in the social sciences. For a social scientist such as Chombart, therefore, World War II provided an unprecedented opportunity to become involved in two issues that were now at the very center of French politics: housing and large-scale territorial management (*l'aménagement du territoire*).

ETHNOGRAPHIC INVESTIGATIONS OF RURAL LIFE IN FRANCE AT THE ÉCOLE DES CADRES D'URIAGE

When France and Britain declared war against Germany in June 1939, French military generals were highly confident in the French army's capacity to defend France against a potential invasion from the east. In a public address that month, one French general exclaimed: "I believe the French army has a greater value than at any other time in its history. . . . If we are forced to win a new victory, we will win it."[3] Yet in June 1940, after only forty days of intense warfare, France—at the urging of Marshal Pétain—capitulated. The Wehrmacht occupied the northern part of France, including Paris, while Pétain directed the "unoccupied" zone from the administrative center of Vichy, in southeastern France.

After the Armistice a number of French intellectuals, citizens, and politicians, including Pétain, argued that the country had been mortally weakened by decadence, individualism, and the parliamentary disputes of the Third Republic. For instance, in a radio speech given on June 20, 1940, Pétain stated: "Since the victory [of 1918], the spirit of indulgence overwhelmed the spirit of sacrifice. . . . People have made too many demands and showed too little willingness to contribute."[4] Even Marc Bloch, writing as a refugee and a member of the Resistance, contended that the Armistice shed light on cultural deficiencies within France, such as citizens' unwillingness to make sacrifices for their country and a lack of preparation for the modern world.[5] To remedy these shortcomings, Pétain called for a

National Revolution that would regenerate the nation by returning it to its core values. At the center of this initiative was what Pétain termed a "return to the land (*la terre*)." The nation was hidden behind a mask of artificiality, he argued, and the "true" France could not resurface until sacrifice and a return to authentic rural traditions removed the disguise. One of his first initiatives was to introduce a new national slogan, "Work, Family, Country," to replace that associated with the French Revolution of 1789, "Freedom, Equality, Fraternity." This act both reflected Pétain's rejection of abstract politics and reasserted values that he believed were at the heart of French culture. As he stated in a speech in June 1940, "I hate the lies that you have made so badly," Pétain stated in a speech in June 1940. "The land, it doesn't lie. It remains your remedy. . . ."[6] Pétain had been raised in the French countryside, and his call for a "return to the land" was highly nostalgic, perhaps even shaped by an idealized view of his own childhood.[7]

One of the institutions created to promote these bucolic ideals and feelings of optimism in the face of defeat was the École des Cadres d'Uriage, a leadership academy for French youths located in the Château de la Faulconnière, near Vichy. Situated in the rolling hills of southeastern France and sponsored by Vichy's Secrétariat d'État à la Famille et à la Jeunesse, the school was founded in 1940 with the aim of inculcating future French leaders with the values of the National Revolution.[8] The finest students from all over the country were to stay at the school for an intensive three-week internship, after which they would return to their homes better suited to solve the grave social problems facing France. According to one Vichy report, the school was "intended for those who are called to fill-in their technical and particular training with lively and concrete information concerning social questions and the great cultural problems that worry the national community."[9]

Upon arrival, interns were divided into teams of fifteen to twenty students, each led by an instructor who was also expected to act as a mentor and friend.[10] Each day, students performed at least 90 minutes of physical exercise, 3 hours of manual labor, and 3 hours of intellectual work. Evenings were spent with the group.[11] The school produced a newspaper (*Jeunesse . . . France!*) and a series of pamphlets on subjects related to the National Revolution.

Among those chosen to teach at this elite academy was Chombart, who knew the director, Pierre Dunoyer de Segonzac, personally. Like many other teachers at this academy, Chombart later joined the Resistance; in the first year of the war, however, he believed, like many others, that France's military defeat had brought France's weaknesses to light. He chose to participate in the school because he saw it as a means of reawakening moral values, discipline, and a sense of community within France. In addition, the academy's focus on rural communities and getting back in touch with "the land" reaffirmed his notion that, even in the face of occupation, the "real" France wasn't entirely bereft of life. "The country-dweller who proudly shows us . . . early-ripened corn, or wheat blonder than his neighbor's," he wrote in *Jeunesse . . . France!* in 1942, "is a living affirmation of the solidarity of a tradition that cannot be destroyed in one day. Alongside him, we feel stronger and regain a sense of peace that carries us far away from partisan divisions. We feel that France is still alive, and beyond the reach of the outsider."[12]

In addition to furthering the aims of Pétain's National Revolution, most notably encouraging a return to "the land," the school served as a place where various sources of power (the social sciences, architecture, and the state) could connect and interact. For instance, it was at Uriage that Chombart commenced his lifelong friendship with the architect Robert Auzelle. Auzelle had been a student at, and later would teach at, the Institut d'Urbanisme de Paris. After 1945, Auzelle became head of the section devoted to National Territorial Management (l'aménagement du territoire) at the Ministère de la Reconstruction et de l'Urbanisme, the main urban reconstruction institution in postwar France. Also present at Uriage, as one of 2,800 interns resident between 1941 and 1942, was Paul Delouvrier, the future head of the District of Paris, who designed the first "new towns" (villes nouvelles) of the 1960s.

Chombart, Auzelle, and other teachers at Uriage came from a variety of academic backgrounds. But they all shared the same pedagogical approach, believing that students could never be educated in France's "true" values through books alone, and that active engagement in the world was necessary. Empirical or inductive research was at the heart of the school's curriculum; this corresponded with Chombart's affiliation with both social Catholicism and the humanist belief that the search for truth and morality begins with empirical investigation. "The true calling of the

French," Chombart wrote in *Jeunesse . . . France!* in 1941, "is not to be the most instructed man, the most erudite, but the most cultivated. It is not a matter for him to solely accumulate knowledge, but to learn to observe, to judge, to discipline his thought. Now, all that is no doubt acquired less in books than in everyday life."[13]

In particular, Chombart and others maintained that France's future leaders should return—literally—to the land, by way of weekly field trips to the French countryside. The purpose of these excursions, which were supplemented by readings in human geography, was to educate interns in France's "true" values. The students did not just make and record observations. They also participated fully in the everyday life of the rural communities they studied, and developed personal relationships with villagers. "In the course of these trips," one report noted, "links are established between students and people of the countryside. They frequently succeed in organizing small parties and meetings in the course of which students of the school give dramatic art performances, singing songs that they have learned in the region and representing legends that they have collected and that country-dwellers themselves have often given up."[14] These outings were therefore a crucial element in Pétain's project to reconnect the nation with its land, both physically and spiritually.

Like ecologists examining the position and networks of plant species on the ground, Chombart and his students at Uriage determined to study French rural communities within the context of their own environment or milieu. In the lectures that were to prepare students for these weekly excursions, Chombart and other instructors focused on human geography. Drawing upon *Le Petit guide du voyageur actif*, a book by the French geographer Pierre Deffontaines,[15] Chombart encouraged students to first note the setting of the village within the landscape, its geology, and the types of plants present. According to Deffontaines, Chombart, and others, interviews with local residents could proceed only when this first crucial step was completed.

Moreover, if human geography was central to these excursions, so were aerial photos, maps, and street-level photos. Aerial photos, obtained from the military, from local tourist bureaus, or from private firms specializing in aerial photography,[16] were especially important. Views of a rural village from above provoked emotional first impressions of the site that could not be obtained in any other way. In an article published in *Jeunesse . . . France!*

in 1941, Chombart drew upon Deffontaines' statement that a student of geography should, "as fast as possible, attempt to gain an overall view of the terrain under investigation," because it "stirred a sentimental reaction that the researcher must note in detail."[17] Beyond this first glance, according to Chombart, aerial photos aided the researcher in synthesizing disparate aspects of the terrain, and provoked reflection on the relationship between the community at hand and the natural environment in which it was situated. Aerial photography was therefore a tool both for carrying out an investigation and for prompting new questions.[18]

Aviation more generally played a figurative role at Uriage. The airplane symbolized national strength and captured the curiosity of the academy's students. In August 1941, an entire issue of *Jeunesse . . . France!* was devoted to aviation. Moreover, in a 1942 letter to an administrator, Joffe Dumazédier (a teacher at the school who later became an eminent sociologist) urged that aviation be incorporated into the curriculum. Teachers at Uriage, he argued, could use aviation as an introduction to other topics, entering literature through the work of plane enthusiast Antoine Saint-Exupéry, or ancient mythology through the myth of Icarus.[19]

Aerial photos and maps were not used alone, however. Much as Griaule, Gourou, and many others had done in French colonies in the years before World War II, research teams at Uriage used aerial photos in conjunction with street-level photography documenting everyday life in the village, interviews with local inhabitants, handmade maps, descriptions of the forms of houses, and various other types of data to analyze the *mentalité*, the moral life, the character, and even the psychology of rural inhabitants in France. A report written in 1941 by one of the interns, for instance, began with a detailed description of the topography, climate, flora and fauna, geology, housing typology, and plowing methods of a certain village.[20] Yet this exterior description was immediately followed by details about the everyday lives of the villagers—their customs, family life, values, and tastes. In this community, for example, cooked pork and other meats were especially popular, and a family consumed "an entire roasted pig every Sunday."[21] The study of the villages' exterior features, including geography, agricultural methods, and spatial form was important exactly because it provided insight into deeper and less visible societal trends, social and economic structures, and cultural norms and values. In a handbook for exploring "the life of a village," two teachers at Uriage wrote the following:

A good way to uncover the secrets of a village: See, before everything else, all the intelligent groupings of agricultural production. Yes, because . . . that which farming requires (craftsmen, sellers, consumers, transport networks, markets, and fairs) . . . forces agricultural production to be organized in order to ensure a sufficient clientele. . . . These production demands have multiple repercussions, on the form of houses, on the rhythm of work, on familial life, on municipal services, on religious life, on demography, and on political life.[22]

Members of the interdisciplinary teams exploring the French countryside formed relationships that would become important in the context of postwar urban reconstruction. The new-town planner Delouvrier, for instance, was among the students from Paris' prestigious École Polytechnique supervised by Chombart in the summer of 1941. As he reported in the *Gazette de l'Inspection* that year, the team visited three French villages (Meylan, Biviers, and Montbonnot) and completed "a triple geographical, economic, and social inquiry."[23] In his discussion of the outing, Delouvrier emphasized the importance at Uriage of lived experience as an alternative to learning about rural communities through books alone. For him, the weekly trips represented the essence of the school's focus on combating abstraction and returning to the "real."[24]

At Uriage, Chombart had an opportunity to apply the methods and perspectives of ethnography, as well as those of geography, to the study of French society. Just as important, he joined in the political conversation concerning postwar urban reconstruction. As we will see, the personal friendships he made there, especially with Auzelle, helped his anthropological theories of spatial organization to gain serious recognition in postwar governmental and urban planning circles.

PLANNING THE POSTWAR FRENCH CITY: SOCIAL SCIENTISTS IN THE DÉLÉGATION GÉNÉRAL À L'ÉQUIPEMENT NATIONALE

At the same time that Chombart, Auzelle, Delouvrier, and others went out into the French countryside to rediscover and to document the nation's cultural norms and moral values, other social scientists took up the problem of postwar urban reconstruction more directly. Unlike Uriage, the Délégation Général de l'Equipement Nationale was created in 1941 to serve immediate practical purposes. It directed the immense project of reconstructing France's towns and cities in the wake of aerial bombardment,

which work provided much-needed jobs in construction, development, and related domains.[25]

Perhaps the most defining mark of the Délégation Général de l'Equipement Nationale was its highly centralized administration. Like Henry Prost and Henry Sellier, two major urban planners of the interwar period, the first director of the DGEN, François Lehideux, believed that the massive project of postwar urban reconstruction called for a centralized institution. The DGEN's centralized administration was made possible by a 1943 law that divided France into nineteen precincts, each with its own "general urbanism inspector." Upon assessing reconstruction plans for their district, these inspectors reported directly to the secretary of the DGEN, Henry Giraud. Giraud made all final decisions regarding urban reconstruction in consultation with his staff.[26] Thus, the law guaranteed the presence of the French state in all local urban planning initiatives.

Paradoxically, the most pressing issue for this radically centralized institution was industrial decentralization, largely to defend against aerial bombardment. Whereas during World War I only a few rural areas in the northeast were affected by aerial bombardment, during World War II the destruction was much more widespread. During the invasion of France in 1940, the Luftwaffe targeted industrial areas in the north and northeast of France, such as Lille, Dunkerque, and Rouen, as well as ports along the Mediterranean Sea and the Atlantic Ocean, such as Marseilles and Bordeaux. During their own French campaign, the Allies bombarded the port cities of Saint-Nazaire and Brest as well as factory centers including Boulogne-Billancourt just outside of Paris. More than 80,000 French civilians were killed as a result of these bombings, and more than 5 million were identified as war victims (*sinistrés*). At least 84 *départements* throughout France were seriously damaged, including most of the country's major urban areas: Rouen, Le Havre, Lille, Nancy, Strasbourg, Bordeaux, Toulouse, Lyon, Marseille, and Nice.

Yet the mammoth project of industrial decentralization was also embraced for social reasons. In the early 1940s, the geographer Jean-François Gravier and the demographer Alfred Sauvy each published an influential book on the need to redistribute resources throughout France. In *Régions et nation* (1942), Gravier argued that Pétain's National Revolution must not ignore the physical realities of France. The French

nation, he argued, must reconnect with its geographical framework (*cadre*) as well as with its cultural values and its history. "All reconstruction," Gravier wrote, "must rest on . . . the natural or customary groupings of the country . . .as well and even more than its social structure." This was because, Gravier contended, the *cadre* of France was in a dialectical relationship with the country's historical formation, and recreating this harmony was central to regaining national unity and strength. "It is perhaps this harmony [between a country and its territory] that makes nations complete," Gravier wrote; "detached from the soil, [the French nation] is literally a fish out of water."[27]

Sauvy addressed similar issues. In *Richesse et population* (1943), he speculated on the optimal population for France, drawing on theorists from Plato to Malthus. The chapter on "Well Being and Distribution," for example, assessed the impact of resource allocation on the wealth and spiritual happiness—"maximum total satisfaction" (*une satisfaction totale maximum*)—of all French citizens.[28] Industrialization, Sauvy explained, had resulted in an unequal distribution of wealth throughout France. This affected the well-being of a majority of French citizens. Whereas Gravier contended that a renaissance in French civilization required bringing spatial organization and cultural values into alignment, Sauvy argued that such values would never be rediscovered as long as more than half the population, especially in that portion farthest removed from industrial areas, was struggling just to survive.[29]

Giraud and his staff at the DGEN pursued the project of decentralization, which Giraud defined as "the localization of industrial enterprises, and their distribution across French territory,"[30] for the purposes of both national defense and social welfare. Yet before any plan could be put into action, Giraud maintained, interdisciplinary studies of the economic and social effects of decentralization had to be undertaken. In the wake of the Allies' bombardment of the Renault automobile and aircraft factories in Boulogne-Billancourt in 1942, Giraud asked Gabriel Dessus, his close friend and engineer at the Compagnie parisienne de distribution d'électricité, to form an interdisciplinary research group to explore industrial decentralization and its social consequences. In constructing this team, Dessus chose to include a number of prominent social scientists, among them the historian Louis Chevalier; the geographers Pierre George, Pierre Coutin, and Jacques Weuleresse; and the urbanist Gaston Bardet, who had

worked closely with the historian and urbanist Marcel Poëte in the 1930s.[31]

The research group's results were published in 1944 in a collection titled *Reports and Work on the Decentralization of Industrial Centers.*[32] These studies provide a close look at the multiple issues raised by industrial decentralization, and reveal the social-scientific response to this military, economic, and social problem. In his introduction to the *Reports*, Dessus discussed the definition and implications of industrial decentralization for France by referencing the work of Maurice-François Rouge, a geographer and urbanist who had worked under Henri Prost at the Institut d'Urbanisme de Paris before the war. In the early 1940s, Rouge had begun calling for the creation of a new science, to be called *la géonomie*, that would further knowledge about the use and organization of space. As the historian of geography Marie-Claire Robic has pointed out, the aims of *la géonomie* differed from those of traditional geography. Like human geographers, experts in the new discipline would focus on the intersection of human and geographical characteristics, but their primary emphasis would be on action rather than reflection. "Although close to geography," Robic wrote, "it is distinguished from it because it is in the realm of practice."[33]

The science of *la géonomie* was innovative in that it brought the differing perspectives of economics, sociology, history, and geography to bear on the question of spatial organization.[34] "The problem of location," Dessus wrote, "is tied to all the other general problems concerning the importance and the structure of industry on the one hand, and the social state of the workers on the other hand."[35] In line with Gravier and Sauvy, Dessus and his research group repeatedly asserted that industrial decentralization was a social issue as well as a military tactic. Any detailed study of industrial decentralization, therefore, necessarily entailed a thorough investigation of how the siting of industries across France altered the physical, intellectual, and even spiritual needs of "the workers" themselves.

The social scientists involved in writing the *Reports*, many of whom were located on the political left, used their work as an opportunity to discuss a subject that had been a concern of the French left since the nineteenth century: workers' housing. Because displacing factories meant displacing workers and their families, planning for industrial decentralization required attention to the forms of housing to be built in new areas. "In approaching the problem of human habitation," Dessus wrote, "it

appears that we would touch upon one of the essential points of our study. We must consider the problem of workers' housing taken in its entirety as one of the first to resolve in France."[36] For Dessus and others, decentralization offered a solution to the problems of insufficient and inadequate housing in cities all over France.

Thus, the project of industrial decentralization, a response to aerial bombardment, quickly segued into a social issue, housing, which in turn touched upon questions of family life, moral order, and social structure more generally.[37] Workers' housing was so important that an entire section of the DGEN's findings was devoted to it. Part IV of the *Reports* (titled "Decentralization and workers' housing. Questions of fact and methods") included studies by Mademoiselle A. Dissard, by Chef du Service des études à la Caisse de Compensation de la Région Parisienne, the geographer Pierre George, and by Dessus himself.

In her essay, Dissard argued that decentralization was imperative for economic, defensive, and, most important, ethical reasons. It would, she maintained, alleviate overcrowding in cities and provide better living accommodations for workers and their families. In his study, titled "The Problem of Housing and Industrial Decentralization," the geographer Pierre George echoed many of Dissard's sentiments. George began with a description of the appalling housing conditions he found in Paris and its suburbs: "Many do not have electricity; as for gas, it's better not to talk about it. Hygienic conditions are frightening. An apartment of two rooms containing ten people is only lit by one window in the kitchen and by the door in the entryway; many rooms only have a skylight for ventilation.[38]" Like Dissard, George concluded that the only way to adequately address the problem of insufficient housing was to decentralize large cities throughout France. This, in itself, was a two-step process. First, industries had to be developed in new locales in order to draw workers away from problem areas. Second, the form of the new workers' housing had to be determined.

One housing option was the company town (*cité patronale*), in which workers lived in an insulated community close to the factory. Entrepreneurs in American cities had experimented with this type of housing since the late nineteenth century. The idea behind company towns was also to make workers happier and more morally sound, and thus more productive and efficient, by providing comfortable and affordable

housing within walking distance of work. Drawing upon Gravier's work, George pointed out the numerous drawbacks of the company town. Above all, George asserted, it took away the worker's individuality and made him feel as though he was under constant supervision by the company. "It gives the occupant," he explained, "the impression . . . of being constantly under the control and the dependence of the company that employs him."[39]

George also criticized another housing model, the collective building (*immeuble collectif*). Although these housing blocks had much to offer in terms of goods and services, George explained, their "artificiality" would eventually make daily life extremely unpleasant. He argued that the only way to ensure social harmony in these new areas was to construct *pavillons* (detached individual houses, each with its own private garden). "Among the types of constructions to envisage," he wrote, "the individual house . . . appears the best solution from the social and familial perspective."[40] He concluded by discussing the psychological, economic, familial, and moral benefits of living in an individual house as opposed to collective apartments.

Thus, the issue of decentralization for defensive purposes introduced a number of social concerns that continued to occupy government officials, urban planners, and social scientists long after the end of World War II. The decentralization of industry entailed the reorganization of transportation, the redistribution of cultural and educational facilities, and, perhaps most important, novel forms of housing that would accommodate the influx of industrial workers and their families into small and mid-size towns. As Dessus pointed out in his conclusion to the DGEN's *Reports*, these changes were initiated for the purposes of national defense, but were nevertheless welcome for shaping the future of France in a positive manner. Small towns would undergo a revival, more affordable housing would be produced, and a conscious rhetoric would emerge to address the cultural, economic, and educational opportunities for working-class populations throughout France.

In the early to mid 1940s, then, the DGEN promoted the benefits of decentralization not only by drawing upon social-scientific theories but also by inviting intellectuals such as George, Chevallier, and Coutin to participate in the planning process. After 1945, with the creation of the Ministère de la Reconstruction et d'Urbanisme, these collaborations

ntists were beginning to become integral
al management (*l'aménagement du territoire*)
l.

E, AND *L'AMÉNAGEMENT DU*

ion et de l'Urbanisme, the central urban
ostwar urban reconstruction in Paris, was
h state emerged. Although it came into
ench history, the MRU incorporated the
of its predecessor, the DGEN. As the
pointed out, the institution emerged
ious groups of architects, engineers, and
o maintain or to expand the power they
gime."[41]

the MRU's orientation and goals were
r, Raoul Dautry, a graduate of the École
try had been fascinated by the work of
gson. He also supported the functionalist
CIAM group, as outlined in the Athens
diate aftermath of World War II, Dautry
architecture, and especially in housing.[43]
tance, that Le Corbusier constructed the
on, a seventeen-story residential building
ille.

crisis in cities throughout France (attrib-
dment but also to the cessation of con-
pression of the 1930s) and Dautry's own
Ministère de la Reconstruction et de
using program during Dautry's tenure. As
al constraints of the late 1940s forced
plans for industry and plans for housing.
of 1947, MRU leaders decided to con-
centrate their efforts on industrial modernization. Ultimately, Voldman
explains, that strategy made the housing crisis even more severe. But its
immediate effect was to inaugurate the "thirty glorious years" (*les trentes*

glorieuses), a period of rapid modernization and prosperity in France that lasted until the 1973 oil crisis.

In 1948, Eugène Claudius-Petit—like Chombart, a social Catholic—replaced Dautry as minister of the Ministère de la Reconstruction et de l'Urbanisme and initiated a new policy intended to counterbalance the Monnet Plan. The new policy, which Claudius-Petit termed *l'aménagement du territoire*, aimed to develop each particular region of France for the moral and spiritual, as well as the economic, benefit of the nation as a whole. In a 1950 pamphlet promoting the plan, Claudius-Petit defined *l'aménagement du territoire* as "research, in the geographical framework (*cadre*) of France, of a better division of men, in function of natural resources and economic activity."[44] He made a crucial distinction between this initiative and *mise en valeur*, which referred only to economic development. For him, the central goal of *l'aménagement du territoire* was to elevate the quality of life of all French men and women, and to make them more content. "We must not," he explained in a 1950 pamphlet, making direct reference to the Monnet Plan, "develop France's economic potential while ignoring the spirit."[45]

Claudius-Petit's policy was, in part, a response to public and governmental interest in decentralization sparked by the work of Gravier and Sauvy. In 1947, five years after the appearance of *Régions et nation*, Gravier published another enormously popular book, *Paris et le desert français*, in which he described the social consequences of the regionally unequal division of wealth throughout France.[46] Yet, as the historian Benoît Pouvreau has demonstrated, Claudius-Petit was motivated equally by personal experience, and especially by his contact with working-class populations and his affiliation with social Catholicism. Before the war, Claudius-Petit had been a teacher in the suburbs of Paris and then in Lyon. "It is this classic provincial itinerary," Pouvreau explains, "that made him measure the unevenness between French regions. From the Ile-de-France to the Rhône and Gier valleys, he discovered the contrasts between industrial centers and the mountains which are empty."[47]

In implementing his new policy, Claudius-Petit turned his eyes to the sky as well as to the ground. Aerial views contributed much to the development of this postwar policy. First, the entire policy of *l'aménagement du territoire* depended upon the process of abstraction and representation that had been developing since the nineteenth century.[48] By illuminating the abstract forms of the landscape, aerial photos, in combination with

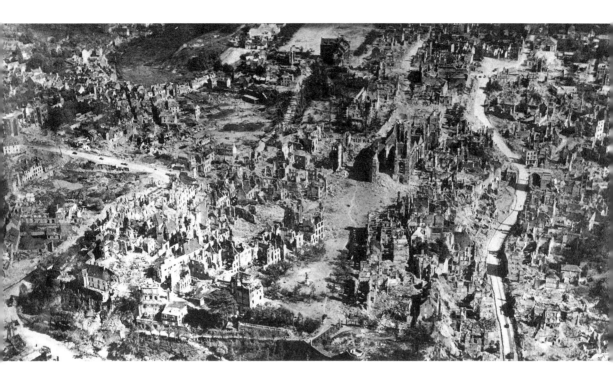

FIGURE 3.2
Surveying war damage at the MRU's Service Topographique. © METL-MEDDE.

demography, statistics, and cartography, enabled MRU officials and others
to think about the problem of large-scale territorial management—and its
social dimensions—in a new and more abstract way. "In order to engender
regional development," the historian Antoine Picon writes, "it was neces-
sary first to move from the everyday experience of space to a collection
of abstract representations; it was necessary in other words to construct
the notion of territoriality. . . . In the course of the last two centuries, the
links between space and society were the object of a series of redefinitions,
the birth of territorial development in the aftermath of the Second World
War represented one of these."[49]

Of course, aerial photos had been an integral part of the work of the
MRU before the emergence of the policy of *l'aménagement du territoire* in
the late 1940s and the early 1950s. In 1945, Dautry created the Service
Topographique to assess damage from World War II, especially that due to

FIGURE 3.3
Surveying war damage at the MRU's Service Topographique. © METL-MEDDE.

aerial bombardment.[50] Between 1945 and 1951, Service Topographique photographers took thousands of aerial photos of all parts of France at various scales. They then gave everyone—architects, urbanists, social scientists, and the public—free access not only to the photos but also to the tools needed to interpret them.[51]

The stereoscope was particularly important in the process of interpreting aerial photos for the purposes of postwar urban reconstruction. Most notably, use of the stereoscope allowed MRU officials to focus on details of the spaces that were photographed. With the aid of a stereoscope, an interpreter—whether a planner, an architect, or a social scientist—could home in on small areas within an aerial photograph, such as a particular section of a city or a specific architectural structure, such as a prison or factory. "With this device," the Direction de l'Aménagement du territoire stated in a description of "l'interpretation stereoscopique" in 1952, "the interpretation of details represented on vertical aerial photos is very easy. . . . [It] allows for the direct drawing on the negative in the course of stereoscopic observation itself."[52]

After taking and developing numerous photos of one area, interpreters created a schematic map that illustrated how a selection of photos matched

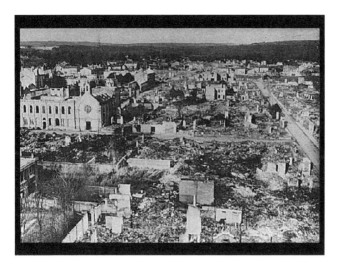

FIGURE 3.4
Surveying war damage at the MRU's Service Topographique. © METL-MEDDE.

up with the geographical reality of the landscape. These relevant photo-
graphs were then placed side by side to allow for comparison, with the
aid of the stereoscope and other tools, in order to illuminate the relation-
ships between geographical and human elements in the landscape.[53] When
describing the process of interpretation, postwar urbanists often used terms
borrowed from biology. For instance, one planner from the MRU's Service
Topographique explained that with aerial photos one could "dissect urban
matter as well as other elements that one desires and . . . select informa-
tion in order to put them to better use."[54]

 Moreover, aerial views also played a symbolic role in the emergence of
the policy of *l'aménagement du territoire*. In his 1950 pamphlet, Claudius-
Petit promoted this initiative in part by making reference to aerial views.
Echoing the aerial critique of Western capitalist societies that Le Corbusier
had published 15 years earlier, Claudius-Petit stated that flying over France
revealed the chaos of the nation below, especially the disparity between
its (supposedly) egalitarian values and its present reality. There were enor-
mous disparities in wealth and opportunities from one region to another.
Although France aimed to be a paragon of democracy and equality, the
airplane demonstrated that the nation was far from realizing the ideals of
the French Revolution of 1789. Instead, this military machine revealed the

dramatic extent to which France was segregated, both culturally and eco-
nomically. Claudius-Petit wrote:

The voyager who boards an airplane in Paris directed towards Nancy, after having
surveyed an enormous suburb, meets a country where the human density is
extremely weak and falls sometimes to less than twenty inhabitants per km^2. . . .
Contrary to that which one is often taught, France is not a country in equilib-
rium. . . . This situation brings the most serious effects, as much from the economic
and financial perspective as from that of the social and human [perspective].[55]

As we have seen, Claudius-Petit's aerial critique of French society can
be situated within a much broader trend, one that dated back to the 1930s
and included Lewis Mumford and Le Corbusier. It also included Chom-
bart. In the early 1950s, in a work titled *Photographies aériennes*, Chombart
discussed the aerial photography's usefulness to a number of academic
fields as well as in solving the urban problems of 1950s France. Drawing
upon dichotomies developed during the Enlightenment, he compared the
"natural" spatial organization of rural villages in northern Cameroon with
the "artificial" organization of urban space in France. With the aid of aerial
photos, Chombart argued, one could see that Paris and other large French
cities were not "healthy"; they were diseased, and they were sickening the
body of the nation.[56] From the air, social scientists, government officials,
planners, and the public alike could see the disorganization of French cities
in comparison with non-Western colonial areas, which were said to be
composed in a more "organic" manner. Aerial photos sparked interest in
the comparison of the spatial form of human settlements in Western and
non-Western areas, and suggested that the way in which rural, urban, and
suburban spaces were arranged affected the well-being and happiness of
the inhabitants who lived there.

The concept of adaptation, the use of which was partly inspired by the
airplane, was central to the postwar policy of *l'aménagement du territoire*. In
the mid 1950s, Robert Auzelle, then head of the MRU section devoted
to *l'aménagement du territoire*, explained that the goal of this initiative was
to make French citizens more adapted to their land, and vice versa. "The
goal of *l'aménagement du territoire*," Auzelle wrote, "is . . . research of an
optimum adaptation of the works of humankind and of social and eco-
nomic factors to natural elements. It is, according to the recent expression
of M. Alfred Sauvy, 'to adapt the milieu to humankind and humankind to

its milieu.'"[57] The discourse of adaptation reflected the thinking of not only Sauvy but also that of geographers such as Jean-François Gravier and Max Sorre. In the 1940s, Sorre (then director of the newly created Centre d'Etudes Sociologiques in Paris) published a landmark three-volume work titled *Les Fondements de la géographie* humaine. In its last volume he argued, following the Chicago School of Sociology, that the city was a natural environment to which humans could be either adapted or maladapted.[58]

Just as the Ministère de la Reconstruction et de l'Urbanisme may have been inspired by public and academic interest in aerial photos, interest in aerial photography within the MRU spurred great curiosity about this technique within multiple social-science institutions. In 1945 and 1946, several international aviation conferences served to nurture this curiosity and to facilitate communication and collaboration among social scientists, government officials, architects, and planners. One of the most important of these conferences was the two-part Congrès national de l'aviation française, which took place at the Sorbonne in Paris in April 1945 and 1946 at the behest of the first president of the Fourth Republic, Charles de Gaulle, and the first Minister of Air, Charles Tillon. The aim of the 1945 conference was to bring together over 2,000 architects, engineers, planners, and government officials to explore the benefits of aviation to the future of France. Le Corbusier presided over the section of the congress devoted to the theme of infrastructure, which was itself subdivided into four sections: Architecture et Urbanisme, Réalisations et Techniques, Signalisations et Télécommunications, and Infrastructure militaire.[59] The director of the subsection focused on architecture and urbanism was Urbain Cassan, an architect and former student of the École Polytechnique who became Directeur Général de la Construction of the MRU under Raoul Dautry in 1944. In his remarks, Cassan introduced the congress' principal theme: the airplane, he stated, would help urban planners, architects, and engineers find a way to redistribute industries and populations across France, a project necessary to ensure national security and protect the social welfare of all French citizens.[60]

At the second Congrès national de l'aviation française, the humanistic aspects of aviation were discussed at length. De Gaulle invited architects, engineers, and planners, as well as scientists and social scientists (among them Griaule and Chombart), to attend. Griaule, now a professor at the Sorbonne, headed a subsection on the social sciences and delivered a report

titled "The Use of Aviation in Ethnographic Research." Other presenters included Chombart (who delivered a paper titled "On the Airplane in Scientific Research Missions in the Colonies"), the archaeologist Antoine Poidebard, the human geographer Charles Robequain, and the botanist Henri Gaussen. All these participants asserted the benefits of aerial photography to research in their respective fields, as well as to establishing links between them.

In addition to bringing social scientists and scientists together with government officials, architects, planners, and engineers, the 1946 Congrès national de l'aviation française resulted in the creation of a new institution at the Sorbonne devoted to furthering the use of aviation in scientific research. At the congress, Griaule first described the benefits of aviation to ethnographic research. Most crucially, he asserted, aerial photos helped make the study of social and cultural phenomena "scientific" by making the data quantifiable. "Aerial photography," he explained, "offers a complete representation, not only of the natural framework, but of the twisted works of mankind on the earth, which may be studied statistically. . . . The different aspects of the ground according to seasonal variations, the rotation of cultures, the regressions or transformations of certain activities may be followed photographically."[61] Griaule then discussed the potential of the Bureau Aéronautique de la Recherche Scientifique to broaden scientific research in all fields, not just ethnography. "This office proposes," he stated, "to establish a permanent and mandated link between the diverse environments of scientific research and those of aviation. It centralizes requests for aerial photographs and airplanes, as well as suggestions from establishments, laboratories, and researchers. It works in coordination with the Minister of Air, with other official organisms possessing the means of aerial investigation or with interest in archives, with official and private foreign establishments. . . . It constitutes archives containing a general repertoire of aerial photos kept by specialized organisms, a photography laboratory, and a library."[62]

While Griaule was establishing his bureau and the Ministère de la Reconstruction et de l'Urbanisme was establishing its Service Topographique, Chombart, the anthropologist Claude Lévi-Strauss, and the archaeologist André Leroi-Gourhan founded an aerial photography laboratory at the Musée de l'Homme in Paris. Lévi-Strauss' interest in topography informed his *Tristes Tropiques*, first published in 1955, in which he investigated the

Bororo tribe in Brazil. The cultural practices of the Bororo, he argued in a way reminiscent of Mauss' work on Eskimo society and Griaule's studies of the Dogon, were tied to the landscape and natural topography in which the group was situated. The connection was so strong that missionaries found it necessary, as a precondition to religious conversion, to remove the tribe from the place in which they were situated so that they would be more likely to let go of their traditions and to accept new ones.[63]

Yet Lévi-Strauss, unlike Griaule, discovered that the image reflected in the organization of space in Bororo society wasn't a reflection of their "true" social structure, but rather that of an ideal social structure that was constructed and perpetuated by the elite. "Among the Bororo," he wrote, "spatial configuration reflects not the true, unconscious social organization but a model existing consciously in the native mind, though its nature is entirely illusory and even contradictory to reality."[64] Thus this father of "structuralism" reaffirmed the need for extensive study of the relationship between social relations and spatial relations in different societies and emphasized the need for participatory observation on the ground in addition to the study of topography.

Other institutions that began to use aerial photography around the same time included the École Nationale des Ponts et Chaussées (ENPC)[65] and the Institut d'Urbanisme de Paris (an interdisciplinary institution devoted to developing novel ways of studying urban environments). In a 1947 training manual for engineers titled *Collection de Stéréogrammes pour l'entraînement à l'identification des détails sur les photographies aériennes à axe vertical*, the Institut Géographique Nationale discussed the importance of the "objective" aerial view to the evaluation of the postwar urban situation: "Vertical photography is an expressive image of the land, trustworthy, and above all complete. It presents practically no dead angles: all the important details of topography are visible."[66] Bringing to light the details of urban environments, making them visible, was the first step in developing a plan to reconstruct them.

This advantage was reiterated by ENPC engineers. In an urbanism course offered at the school in 1947, the urbanist René Danger, who had worked in Morocco with Henri Prost, discussed the utility of aerial photography to urban reconstruction in France. One of the most important steps in formulating a plan for reconstruction, Danger wrote, was to obtain an overview of the form of a city. Aerial photos contained a wealth of

detailed information concerning the physical and cultural aspects of any urban area:

We are first shocked by the abundance of details which appear on [the photos]: in addition to paths of communication of all sorts, masses of constructions, public buildings, factories . . . different cultures, ponds and swamps, the squares with their entangled streets one can discern, looking attentively, the rooftops, the tramway tracks, gardens. . . . It is precisely this abundance of documentation fixed on a photographic plate in a fraction of a second that permits us to propose the idea that the constitution of city plans is certainly one of the most productive fields of application of aerial photography.[67]

Danger also emphasized the role of aerial photos in producing graphic representations of urban space, noting that urbanists used aerial photography as a basis for various schematic diagrams of the terrain. Aerial photos could, furthermore, be combined with other forms of data. As an example, Danger explained how the use of aerial photography along with street-level photography provided a holistic view of the urban environment at hand, and of its evolution.

Just as Dautry and Claudius-Petit at the Ministère de la Reconstruction et de l'Urbanisme were inspired by the ways in which both aviation and social-scientific research might contribute to bringing about a more egalitarian society in France, social scientists were encouraged by newly available governmental support for social-scientific studies of postwar urban problems, especially affordable housing, and were motivated to continue probing the benefits of aerial photography to humanist as well as scientific endeavors. In the late 1940s, for instance, Chombart and his collaborators published a work titled *La Découverte aérienne du monde*. The book was the result of the First Aerial Geography Congress in Paris, which explored the links between aviation, science, and humanism.[68] Financed by the Institut Géographique Nationale and the Armée de l'Air, it brought together Paul-Henry Chombart de Lauwe, Marcel Griaule, the geographer Emmanuel de Martonne, the historian Charles Morazé, and various military personnel. In his preface, de Martonne called the work novel and characterized it as "the first systematic work trying to seize general laws, sometimes even approaching philosophical conclusions."[69] Flying over the world, these social scientists hoped to find common ground across various human civilizations and cultures. Such a discovery would provide the basis for broader,

more interdisciplinary social-scientific research and, at the same time, serve the humanitarian purpose of demonstrating scientifically the unity of humankind despite its great diversity. Thus, aviation seemed to provide the basis for a twentieth-century Enlightenment project.

In the first chapter of *La Découverte aérienne du monde*, Chombart described the multiple benefits of an aerial view. Perhaps inspired by the geographer Max Sorre's biological studies, he compared the technique of aerial photography to biologists' use of the microscope to study the natural world. Whereas the microscope provided a detailed look at the interior of individual organisms, aerial views provided the opposite: a broad overview of the exterior of the earth, which, in turn, would provide insight into human culture and history. In short, aerial views placed all human activity within a common framework. In addition, Chombart noted that aerial photography allowed for comparison, synthesis, and a new aesthetic in which spatial forms were of primary importance. For example, an aerial view of human settlements could illuminate broader patterns in shape and color.[70]

According to Chombart, the vertical perspective was potentially useful for scholars in all academic fields, as it allowed them to view their object of study within its "true framework" and in all its "reality."[71] For an archaeologist, aerial views could help illuminate patterns of past human settlement not visible from the ground. For a historian, an art historian, or a sociologist, an aerial perspective of the shape of a particular culture's agricultural fields might aid in uncovering its farming techniques. An overview of a society's urban monuments would shed light on its values, its religion, and its national history. Aerial views thus provided new ways of seeing cultures around the world, including their particular histories, while simultaneously presenting the opportunity for comparison.

The comparative aspect of aerial photography was even more profoundly explored by Griaule. In an article on aerial photography in ethnographic fieldwork, he explained that the airplane aided ethnographers by bringing to light the mentality of "primitive" civilizations. As all past activities as well as cultural values and organization are inscribed in the soil, the analysis of any society would be complete only once the spatial component of social phenomena was accurately recorded. The layout of Kotoko cities in northern Cameroun, for example, could be shown to diagram the culture's origin myths. Aerial photos and schematic maps thus

revealed the unconscious aspects of a society's organization and even its collective psychology. Moreover, these images played an important role in fieldwork: when native populations saw the representation in an aerial photo of the meaningful design of their villages or agricultural fields, they gave the ethnographer more detailed information.

Similarly, the historian Michel Parent focused his chapter on the use of aerial photography in the comparative and "scientific" study of cities. Aerial views made the "physiology" of cities visible. Seeing this structure was the first step in compiling a classification system and developing a scientific understanding of urban development and change. According to Parent, aerial views would be helpful in diagnosing "diseased" urban development patterns and in finding solutions to the problems that plagued twentieth-century cities, such as circulation.

Clearly, these comparisons between Western and non–Western societies served a scientific purpose by aiding ethnographers such as Chombart in discovering what was distinctive about diverse regions and cultures. They also served philosophical and moral purposes. According to the social scientists responsible for *La Découverte aérienne du monde*, aerial views revealed a worldwide spatial congruity. By making this universality visible, aerial photography was thought to promote social harmony, thus helping to counteract the forces that had led to World War II. In the conclusion, Morazé asserted that, thanks to the airplane, "a new morality [was] in gestation."[72] Cultures all over the world were becoming closer, Morazé argued, thanks to the rapid spread of technology and new methods of transportation. This "unification" was already underway before the airplane, but the airplane had accelerated the process. "Like a sign appearing in the sky," Morazé remarked, "the airplane predicted the era of the ultimate terrestrial progress: Human civilization will be one, or it will disappear. . . . Thanks to the airplane, humans can rediscover Humankind. . . ."[73]

In 1950, Chombart published another work building on his previous work with Griaule in northern Cameroon and on his experience in World War II and his subsequent explorations into the use of aerial photography for improving the human condition. Titled *La Terre Vue du Ciel*, the book began by praising the benefits of the airplane and aerial vision for the social-scientific study of human civilization. For Chombart, the holistic view provided by this machine allowed social scientists to have "a larger, more complete, more precise" view of human groups all over the world,

and a better understanding of the relationship between humankind and the environment. Not only could the airplane help document existing features of the landscape and human communities at a particular moment in time; it could also, Chombart contended, show how the landscape had changed over time (thus illuminating history) and aid researchers in global comparisons of human civilizations. It "permits us to have, on humankind as a whole, views at once quite general and quite precise in order to judge men of our epoch at his exact scale on the surface of the globe and in the universe."

In the wake of World War II, therefore, social scientists, urban planners, architects, engineers, and government officials faced the same problems that Dessus and his team at the DGEN had been faced with under Vichy: How could the complexity and reality of urban problems be understood, and how could they be corrected? The DGEN's attempt to decentralize large industries and populations in response to aerial bombardment during the war had demonstrated just how complicated and all-encompassing urban issues were, and how profoundly matters of territorial management coincided with social questions, especially that of affordable housing. During and after the war, Dessus, and later Dautry and Claudius-Petit at the Ministère de la Reconstruction et de l'Urbanisme, drew social scientists such as Chombart into the political conversation. But the need for new theoretical models that could help social scientists analyze the intersection of the "social" and the "spatial" in urban environments across France persisted. In the early 1950s, as the next chapter will show, social scientists of various academic disciplines began developing such models, and continued to find benefits in viewing urban environments from above.

In the aftermath of World War II, Chombart, now based at the Musée de l'homme and the Centre d'études sociologiques (CES) in Paris, began to embody the coming together of the aerial and ground-level perspectives. A perfect example was the 1952 study *Paris et l'agglomération parisienne: L'Étude de l'espace social dans une grande cité*, in which Chombart and his research team demonstrated that Paris was divided both geographically and socially, bourgeois residents living mostly in the West and working-class individuals largely in the East.[1] What was novel was not so much this conclusion as the methodological basis used to support it: aerial photos of the overall physical form of various neighborhoods (*quartiers*) of the city, Chombart and his colleagues argued, reflected the social and economic character of these areas. Moreover, like Griaule's and Chombart's prewar studies of the Dogon of West Africa or Gourou's studies of the Tonkin in northern Vietnam, Chombart and his CES research group linked differences in the physical form of these residential districts with variant levels of sociability. From the air, they maintained, one could clearly see that the wide, geometrical streets of bourgeois districts in the West clearly differed from the narrow, irregular streets and close-knit buildings of the working-class East. (See figure 4.1.) Ethnographic fieldwork on the streets further revealed that bourgeois individuals in western districts had very little contact with local merchants and neighbors in daily life, while workers

FIGURE 4.1
Aerial views of two different quartiers in Paris, from Paul Henry Chombart de Lauwe's *Paris et l'agglomération parisienne: L'Étude de l'espace social dans une grande cité* (Presses Universitaires de France, 1952). Chombart argued that the spatial form of these districts revealed the social classes of the inhabitants, as well as the differing levels of sociability.

located in the eastern parts of the city had much deeper ties to their neighborhood.

Chombart and his colleagues used term *l'espace social* to capture the holistic *vue d'ensemble* of social and spatial relations in Paris that aerial photos, in combination with a variety of other qualitative and quantitative methods, revealed. Drawing upon multiple prewar anthropological and psychological theories (among them those of the anthropologists Maurice Halbwachs, Marcel Griaule, and Marcel Mauss, those of the Chicago School of Urban Sociology, and those of the psychologist Kurt Lewin), they defined "social space" as "the division of space according to the particular norms [*normes particulières*] of a group."[2] Social space was intended to signify space abstracted beyond the chaos of the ground but not divorced from it; not solely geographical or social, it was, rather, a model of the relationship between these two analytical categories—a spatialization of complex social and economic relationships within a particular urban environment.

For the social Catholic Chombart, obtaining photographic evidence of the stark division of wealth in Paris served to reinforce the notion that Marxism was not solely an ideology, divorced from concrete events and real-world trends, but rather a science, based upon empirical observation and inductive research. His use of aerial photos established, in a manner that government officials, planners, social scientists, and the public alike viewed as "objective" and scientific, the continuing relevance of Marxist theory in the post-industrial era.[3] It thus served to reinvigorate left-wing political concerns among social scientists at a time when French Marxism was in the midst of a deep and lasting crisis.

At the same time, the success of this study helped to bring *qualitative* sociological research into the traditionally quantitative sphere of urban planning. In the decade after the publication of Chombart's aerial study of Paris, urban planners, architects, government officials, and other social scientists began to utilize the concept of "social space" in their writings. Planners such as Gaston Bardet found it a useful analytical category for approaching plans for the reconstruction of cities like Louviers, the engineer and planner Alexandre Burger used Chombart's notion of "social space" to analyze spatial segregation in a town in Alsace in the late 1950s, and numerous others began incorporating it into their studies of spatial segregation in cities across France. The book's astounding success, in turn, hastened more government funding of new urban sociological institutions

and studies of urban problems, especially housing, throughout the 1950s. As the idea of "social space" developed and began to take hold in the social sciences and urban planning, therefore, so too did the perception of the application of sociological expertise to the study of the built environment.

THE POSTWAR HOUSING CRISIS AND THE CONSTRUCTION OF THE *GRANDS ENSEMBLES*

Chombart's aerial investigation of Paris was completed against the backdrop of a housing crisis in Paris and other large French cities that developed in the wake of World War II. Few new buildings were constructed during the economic depression of the 1930s, and even fewer during the early and mid 1940s. In the immediate aftermath of the war, as the historian Danièle Voldman has explained, the housing predicament was exacerbated by the state's decision to concentrate, during the Monnet Plan (1948–1953), on the regeneration and growth of industrial areas rather than residential ones.[4] Although only 5.3 percent of residential buildings in Paris were damaged and destroyed as the result of aerial bombardment during the war, the housing situation was much worse in the capital than in other cities across France because of rural–urban migration (almost 200,000 new residents entered Paris each year), a severe lack of basic construction materials, and a conscious decision by officials from the main reconstruction institution in Paris, the Ministère de la Reconstruction et de l'Urbanisme (MRU), who were influenced by the work of Jean-François Gravier, to build outside of the center of Paris in order simultaneously to dissuade more migration to Paris and to promote a larger national project of urban decentralization throughout France, as discussed in the last chapter.[5]

The lodging predicament in Paris reached its apex in the early and mid 1950s. During the winter of 1953–54, seventeen homeless Parisians froze to death, including a baby.[6] The Catholic Church took an active role in publicizing these horrific events. Most notably, the Reverend Henri de Grouès, who adopted the name Abbé Pierre, publicized the severity of the crisis in newspapers and magazines. "The tragedy of eviction," the historian Norma Evenson wrote, "began to provide a recurrent theme in the Parisian press, with human-interest stories frequently involving elderly people forced out of homes in which they had been long-time residents."[7]

Public outcry over the severity of the housing crisis, fueled by the activism of the Catholic Church, placed pressure on the MRU to enact new policies that ultimately ushered in an "era of mass living."[8]

Ideas for large-scale residential dwellings had, of course, been developing for years. As we saw in chapter 2, Marcel Lods and Eugène Beaudouin began experimenting with prefabricated housing in rectangular housing blocks outside Paris in the 1930s. After the war, important officials at the DGEN and at the MRU showed considerable interest in the principles of modernist architecture outlined in the Athens Charter of 1943. A new modern style would, some thought, signal a rejection of the traditionalism of Vichy. In 1945, André Prothin, formerly head of the DGEN and now director of urbanism at the MRU, offered French and international architects to experiment with prefabricated housing in the Parisian suburb of Noisy-le-sec; when the MRU took over the national Habitations à bon marché program, these subsidized housing complexes became laboratories for the testing of construction materials such as concrete and new interior layouts and amenities.[9] MRU-sponsored architecture competitions in the late 1940s further hastened the construction of large concrete-block fabricated residential buildings in peripheral areas of Paris, Strasbourg, and other large cities, funded as part of the Habitations à loyer modéré (HLM) program. In 1950, for instance, a competition sponsored by the MRU led to the construction of the Cité de Rotterdam outside of Strasbourg, which was built rapidly (in only 18 months) and cheaply (for about 1,625,000 francs per unit).[10] The Cité de Rotterdam, designed by Eugène Beaudouin, is considered to be the first concrete example of a *grand ensemble*, and became a prototype for the construction of many other large-scale concrete housing projects in the outskirts of other cities across France.[11]

These MRU-sponsored architectural competitions in what Voldman refers to as the first phase of postwar urban reconstruction set the stage for the construction of large-scale housing complexes throughout the 1950s. A variety of governmental policies developed by MRU officials such as Eugène Claudius-Petit facilitated the process of realizing these projects, most notably the Plan Courant, Operation Million, and the LOGECOS Program (1953–1963), which provided state subsidies to private developers to construct low-cost housing as long as it was intended for middle-class French families with children (immigrants were

excluded); Opération Million, developed in 1955, which aimed to construct 25,000 standardized dwellings for half of their estimated cost; and the creation of Zones à Urbaniser en Priorité, or designated development zones, which provided local authorities with government funds to purchase land for the purposes of development projects, and especially affordable housing.[12]

In the early and mid 1950s, a spirit of optimism surrounded the idea of the *grands ensembles*. These buildings appeared, the historian Annie Fourcaut has explained, "like a miracle solution allowing all at once to solve the housing crisis, modernize the suburbs and control their growth."[13] Above all, these dwellings promised to provide modern living at an affordable cost. At a time when many areas of Paris lacked indoor plumbing, these residences offered showers, toilets, and spacious, sunlight rooms. The hopefulness associated with this form of housing was portrayed in *Se Loger*, a short film produced by the MRU in 1948.[14] After documenting the lodging crisis throughout France and showing families living in squalid conditions with little light, the film ended with the narrator flying over the outskirts of Paris, where tall, white-washed, rectangular housing complexes were being constructed. As the narrator flew above a barren landscape dotted with cranes and half-built housing towers, uplifting music played in the background. "We must construct," the narrator proclaimed, his voice breaking through the music, "with the aid of the state."[15]

Despite such sanguine expectations, by the late 1950s this "solution" to the postwar housing crisis had yielded a whole new set of problems. Although they provided more living space, modern kitchens, and bathrooms, many residents of the *grands ensembles* complained that these complexes, and the suburban areas in which they were located, lacked a sense of place and identity. This sentiment was portrayed in novels such as Christiane Rochefort's *Les petits enfants du siècle* (1961) and in television reports.[16] The housing complex of Sarcelles, located north of Paris and constructed in the mid 1950s by Jacques-Henri Labardette, became emblematic of the social problems associated with all *grands ensembles*. Just a few years after its construction, the French press portrayed living in Sarcelles as akin to having a disease; the sociologist Marc Bernard even developed a term for this affliction: Sarcellitis.[17] Modern amenities such as kitchens, bathrooms, and washing machines—what the scholar Kristin Ross has described as "American-style patterns

of consumption"[18]—seemed, to sociologists and journalists, to go hand in hand with isolation, alienation, and ennui.

Governmental institutions, under pressure from the Catholic Church and the public, took notice of these problems. In 1957, the Ministère de la Construction et de l'Urbanisme, the institution that replaced the Ministère de la Reconstruction et de l'Urbanisme, produced a report on the problems of social life in the *grands ensembles*.[19] The construction of these residences on the outskirts of large cities, the report stated, had resulted in a variety of social, moral, and physical problems, not only for individuals but for the "collective life" of the neighborhood (*quartier*) as a whole. "The creation of the *grands ensembles* of habitation," the author of the report explained, "poses serious problems for collective life which still are not well understood. . . . They challenge the physical and moral health, social equilibrium, well-being, and familial or collective budgets for several generations."[20] The report called for more studies of the problem and for increasing the "individuality" of the neighborhoods by constructing more sports and social centers, creating more green space, and other initiatives.[21]

Of course, the problems of the *grands ensembles* were not limited to those built on the outskirts of Paris. Residents of residential complexes across France were affected, though in different ways. For example, in the wake of World War II, residents of the southwestern provincial metropolis of Toulouse gladly welcomed the construction of relatively large and affordable apartments with modern amenities such running water, toilets, and heat. Yet after three large *grands ensembles* were built, local residents reacted negatively to the stark visual transformation of the urban landscape.[22] Local newspapers reported feelings of intense anxiety among residents of Toulouse over the *défiguration* of their city. Public historians from the local university started an activist group that published critiques of the new high-rises in a newsletter titled *Auta*. This group described the *grands ensembles* as "warts" on the rosy facade of the traditional city of Toulouse, and feared that the city would ultimately resemble New York or Chicago.[23]

In the late 1950s and the early 1960s, a series of critiques of the *grands ensembles* emanated from the media, from governmental institutions, and from the social sciences. These expressions of disgust were not limited to the architecture of the buildings themselves, although that was certainly an important focus of the complaints of local residents. Rather, social

scientists and others argued that the appearance of the *grands ensembles* marked the emergence of a new civilization, one marked by Western consumer capitalism, a loss of cultural identity, and a radical disconnection between local residents and the spaces in which they lived and worked. The social problems of the *grands ensembles* only seemed to be worsening, and at stake, it seemed, was the very future of French culture and civilization.

MODELING THE SOCIAL AND THE SPATIAL

In response to such fears, government officials at the Ministère de la Construction et de l'Urbanisme took action in a way similar to that of DGEN officials during World War II and Claudius-Petit at the MRU in 1950: they called for more studies of the problem, and invited experts in a wide range of academic fields to become involved in the process of developing solutions. As a result, in the midst of the construction of the *grands ensembles* in the early and mid 1950s, the relationship between the social sciences, the state, and professionals working in the fields of architecture and urban planning grew even closer. The minister's invitation for studies gave Chombart and other social scientists an opportunity to demonstrate the relevance of their fields of expertise to the contemporary urban problems in postwar France.

Chombart's funding for his 1952 aerial study of Paris was secured largely through his long-term friendship with the architect Robert Auzelle, who headed the section within the MRU devoted to *l'aménagement du territoire*. As we have seen, Chombart and Auzelle had met and had worked together at the École des cadres d'Uriage in the early 1940s. In addition, in the late 1940s, Auzelle and Chombart collaborated on plans for the reconstruction of the town of Petit-Clamart, southwest of Paris, in which they attempted to integrate Chombart's sociological ideas with urban planning and architectural realities. Now, in the early 1950s, in the wake of Claudius-Petit's call for interdisciplinary studies of urban problems throughout France, the MRU funded three pilot studies, one of which was Chombart's study of Paris and the Parisian *agglomération*. Auzelle himself was highly sympathetic toward the prospect of integrating sociological theories into the practices and pedagogy of urban planning and architecture.

Trained at the Institut d'Urbanisme de Paris, Auzelle was, like Chombart, deeply engaged in the development of visual techniques for the study of social life in urban environments. In the late 1940s, he authored a multi-volume encyclopedia of urban planning that demonstrated how social life in urban areas could be examined from multiple perspectives with the use of aerial photography, street-level photography, statistics, cartography, and other methods.[24] Auzelle maintained that aerial photography and mapping were essential methods for gaining insight into the sociological details of an agglomeration, as well as for obtaining a holistic view of any urban environment.[25]

Then, in 1953, Auzelle published a book titled *Techniques de l'urbanisme*, in which he explored various ways of studying the complexity of urban environments and called for a new approach to urban planning. In that book, he argued that visual techniques, among them aerial photography, street-level photography, and cartography, offered an empirical approach to the study of modern-day cities. In addition to interdisciplinary perspectives, Auzelle contended, an *inductive* rather than a deductive ensured a "rational" and scientific understanding of the complex entity known as an *agglomération*. "A rational urbanism," Auzelle wrote, "must indeed be based on as exact a knowledge as possible of humans and their multiple needs. Acquiring this knowledge requires the convergence of a mass of disciplines that stretch to the most diverse domains: biology, ethnology, sociology, history, geography, demography, political economy, etc."[26]

One of the techniques of vision that Auzelle helped to develop while at the MRU was the maquettoscope. In 1949, while directing the Centre d'études at the MRU, Auzelle asked engineers at the Institute Optique de Paris to develop a tool that would allow planners to visually enter into a model in order to gain a ground-level perspective from above.[27] H. and J. Vulmière, two engineers who figured in the invention of this instrument, explained that Auzelle had asked them to develop a system that would "respond to the following question: What will an observer situated in such a place determined by the model see: street, window, panoramic views?"[28] Architects and planners had used other instruments to attain this perspective before, borrowing the cystoscope (an instrument used to peer into the insides of blood vessels) from the medical world. The maquettoscope was similar to the cystoscope, except it could also photograph this ground-level perspective, which could then be used in developing plans. It also

FIGURE 4.2
An image produced by a maquettoscope. Source: Fonds Robert Auzelle. DAF/
Cité de l'architecture et du patrimoine/Archives d'architecture du XXe siècle.

provided higher-quality images than those produced by the experimental instruments such as the "inverse perioscope" that had been used by the historian and planner Gaston Bardet at the Institut d'Urbanisme de Paris before the war.[29]

Justifying the development of such a tool in the mid 1950s, Auzelle explained that, previously, most planners could not predict how their plans would translate into reality at the street level. By allowing the planner to visualize volume and mass, the maquettoscope would help urban studies be completed faster and more accurately. "Architects now have the possibility," Auzelle write in the mid 1950s, "to take into consideration in a very precise manner the effect of volumes in a model composition, realizing real conditions and natural light at its maximum." The maquettoscope, he continued, "offers architects [the possibility] to place themselves in the position of spectator."[30]

The maquettoscope offered, in short, a technical means for obtaining a street-level perspective. Emphasizing the need for multiple perspectives on the built environment in an article describing the development and utility of the maquettoscope in the mid 1950s, H. and J. Vulmière likened the difference between viewing a model on its own versus with the aid of this tool to looking down on a section of the city from above and seeing it from the ground.[31] "Paris seen from the top of the Eiffel Tower or even from its first platform is . . . hardly comparable to . . . the Paris that we travel through in our everyday lives," they wrote.[32] Though aerial photos were useful for providing a *vue d'ensemble* on a reduced surface, "they are insufficient for a detailed examination and will be advantageously completed with the addition of views taken from the maquettoscope from carefully chosen points."[33] The Vulmières ended the article by speculating that future engineers might find a way of filming at this minute level, which would allow for virtual "strolls through the streets of maquettes."[34]

In view of Auzelle's interests in visual techniques and sociological explorations and his friendship with Chombart, it is little wonder that he supported Chombart's 1952 study of Paris, which demonstrated the utility of both visual techniques and sociological explorations to understanding latter-day urban planning problems in France. Chombart argued that the discipline of ethnography had much to contribute to the endeavor of analyzing urban problems and finding solutions to them. Analysis and

finding solutions to urban problems in France, he contended, required an outsider's perspective; this could be achieved, literally, with the use of an airplane, and by ethnographic fieldwork on the ground:

There is an ethnography of large industrial cities like a sociology of non-machinist peoples. To neglect the ethnography of large cities is to look at our own civilization in a non-objective manner. The ethnography of large cities requires, even more than that of remote countries, its own state of mind. It requires attention to the details of everyday life, to the reaction of characters we rub elbows with every day, and a capacity to disorientation and participation in concerns of people and groups, which is gained at the price of a long learning process. This learning process alone can give the investigator the required assurance of objectivity.[35]

Using aerial photos obtained from the Institut Géographique Nationale in Paris and aerial photographs obtained from other sources, such as the extensive aerial photography collection of the wealthy entrepreneur Roger Henrard,[36] Chombart and his research group set out to map the details of everyday life within various *quartiers* of Paris. In one chapter, they presented a diagram of the everyday activities of a young student living in the wealthy sixteenth *arrondissement*.[37] The diagram demonstrated that almost all of her activities, from school to piano lessons to outings with family and friends, were located in the western half of the city; she rarely spent time in the working-class *quartiers* of the East. They found that this pattern was reproduced in working-class *quartiers* of the city such as Belleville.

Going further, Chombart linked this spatial pattern with differing levels of sociability in different socioeconomic districts. He argued that working-class districts in the East were more sociable and lively than their bourgeois counterparts in the West:

The bourgeois, most of the time, does not even know the name of the tenants of his house. His interactions with storekeepers, provided that his maids do not do all of the shopping, are very cowardly and superficial. The neighborhood as such, in the fullness of its everyday life, matters little in his relationships. The worker, on the other hand, even if he doesn't talk about it because it is so natural, has far deeper relationships with his neighbors, with the people of the *quartier* with whom he talks everyday. These relationships have a considerable importance in his everyday life, as much by the worries that they create as the solidarity that is manifested by it.[38]

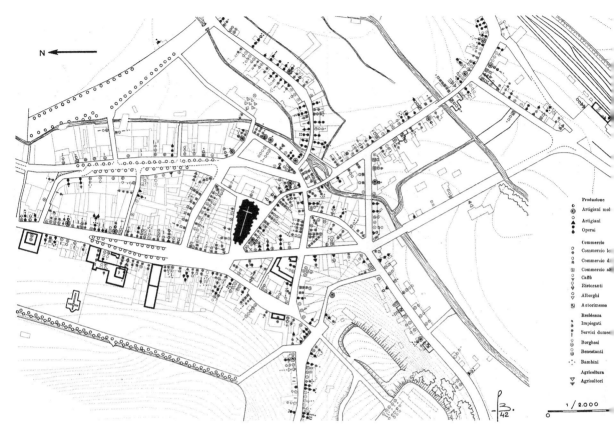

FIGURE 4.3

Mapping social activity, rather than just location, was central to Gaston Bardet's "social topography." Académie d'architecture/Cité de l'architecture et du patrimoine/Archives d'architecture du XXe siècle.

Chombart encapsulated the relationship between spatial relations and social relations within urban environments that he viewed from the air in the term *l'espace social*, and urged sociologists to apply their expertise to this dimension of social life.[39] The study of social space was concerned, he explained, with the outline or *form* of the city (in this case Paris) and the social and economic structures that this form implied. The collaboration between sociologists and urbanists would be particularly beneficial, Chombart argued, in better understanding the relationship between housing and the environment (*l'habitat*) in which it was situated. Together, planners and sociologists could produce an accurate picture of the

"infrastructure of collective life" (*infrastructure de la vie collective*) in urban environments and develop forms of housing that would meet the needs and aspirations of local populations. The sociologist would act, Chombart imagined, as a mediator between local populations and urban planners, expressing local needs and aspirations to planners and architects,[40] thus ensuring that decisions concerning the location of housing, industry, and even businesses would be made with an extensive understanding of present sociological and psychological needs, and not just economic ones.

This approach provided an alternative to the dominant functionalist perspective in architecture at the time as outlined by the Congrès Internationaux d'Architecture Moderne and its main publication, the Athens Charter of 1943, which classified the main human needs as dwelling, work, leisure, and circulation. The Athens Charter and functionalist architecture more generally, Chombart argued, ignored symbolism and memory, which were absolutely essential for improving the *psychological* health of urban inhabitants. The study of social space was to provide a way of restoring social harmony in Paris and other large cities by drawing attention to these crucial psychological needs. For instance, through the social-scientific study of "social space," the social problems of the *grands ensembles* could be viewed in a new light: at issue was not the buildings themselves but rather their distance from the cultural, symbolic, and economic centers of the city. "We need," Chombart wrote, "in the city of Paris, to examine the situation of populations such as the one of suburban projects, who find themselves cut from vital centers and feel for that reason outside of the national life."[41]

This distanced and holistic perspective proved useful to social-scientific investigations of the social problems that surrounded postwar cities. Yet it is important to note, once again, that aerial views were never used in isolation. The practice of modeling the social and the spatial required a myriad of other types of data, especially numerical or quantifiable data that could be turned into statistics and demographic data. Indeed, this crucial juxtaposition is where the importance of aerial photography in postwar urban planning becomes most visible: aerial photos helped make urban space and its sociological dimension quantifiable, thus providing a scientific way of modeling socio-spatial relationships.[42] Aerial views drew attention to the overall form of the agglomeration—that is, the relationships between various parts of urban areas, rather than any single component. They also

helped planners and social scientists focus on how local inhabitants utilized urban space in everyday life.

SOCIOLOGICAL EXPERTISE AND THE STUDY OF THE BUILT ENVIRONMENT

At the moment when Chombart and his research group at the Centre d'études sociologiques published their seminal study, the environment was especially ripe for the idea of "social space" to develop and to take hold in postwar urban planning and the social sciences. Urbanists from the Institut d'Urbanisme de Paris and other organizations had already been calling for a new approach to urban planning that would use visual techniques to obtain a closer look at the sociological details of urban environments. Some of the most illustrative examples of this trend can be found in the works of Gaston Bardet and those of Maurice-Françoise Rouge.

Bardet had begun experimenting with visual techniques before the war as a professor at the Institut d'Urbanisme de Paris. Influenced by the historian and planner Marcel Poëte, who like many others in the 1930s was inspired by the phenomenological theories of Henri Bergson, Bardet sought to develop a more "organic" approach to urban design through the utilization of newly available visual techniques for studying the built environment, among them aerial photography.[43] During World War II, his interest in topographic mapping and in its application to the practice of urbanism increased as a result of his participation in the group Économie et Humanisme, led by Père Lebret in Lyon.[44]

The war and the postwar urban reconstruction gave Bardet opportunities to test his ideas in practice. For instance, in the early 1940s, Bardet used aerial photos and mapping to develop a reconstruction plan for the bombed out center of Louviers. In contrast to a strictly linear approach, his methods yielded a plan that, he argued, was more in line with the sociological needs of the local population.[45] Bardet's work on the reconstruction of the destroyed center of Louviers allowed him to test ideas that he had formulated in the prewar period, and, as a result, to develop a new approach to urban planning. Bardet labeled this novel approach *topographie sociale*, a term that highlighted his focus on the relationship between urban space and sociological phenomena.[46] Social topography was Bardet's prescription for creating urban environments that were "organically" in line

with the needs of local inhabitants. At the heart of his approach was the mapping of social activity within a city. Whereas geographers such as Albert Demangeon had mapped the location of banks, schools, and other public buildings in Paris in the 1930s,[47] the method of social topography differed. It represented Bardet's attempt to schematically depict the contours and character of social life within a city, rather than merely where buildings, landmarks, parks, and other components of a city were located. "For us as planners," Bardet wrote, "it is not a question of looking at the distribution of some elements of similar character and comparing them to others in the town as a whole, but of grasping all of them in their interrelationships. Twenty analytical maps, containing individual characteristics, cannot take the place of the synthetic or composite cartogram of social topography neither practically nor for the richness of the discoveries of ways of living offered by an urban fabric not already degenerated or decayed at birth."[48]

Bardet's use of the term *tissu urbaine* was intended to draw attention to the biological—to view a city as an organism, whether healthy or diseased. Bardet even compared his own methods to those of biologists: "I believe that the introduction of the methods of social topography can be compared to the introduction of the microscope in biology. . . . We have at one stroke removed the roofs from the houses, which were only the material aspect of urban form, to look at the swarming of individualities that make up the very structure of the town."[49] On the one hand, Bardet's frequent references to biology distanced his innovative approach from linear, abstract, or geometrical approaches to urban planning, which drew upon physics and mathematics rather than the natural sciences. On the other hand, these biological allusions reaffirmed that an organic approach was at least as "scientific" as one dictated by abstract or Euclidean notions of space, because it was based on *direct observation* of social life. The great benefit of this truly scientific method, according to Bardet, was to preserve "social harmony" and unity within a city:

How many mistakes might have been avoided by just a glance at a map of social topography! . . . It will no longer occur to anyone to cut through a commercial frontage with a diagonal road, causing a hemorrhage that cannot be stopped. He will first examine what has happened when this has been done. There will no longer be an automatic tendency to link two crossroads (or what is worse, two

squares) by a diagonal road, or to extend a road in a straight line! The planner must oppose easy geometric solutions.[50]

Joining Bardet in calling for a "new urbanism" was the geographer Maurice-François Rouge, who studied at the Institut d'Urbanisme de Paris before obtaining a position at the Ministère de la Reconstruction et de l'Urbanisme with Auzelle. As we saw in chapter 3, Rouge emphasized the supposed "objectivity" of this novel way of approaching urban space by calling for the creation of a new science, which he termed *la géonomie*. Like Bardet, Rouge looked to biology as a base for this new science. "We need," Rouge wrote in his *Introduction à un urbanisme expérimentale* (1951), "to design a scientific urbanism: as science covers very different domains, we need to gain inspiration from the closest discipline, biology, and to aim . . . for an organic urbanism."[51] The "new urbanism" as proposed by Rouge would include a deep transformation in ways of thinking about cities. "This new science," he argued, "must entail very deep changes, a true revolution . . . in the design and implementation of cities and towns, because it will bring the rigor of a new logic in the way to 'think' about cities."[52]

Chombart's 1952 study was unexpectedly popular. "The collective work of 1952," Chombart recalled years later, "sparked different reactions. . . . It caught the attention, immediately after its release in Paris, of multiple urbanists, sociologists, geographers, doctors, politicians. The architect Robert Auzelle . . . insisted on presenting it to the Minister, M. Claudius-Petit, who immediately adopted it."[53] With *Introduction à un urbanisme expérimentale*, he had successfully demonstrated the utility of ethnography to the endeavor of finding a new way of conceptualizing and approaching urban environments. Just as significantly, by capturing the attention of numerous figures in different domains, *Introduction à un urbanisme expérimentale* helped Chombart's theories of spatial and social organization to gain a foothold in urban planning and governmental circles in Paris.

The success of *Introduction à un urbanisme expérimentale* inspired Chombart to create a new institution that would use sociology to study

FIGURE 4.4

An aerial photograph of a village in northern Cameroon from Paul-Henry Chombart de Lauwe et al., *Famille et habitation*, 2 volumes (Centre Nationale de la Recherche Scientifique, 1959–1960).

contemporary urban problems in France, including those associated with the *grands ensembles*. He called this new institution, which was largely funded by the MRU, the Centre d'études des groupes sociaux.[54] Modeled after the London School of Economics, the CEGS aimed to further "the link between the institutions in charge of technical and social transformations, the representatives of various applied disciplines: architects, urbanists, teachers, social workers, and the representatives of various groups and social classes." "The scientists," Chombart wrote, "can either be called in for 'consultation' by the concerned people, or to publish the practical conclusions that fundamental research may lead to."[55] Auzelle had strongly encouraged the formation of the CEGS, noting that planners and sociologists shared many of the same concerns but lacked administrative structures that might enable them to interact meaningfully.[56]

Chombart maintained that the main contribution of sociologists to the study of urban planning, and of the CEGS in particular, was to present analyses of urban problems that "rose above" the practical needs of local inhabitants and drew out deeper psychological, moral, and cultural needs. "There is," he wrote, "a pressing need to rise a lot higher and to see what are the broad cultural trends that act on the form of groups and on the needs that they express."[57] Throughout the 1950s, the CEGS received funding from various governmental institutions involved in postwar reconstruction, including the Commissariat général du plan, the Ministère des travaux publiques, and the Ministère de la construction, to carry out sociological studies of urban problems.

As we have seen, one of the most pressing problems in Paris and in other cities at this time was that of the newly constructed *grands ensembles*. Using the concept of "social space" outlined in his 1952 study, Chombart and his research team at the CEGS contributed to analyzing this problem by highlighting the social dimension of the division between the inner city and the suburb in France and the inadequacy of the *grands ensembles* to meet the *spiritual* needs of local inhabitants. Using the concept of social space, Chombart and other CEGS researchers brought attention to the problem of spatial organization in Paris and in other French cities. More than by architecture, they suggested, the social problems of the *grands ensembles* were caused by the placement of these structures within the overall form of the city.

Between 1954 and 1962, the CEGS conducted a study the results of which were published in 1963 under the title "The Behaviors and Needs of Parisians in Relation to the Structures of an Agglomeration."[58] In that report, on the basis of the inequalities they observed between peripheral areas of Paris and the center, Chombart and his research team portrayed the suburb (*banlieue*) as its own social-scientific problem. Above all, their research revealed that populations in the center and at the periphery of the city had different ways of life, and that the cultural, social, and economic, opportunities of those at the peripheries were limited.

Similarly, in a study conducted in 1956 and 1957 for the Comité interprofessionel du logement Girondin, Chombart and his CEGS research group outlined ways to increase the sociability of three new collective housing complexes in Bordeaux by constructing public parks, playgrounds, libraries, gardens, child-care centers, and even "party rooms."[59] Another study, completed in 1958 for the Union nationale des caisses d'allocations familiales, noted that working-class individuals who moved from the inner city to new collective residences in the suburbs often felt lost and disconnected from their former, and more sociable, ways of life. Living in larger and more modern spaces better satisfied their basic needs, but made them less likely to go out. Through direct observation, Chombart and his team argued that, overall, residents in these new complexes resented the negative effects of their living conditions on the quality of their lives.[60]

Going further, Chombart used the concept of "social space" to argue that the *grands ensembles* did not reflect the true needs of the local populations that inhabited them. The reason why inhabitants of the *grands ensembles* were so dissatisfied was that they were not adapted to their environments, and vice versa. Drawing upon his prewar studies of spatial organization in Cameroon and other colonial areas, Chombart contrasted the "natural" relationship between space and society in non-Western or non-industrialized countries with the "artificial" organization of space in the West, as exemplified by the *grands ensembles* of postwar France. He concluded that sociologists, architects, and planners should work together to restore harmony to postwar cities by constructing housing that would fit the true contours of French culture, family life, and values, rather than requiring families to adapt to housing that did not meet their needs.

Chombart began *Famille et Habitation*,[61] a two-volume study of the relationship between family structure and the spaces of human habitation published in 1959 and 1960, with one of the most basic premises of anthropological research: that "human habitation is the reflection of a society."[62] He argued that this was not merely a theoretical principle but something that could be directly observed with the use of aerial photography. Aerial photos exposed the overall form of habitation in a particular area, the meaning of which could be derived from interviews with informants on the ground in regard to their familial structure, their religious beliefs, and their ways of life. For instance, in northern Cameroon each house was a conglomeration of clearly defined rooms with specific purposes; the largest of these was "the womens' and childrens' room," and its placement at the center of the home represented their privileged place.[63] "In pre-industrial societies," Chombart wrote, "the house is a direct reflection of family structure. Every feature refers to the role of a character designed in conjunction with representations and beliefs. The father, the mother, the ancestor, every child has a place that he deserves traditionally. . . . In the system of values of a society, the habitat of the family of which it is a product, still has an efficiency of another order. In the best conditions, it allows inhabitants to adapt to their own social milieu."[64]

The harmonious and "natural" organization of space in "pre-industrial" societies stood in stark contrast with the chaos and disorder of Western cities such as Paris, whose lack of harmony was, Chombart argued, clearly visible from the air. In postwar cities in France and other capitalist nations, he and others contended, disconnections between familial values, social life, and the organization of urban space were worsening. As seen from above, French cities such as Paris looked "sick" in comparison to the healthy, natural layout of villages in northern Cameroon.[65]

Chombart traced the origins of the problem to the "erroneous" ideas of Functionalist Architecture, which had been formulated in CIAM meetings and in the work of Le Corbusier and other architects. Functionalist architecture aimed to meet the needs of local populations. But these "needs," Chombart contended, were based on preconceived notions rather than on direct sociological or anthropological investigation. True needs and aspirations could be discovered only through empirical observation by methods of research that were inductive rather than deductive. "Modern architecture," Chombart explained, "was presented to us as an anticipation

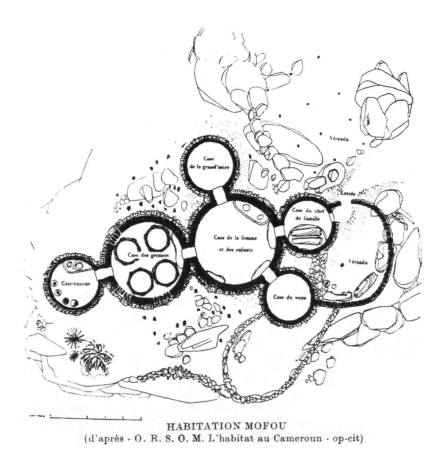

HABITATION MOFOU
(d'après - O. R. S. O. M. L'habitat au Cameroun - op-cit)

FIGURE 4.5
A diagram of the village in northern Cameroon, also from *Famille et habitation*.

of needs. But how? Anticipating needs is not only supposing, based on personal reasoning, what objects will be necessary for the people of tomorrow, it is in our opinion discovering, through a series of methodical observations, the meaning of an evolution. Tomorrow's needs can be partially forecast based on the analysis of today's aspirations and, at the same time, on material transformations that happen progressively. The intuition of the creator will only be successful using this difficult but safe way."[66]

Chombart's study of habitation and family life was central to his scientific observation of daily life. A new approach to urban planning was absolutely crucial to restoring harmony and balance to large cities such as Paris, Chombart argued, but this novel approach should not be utopian.

On the contrary, it should be based on direct observation of everyday life within various housing complexes. "Empirical observation" included questionnaires and interviews with local residents, information obtained from statistical and demographic institutions such as l'INSEE and l'INED,[67] and, most crucially, newly available techniques of visual documentation such as street-level photography, aerial photography, and film. "To the most commonly used techniques, such as questionnaires, free or directed interviews, tests, press content analysis etc.," Chombart wrote, "we must add, more and more, new techniques which efficiency has not yet been highlighted in sociology: photography, cinema, aerial views, tape recorders, group discussions. . . . These techniques can be used to record data collected directly. They can then allow us to present investigations of an image either of their milieu of existence (aerial views, photographs), or scenes of everyday life (cinema) by provoking reactions that are extremely useful for sociologists for understanding the problems they study."[68]

The use of a variety of empirical methods allowed Chombart to bring the study of problems facing individuals residing within large-scale housing complexes to the level of the collective. As Chombart often stated, the basic unit of ethnographic study was not the individual but the group.[69] For that reason, he maintained, all sociological studies of social life in the *grands ensembles* should be integrated into the broader context of a city's "social space."

Referring to his previous work on Paris, Chombart explained that by "social space" he meant the analysis of urban space beyond its strictly geographical dimension. "We cannot study social life in geographical space in the traditional sense, or in a social space purely independent of its links with material life," he wrote. "It is in a socio-geographic space that we must situate ourselves."[70] This way of modeling the connection between spatial relations and social relations within urban environments would allow architects, planners, government officials, and social scientists to compare different forms of habitation and different familial structures in cities throughout France and the world. "We need," Chombart wrote, "to rediscover a global view of familial space, taking into account its various dimensions (material and social) and going back to the study of a plan or, rather, to various types of plans corresponding to the needs of families. The pursuit of comparative research should allow us to define these types of plans if a collaboration between technicians, architects and representatives of human sciences could be developed in good conditions."[71]

Chombart's emphasis on the utility of empirical observation helped to promote interdisciplinary collaboration between social scientists, urban planners, and government officials. In particular, his use of aerial photos encouraged government officials and planners to perceive sociological research as a valid science that was on par with other sciences. Without aerial photos, Chombart's work might not have been received as enthusiastically as it was received by such governmental institutions as the École Nationale des Ponts et Chaussées and the Ministère de la Reconstruction et de l'Urbanisme.[72] As we saw in chapter 3, in 1950 Eugène Claudius-Petit introduced the national project of *l'aménagement du territoire*, which aimed to correct the "chaos" of spatial organization in France—as viewed from an airplane—through the rational redistribution of population and industry throughout the national territory. Crucially, Claudius-Petit wrote, *l'aménagement du territoire* was to be based on empirical studies. There were practical reasons for this, as well as symbolic reasons: developing plans for territorial management based on empirical and interdisciplinary research would prevent the reproduction of mistakes made by the over-theoretical Third Republic. If the airplane had brought to light the "chaos" of Western cities, thereby leading to the postwar project of *l'aménagement du territoire*, it could also, Claudius-Petit and others argued, be used (in conjunction with a variety of other scientific tools) to solve those problems.

Thus, the technique of aerial photography, and the idea of "social space" that it helped to engender, served a communicative role by helping Chombart and other social scientists to join the conversation about the future of territorial management in France. From the late 1950s to the mid 1960s, Chombart's theories were integrated into pedigogical teachings at the École Nationale des Ponts et Chaussées, one of the most prestigious engineering schools in France, and Chombart was invited to give a seminar there on the contribution of sociology to urban planning in 1964.

In addition, a number of new works were inspired by the CEGS's sociological investigations. For example, in a work titled *Photographies aériennes et Aménagement du territoire*, first presented at the Institut d'Urbanisme de Paris in 1957,[73] the engineer and planner Alexandre Burger, who had studied at the IUP under Robert Auzelle, devoted an entire chapter to the contribution of sociology to postwar urbanism.[74] That chapter focused on Chombart's extensive use of aerial photos and his notion of "social space." Burger began by quoting from Chombart's 1952 book on Paris, in

which Chombart had called for empirical studies to prevent the development of "abstract plans" that ignored the true needs and aspirations of local populations. Like Chombart, Burger now maintained that interdisciplinary collaboration between experts in a wide range of fields, and especially between sociologists and planners, was crucial to solving the problems that faced postwar cities in France. At the same time, he noted how difficult this collaboration was to achieve in practice, and suggested that aerial photography could be used to construct an interdisciplinary bridge between sociologists and urbanists. "By using the same methodological tool," Burger wrote, "everyone is driven to become more clearly conscious of his neighbor's concerns and to confront the results of his research."[75]

By placing social facts within the physical world in which they evolved, Burger concluded, aerial photography made sociological data more comprehensible to urban planners. Aerial photos clearly exposed the geographical contours of *quartiers* of a city, as well as that city's sociological character and the level of sociability among local residents. In an aerial photo of an agglomeration, he explained, planners were viewing not only a city's geographical traits but also its sociological composition. Only aerial photos provided a planner with a view into the relationship between disparate spaces within a city and how spatial networks (*réseaux*) had evolved over time.

As a case in point, Burger cited aerial views (obtained from the MRU) of two sections of the Alsatian city of Colmar. The first, a view of the Saint-Marie section, appeared relatively homogeneous on a simple topographic plan. Yet aerial photographs of that section revealed details that allowed urban planners to see into its character at a glance. For instance, looking at an aerial photo, one could clearly see the existence of two types of housing: individual houses (*pavillons isolé*) and collective apartments (*grands ensembles*). Examining the photograph even more closely, a planner could see that each type of habitation was associated with a different type of garden: those attached to the *pavillons isolés* had trees, while those in the *grands ensembles* were used solely for growing food. This difference, Burger argued, pointed to different socioeconomic levels, as those living in individual houses could afford to lose valuable land for cultivation whereas those living in the *grands ensembles* could not. Going further, Burger compared the "social space" of Sainte-Marie with a neighboring section of Colmar, Château-d'Eau, which aerial photos revealed to have a very

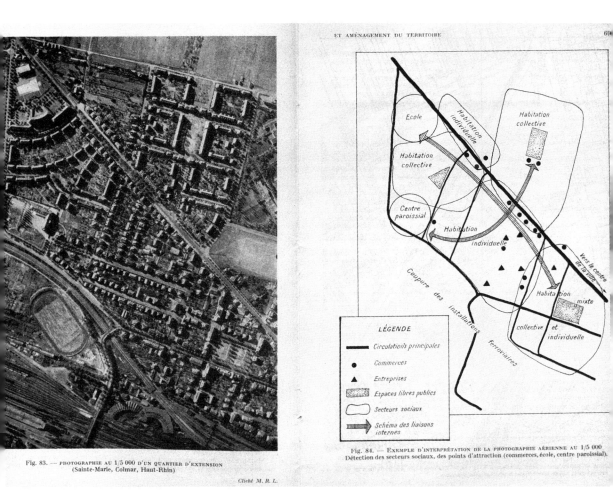

ET AMÉNAGEMENT DU TERRITOIRE

Fig. 83. — PHOTOGRAPHIE AU 1/5 000 D'UN QUARTIER D'EXTENSION
(Sainte-Marie, Colmar, Haut-Rhin)

Cliché M. R. L.

Fig. 84. — EXEMPLE D'INTERPRÉTATION DE LA PHOTOGRAPHIE AÉRIENNE AU 1/5 000
Détection des secteurs sociaux, des points d'attraction (commerces, école, centre paroissial).

FIGURE 4.6

Burger's analysis of the social space of Colmar, directly inspired by Chombart's 1952 study of Paris. Alexandre Burger, *Photographies aériennes et aménagement du territoire. L'Interprétation des photographies aériennes appliquée aux études d'urbanisme et d'aménagement du territoire* (Dunod, 1957).

different character. Château-d'Eau was composed entirely of spacious houses, all with decorative gardens. Each house had a garage, and the streets were harmoniously aligned and well maintained. The form of the houses, the gardens, and the surrounding streets revealed that the population of Château-d'Eau was more bourgeois than that of Sainte-Marie.[76]

Burger's analysis of the social space of Colmar recalls Chombart's study of the social space of Paris. It shows the role of photographic techniques and empirical observation in the development of a new approach to urban planning. By helping to quantify urban space and its sociological dimension, aerial photos presented an alternative way of designing urban environments that was not utopian but, in the eyes of its advocates, scientific. If during the Vichy period Gabriel Dessus and his interdisciplinary team of researchers at the DGEN had attempted to reverse the problems of the Third Republic through the empirical study of urban problems during World War II, in the postwar period this inductive approach, which centered on the scientific study of topographical space and its social dimension, was intended to combat the tyranny of technocratic planning from above.

CONNECTING MARXISM AND URBAN PLANNING

The emergence of "social space" as a model for understanding the correlation between spatial relations and social relations within the urban environment served professional needs: it made sociological studies of urban trends appear more "scientific," and as a result it helped Chombart and other sociologists gain authority within urban planning and governmental circles in Paris. At the same time, that analytical tool also served political needs. Chombart's 1952 study of spatial segregation in Paris demonstrated to social scientists, government officials, and planners alike the continuing relevance of Marxist theory, and suggested a scientific, rather than philosophical, basis for Marxist ideas. The question was not only why socioeconomic populations were divided in urban space, but also why such divisions had continued for so long—since Haussmann's mid-nineteenth-century urban renovations. The organization of urban space, it seemed, was at the root of the reproduction of socioeconomic inequality in France, and perhaps other capitalist countries.

Chombart, however, was not a Marxist. In fact, he never officially joined any political party, but he had been closely aligned with the Catholic left since the 1930s, and he was deeply committed not only to studying but also to improving the conditions faced by working-class individuals and families.[77] Chombart was particularly inspired by the writings of the Jesuit priest and paleontologist Pierre Teilhard de Chardin, who was based at the Catholic Institute in Paris. In particular, he supported Teilhard's claim that "the development of human aspirations is . . . an essential condition of progress, of progressive liberation of persons and of their expansion in a final unanimity" and Teilhard's belief that modern technology had the potential to liberate humankind from the problems of the modern world.[78] Chombart reminisced in the mid 1970s that his own work on Paris confirmed the continuing segregation of socioeconomic classes in France, and the reproduction of divisions of wealth into the organization of urban space.[79] The social-scientific study of "social space" was rapidly replacing, or at least modifying, the traditional Marxist focus on class as the starting point for explaining other differences.

Thus, what began in the 1930s as a (social) scientific endeavor—anthropological analysis of colonial areas—was, by the late 1950s, quickly becoming a focused social-scientific critique of urban planning practices in postwar France. It was also becoming, simultaneously, the focal point of the French New Left, a leftist movement spearheaded by the Marxist urban sociologist and philosopher Henri Lefebvre, that sought to go beyond the confines of the French Communist Party, especially that party's neutral position on the Algerian War. Disillusioned with the party, Lefebvre and other Marxist thinkers began actively searching for a new focus. They found, in the analysis of urban space and its social dimension, not only a novel "science," as Lefebvre called it, but also a new political program that would influence French politics and social life for years to come.

In the 1960s, the hopes for interdisciplinary collaboration that only a few years earlier had been fostered by aerial photography and by the idea of "social space" came to an end. Rather than facilitating communication between sociologists such as Chombart, architects such as Auzelle, and planners such as Bardet and Burger, aerial photography did the opposite. Against the backdrop of the Algerian War, the first satellite views of Earth, and Charles de Gaulle's large-scale housing program, Lefebvre and other leftist thinkers began to combine social-scientific methodology and politics in new ways. The view of the whole (*vue d'ensemble*) offered by aerial photography—which, as we have seen, had been central to the technique's unique utility since its development during World War I—now signified not the humanistic, Enlightenment-inspired promise of global unity through technology, but rather the "voyeuristic" viewpoint of colonialism, the "spectacle" of capitalist consumerism, and the repressiveness of state-controlled urban planning.

Part of this skepticism towards aerial photography reflected a technological change: Views from above were taken from increasing distances and were used in new ways—most notably, for aerial bombardment during World War II and the Algerian War. Whereas in the 1930s the practice of aerial photography explored spatial habitation at the scale of the neighborhood or the village from a distance of hundreds of feet in the air, aerial photography in the 1960s and the planning that it supported had "scaled up" to the analysis of entire regions from tens of thousands of feet above. Unease at the increasing distance would reach its peak as the first French satellites went into orbit in 1965,[1] and images of the entire earth as a pale blue dot were sent from the moon.

Nevertheless, the language of aerial photography, i.e. "social space," persisted. Lefebvre and others used it to promote a new type of urban planning that would privilege the ground-level perspective of the "user" of urban space rather than the (supposedly) "top-down" gaze of architects, planners, and government officials. This last chapter in our story, then, will first explore how and why Lefebvre's program to develop a "new science" of (social) space became detached from the visual technique that had helped to engender it. It will next examine the concept's new life as a focal point of the burgeoning political program of the New Left, especially their call for "participatory urban planning" as an antidote to the "internal colonization" of French cities under de Gaulle.

THE SCALE OF URBAN PLANNING UNDER CHARLES DE GAULLE'S FIFTH REPUBLIC

Under de Gaulle's presidency, the *grands ensembles* were no longer built as an emergency response to the postwar housing crisis, as they had been in the late 1940s and the 1950s. Instead, they were part of de Gaulle's nationwide program to revitalize French cities in the hope of modernizing the country as a whole.[2] This large-scale project of "urban renewal" was already underway in 1955. Entire slum areas (*îlots*) of Paris and other cities were targeted for demolition, and were to be replaced with office buildings, commercial centers, and luxury dwellings.[3] But in 1958, the year de Gaulle became president, the move to regenerate the country through the revitalization or "reconquest" (*réconquête*) of urban areas throughout France increased dramatically. By destroying low-cost housing within the center of the city, these revitalization efforts created a need for even more affordable housing in outlying districts, leading not only to an enlargement in the size of individual buildings, but also to an extension of these projects to new areas.

De Gaulle made this increase in scale possible through new government incentives and privatization. One of his most significant pieces of legislation in this regard was the creation, by Decree No. 58-1464 of December 1958, of specified *Zones à urbaniser par priorité* (ZUPs). The aim of this program was to address existing criticisms of the *grands ensembles*, especially Sarcelles, by making sure that the construction of new housing units was accompanied by the creation of infrastructure, commercial centers, and

other facilities. ZUPs would ensure, it was hoped, that local residents would feel connected to their neighborhoods, rather than isolated in modernist housing complexes. As the geographer Jacques Brun and the historian Marcel Roncayolo have explained, the idea behind this initiative was to "regroup" the project of the *grands ensembles* and to integrate them more directly with existing regional planning throughout France.[4]

The way ZUPs were supposed to work was that state officials, in close collaboration with the local Préfet (administrative head of a *département*), would first identify these zones. Then, using the power of expropriation, such zones would be developed with at least 500 new housing units with the aid of funds from both the state and private investment. Ideally, the land set aside would be inexpensive but well located. In practice, however, ZUPs differed little from the preceding procedures that had led to the construction of Sarcelles and numerous other *grands ensembles* in the previous decade.[5] Although local groups were involved at some level, non-local engineers and planners from state institutions made most all of the final decisions. Additionally, as Pierre Randet, head of the l'Aménagement du territoire section of the Ministère de la Construction (the institution that replaced the Ministère de la Reconstruction et de l'Urbanisme in the late 1950s) explained decades later, well-located land at an affordable price turned out to be contradictory.[6] "Too often," Randet reminisced in the 1990s, "in order to not exceed a price level . . . and to save time . . . ZUPs occupied marginal sites, rather poorly served, at the very limits of the construction area fixed by urban plans, if not beyond."[7]

The use of aerial photos, maps, and other quantitative methods only reinforced, in the public eye, the perception that ZUPs were a planning program directed by the state with little input from local groups. Aerial photos and maps were utilized to locate areas for new development, many of which were on the peripheries of large cities. The deep involvement of the state also fostered privatization, which in turn led to an increase in the size of the *grands ensembles*. In order to increase the number of housing units being built each year, the state relaxed building regulations, permits, and rules, and provided tax incentives to private construction companies.[8] The result, as the historian Rosemary Wakeman has explained, was increased involvement in planning by various experts: "In the space of ten years," Wakeman writes, "an extensive web of bureaucratic authority had been spun over an invented set of fields—the city, the suburb, the priority

zone, the region. Planning texts were filled with panoramic maps that displayed the new arrangements of space. They imposed a uniform, rational composition upon the whole."[9]

In 1965, the new head of the District of Paris, Paul Delouvrier, who, as we saw earlier, had participated in the École des Cadres d'Uriage under Vichy alongside Chombart and Auzelle, initiated an ambitious program to address the problem of growth in Paris that exemplifies this approach. Developed in collaboration with intellectuals, planners, and many others,[10] the Schéma Directeur d'Aménagement et d'Urbanisme de la Région de Paris[11] proposed to deal with the rapid expansion of the suburban areas of Paris by creating five "new towns" (*villes nouvelles*) around the city that would be connected to the center. Roads, highways, and rail networks (including suburban trains) would connect these new towns to the center of Paris.[12] According to the historian Larry Busbea, "the purpose of this vast new circulation system, integrated into Paris proper and branching out across through the axes of the Schéma Directeur, was to bring the region into a state of equipoise, in which any location was equally within reach of the center."[13] In other words, much like the proponents of *l'aménagement du territoire* a decade earlier, Delouvrier proposed addressing the growing chaos of Paris and other French cities by implementing an urban scheme on a grander scale than ever before. The goal was to decrease dissatisfaction among urban residents by creating new centers of activity and by providing better transportation to and from other parts of the city. "Paris and its future," Delouvrier explained, "must respond to three imperatives: to put to the best use a space that is very dense, old and small in extent; to respect the complexity of the functions and structures indispensable to the equilibrium between its territory and that of its region and, equally, the ensemble to the national territory."[14]

Aerial photos, maps, and diagrams, meant to make the city of Paris and its surroundings more "legible," were central to the Schéma Directeur as proposed by Delouvrier. Delouvrier even began by defining the Parisian region "as seen from an airplane."[15] He used these visual aids to pinpoint areas of growth and to develop a transportation network to serve specific locations. He continually emphasized the need to approach the problem of growth through a plan that encompassed the *ensemble* of the *agglomération parisienne* rather than focusing on isolated parts. Aerial photos, maps, and diagrams were central to this holistic or "synoptic" perspective, which

was intended not only to be geographic but also social, economic, and cultural. "Ideas, techniques, needs, and income," Delouvrier remarked in the conclusion to the plan,

will continue their evolution or their growth; the way to register them in the urban texture will be modified; similarly the desire of these people to project their distant future and to anticipate their immediate future will be asserted in the actions of the day; similarly, after the year 2000 the increase in number of inhabitants of France will continue. . . . This is why this guiding scheme does not plot an urban region closed on itself—whatever the surface area—but project toward Rouen and the sea, through the Val de Seine, directions through which, based on the progress of its wealth and population, Paris, if needed, will be able to advance.[16]

During this time, Lefebvre and others began to connect state-sponsored urban planning with the "spectacle" of consumer capitalism. The same techniques that Chombart had used to develop a systematic understanding of "social space" were thus interpreted, in Lefebvre's work, as the basis of the problem. The French state, Lefebvre argued, was able to "colonize" everyday life by making urban space "legible" through aerial photos, maps, statistics, and other methods. He described the space of capitalism as a "homogeneous, optico-geometrical, quantifiable, and quantified and thus abstract space,"[17] one that was separated artificially from the human body. "In modern space," Lefebvre wrote, "the body no longer has a presence; it is only *represented*, in a spatial environment reduced to its optical components."[18] Linked to military practice of bombing,[19] not only in World War II but also in the more recent Algerian War, aerial photography now represented the authoritative approach that Lefebvre so passionately critiqued.

Lefebvre's stated disdain for the colonizing "gaze" was part and parcel of a more general critique of Western capitalism. The emergence of this mode of production, Lefebvre argued, was accompanied by the hegemony of sight, a sense that he equated with distance and passivity. Techniques of visual representation such as aerial photography only served to "flatten" the complexity of social life, reducing its richness to an abstraction impoverished of meaning and experience. Although planners claimed that these qualitative methods were indispensable to the "scientific" analysis of urban environments, Lefebvre warned that they actually concealed more than they revealed.

In particular, Lefebvre asserted that these abstract techniques masked the omniscience of the state in local affairs, especially in urban management, under the neutral umbrella of "science." According to Lefebvre, the state maintained its vast bureaucracy largely by collecting data on all areas of social life. Visual methods were particularly important in government record keeping, because officials, planners, and the public alike considered them to be "objective" and scientific. The quasi-colonial presence of the state in local affairs, Lefebvre argued, perpetuated the boredom, monotony, and sterility of everyday life under Western capitalism, wherein authenticity was lost to abstract representation. Lefebvre expressed his antipathy for the "repressive" potential of vision in *The Production of Space*:

That which is merely *seen* is reduced to an image—and to an icy coldness. . . . Inasmuch as the act of seeing and what is seen is confused, both become impotent. By the time this process is complete, *space has no social existence*. . . . It is thus—not symbolically but in the fact—a purely visual space.[20]

The historian Martin Jay has argued that postwar France was permeated with critiques of visuality such as these. Of course, as this book has shown, Lefebvre's condemnation of the colonizing gaze was, in fact, deeply rooted in visuality and the new ways of seeing engendered by aerial photography and other techniques of representation. The same was true for other philosophers whom Jay has described as "anti-ocularcentric," including Michel Foucault and Guy Debord. In the late 1950s, Debord (a colleague and friend of Lefebvre) launched the Situationist International, which helped to inspire the student riots in Paris in May 1968. In 1966, Debord published his ideas on capitalism in a book titled *The Society of the Spectacle*, which focused on how images and mass media were used in capitalist societies. In this work, Debord linked the low quality of life in wealthy Western capitalist societies to the "seductive" power of vision. Although consumer goods were now plentiful, he argued, inhabitants of Western capitalist societies struggled to find authenticity, sociability, and spontaneity in their everyday lives. This quest, however, was especially difficult because the process of "spectacularization"—and with it the omniscience of the state—was inescapable; it ordered everyday life at every turn. Debord thus tied mass media to the repressive practices of political power and domination.

In developing this capitalist critique, Debord and his collaborators in the Situationist International placed special emphasis on the practice of (mis)representing cities through maps and aerial photos. For example, in a work titled *The Naked City*, Debord's collaborators took an aerial photo of Paris from Chombart's 1952 aerial study and transformed it into a collage of nineteen distinct sections connected by thick black arrows. While they retained Chombart's focus on the *quartier*, they aimed to challenge the notion that a map can adequately represent urban life. On the contrary, *The Naked City* suggested that urban plans based on such geometrical representations only hid the diversity of everyday life, reducing it to an abstract plan. The map was intended to propose that space was an element of social practice, not merely a "container" within which social relations took place.[21]

Lefebvre, then, in direct opposition to Chombart, rejected the use of aerial photography in sociological studies of the built environment. Going further, he and others integrated this critique of the eye with their new approach to urban planning that rejected passive observation of planners (with aerial photography and other visual techniques of observation) in favor of the active participation of residents in the planning process. Lefebvre thus linked the social-scientific study of "social space" with a Marxist theory of practice, arguing that a radical change in spatial relations and organization was an essential component of any successful social revolution.

PARTICIPATORY PLANNING, CULTURAL CRITIQUES OF THE EYE, AND "SOCIAL SPACE"

Yet, if the decade of the 1960s was characterized by what Lefebvre and other theorists would eventually criticize as de Gaulle's authoritative, capitalist, and large-scale modernization programs, it was also marked by a remarkable openness to novel approaches within government institutions. Chombart's work in urban sociology in the 1950s (as we saw in chapter 4) had paved the way for this development, giving future urban sociologists an opportunity to become involved in the planning process. By serving on government-funded interdisciplinary urban research teams, Lefebvre and many other left-wing sociologists found a way not only to further

their own professional careers, but also, as we will see, to further the political aims of the French New Left.

From early on, Lefebvre held a deep interest in spatial issues, which for him was intertwined with politics.[22] His doctoral thesis, for instance, was an analysis of geographical space in the Val de Campan, written while he fought as part of the Resistance in the Pyrenees during World War II.[23] In an interview conducted in the mid 1970s, Lefebvre remarked that it was his adherence to Marxist thought that had led him to the study of urban space, and that he saw the two as deeply connected. For him, writing about urban space provoked deep reflections on a variety of social phenomena—especially class. "Others," he wrote, "take as a guideline, through the increasing in complexity of the modern world, another concept, say writing, or the subconscious, or language. I take space. . . . We will see what organizes the convergence of the largest number of problems, orientations, and maybe solutions."[24]

Lefebvre fully took up the study of urban social space in France only in the late 1950s and the early 1960s, largely because of his opposition to the work of the newly created Délégation à l'Aménagement du Territoire et à l'Action Régionale.[25] The goal of DATAR (which, paradoxically, was located in the very center of Paris) was to hasten the process of decentralization in France that had begun before World War II with Dautry and continued during the war under Vichy's Délégation Générale à l'Équipement National. DATAR officials sought to assist regional development by designating eight cities as *métropoles d'équilibre*, a concept borrowed from the human geographer Paul Vidal de la Blache.[26] Only through the development of provincial centers, it was thought, could France reach its full economic, social, and cultural potential.

One of the *métropoles d'équilibre* was the town of Mourenx, located near the Pyrenees, where Lefebvre carried out his first sociological study of housing. In Mourenx, Lefebvre claimed to have witnessed, firsthand, the effects of modern, rational urban planning produced by state-funded programs. "Whenever I set foot in Mourenx," Lefebvre once remarked, "I am filled with dread."[27] Built in the late 1950s to provide affordable housing for the industrial workers of the nearby town of Lacq, Mourenx represented for Lefebvre the loss of spontaneity, history, and beauty in the face of modern bureaucratic society. The beautiful fourteenth-century village of Navarrenx, 10 miles from Mourenx, was also a "victim of changes in

industry and agriculture, trampled on by the march of 'progress.'" Its trans-
formation into a *ville nouvelle* symbolized for Lefebvre "a thoroughly
modern boredom, one affecting heavily the youth, those without a future,
and women, who always . . . bear the brunt of an isolated and dismem-
bered everyday life."[28]

As early as 1961, Lefebvre began calling for the creation of a "new
urbanism" that would challenge technocratic planning and would place
renewed emphasis on the subjectivity of inhabitants.[29] His inspiration in
this instance was a "new city" that had been constructed in Switzerland
near Zürich. Unlike planners in France, those in Switzerland sought to
offer the inhabitants of this new town not only a framework (*cadre*) and
a decor, but also multiple ways to "accelerate the enrichment [*l'épanouissement*]
of individuals and groups in the community."[30] In short, Lefebvre wrote,
the new city's planners "offered harmony."[31] A "new urbanism" in France
should look to such approaches as a model, and should try to integrate
old-fashioned values of tradition, social relations, morality, and history into
their modernization efforts. It would focus not on the expertise of the
architect, the planner, or the government official, but on the everyday
experience of diverse "users" of urban space.

Thanks to the increasing openness of state institutions to input from
the social sciences, which can largely be attributed to Chombart's success
in the immediate postwar era, Lefebvre had an opportunity to further
theorize this "new urbanism" while working directly with the state on
evaluating urban planning programs across France. Throughout the 1960s,
he served on interdisciplinary urban research teams funded by the Déléga-
tion à l'Aménagement du Territoire et à l'Action Régionale and by
another state-run urban planning institution, the Ministère de l'Équipement
et du Logement. Created in 1966 out of two preexisting agencies, the
MEL made all decisions related to infrastructure, housing, and, in conjunc-
tion with DATAR, *l'aménagement du territoire*.[32] While the centralization
and direction of de Gaulle's urban planning initiatives might suggest that
this institution would be closed to diverse opinions, especially those of
leftist sociologists, its officials were actually especially enthusiastic about
sociological research.

In fact, the Ministère de l'Équipement et du Logement devoted an entire
division, the Service Technique Central d'Aménagement et d'Urbanisme,
to fostering a working relationship between sociologists, planners,

government officials, and specialists in other disciplines. Directed by the planner Françoise Dissard, and composed of nineteen engineers, ten architects, seven sociologists, five economists, five geographers, one lawyer, one landscape architect, one mathematician, one photo-interpreter (*photo-interprète*), and one editor for publications,[33] STCAU was created to encourage interdisciplinary studies of urban problems. "Before the complexity of problems," one MEL official stated, "it appears more necessary than ever to develop urban studies in association with specialists of multiple disciplines and qualified representatives of the population."[34] The goals of STCAU were to study urban problems, to develop new methodologies, and to aid urban planners in the concrete development of urban plans."[35]

In turn, the openness of the Délégation à l'Aménagement du Territoire et à l'Action Régionale and the Ministère de l'Équipement et du Logement to social-scientific research affected approaches to the study of the built environment at other major institutions in Paris. For instance, the directors of the École Nationale des Ponts et Chaussées in Paris, where the nation's top urban planners were trained, changed the curriculum in order to respond to the needs of the Ministère de l'Équipement et du Logement and the Service Technique Central d'Aménagement et d'Urbanisme. In particular, they recommended the creation of a new discipline, called *urbanologie*, that would bring diverse fields together in the study of urban problems. In reports issued by the École Nationale des Ponts et Chaussées, the students of this new discipline were referred to as "urbanologues," defined as "the people involved in the various human sciences: economics . . . law, sociology, demography, geography, who apply their respective disciplines to urbanism and land settlement."[36] "Urbanologues" would complete an internship at the Institut d'Urbanisme de Paris and would be prepared to work for the STCAU and related organizations.[37] The creation of the STCAU within the MEL therefore directly affected pedagogical practices at the ENPC; interest in sociological approaches at one government institution led to a response in the other.

Lefebvre used these government-funded studies to develop a spatially oriented critique of capitalism and the French state. Many of his contributions to the Service Technique Central d'Aménagement et d'Urbanisme focused on locating the focal points of decision making in a particular city so as to illuminate the lack of public participation in the planning process. The concept of "social space" was the epicenter of this political endeavor:

government-funded studies of the "social space" of various cities across France focused on the various institutions that made decisions, and called upon local inhabitants to use this knowledge for the purposes of resistance and informed participation. Lefebvre clearly delineated the connection between "social space" and the participatory planning movement when he wrote the following:

To illuminate the junction between the State and space, it is necessary that we stop misrecognizing the spatial, and, correspondingly, that we come to recognize the importance of a theory of (social) space. From this perspective, "users" movements throughout the world are allied with a science of space that can no longer be seen as external to practice. . . . The understanding of social space is the theoretical aspect of a social process that has, as its practical aspect, the "users" movement. They are the inextricable aspects of the same reality and the same potentialities. This corresponds, to a certain extent, to the situation in which Marx found himself vis-à-vis the workers' movement and its protests over work (and the workplace).[38]

Lefebvre's interest in the study of urban space became an important part of his "critique of everyday life" under capitalism.[39] Lefebvre's critique of everyday life aimed to address the rapid changes taking place during an era of modernization in France, from simple changes in daily routines to widespread feelings of alienation, isolation, and boredom as the result of the rise of consumer society. In this way, his work echoes the philosopher Martin Heidegger's notion of Alltäglichkeit (everydayness), although Lefebvre criticized Heidegger's notion as overly philosophical.[40] Lefebvre's interest in the banal or everyday can also be understood in relation to the development of the *Annales* historical school, which encouraged historians to look beyond momentous events and investigate changes on the micro level. Lefebvre saw in the study of everyday life the possibility of true social revolution through the transformation of urban social space. Urban space, for Lefebvre, provided fertile ground for political, economic, and cultural transformation, not only in theory but also in practice.

Lefebvre never cited Chombart when using the idea of "social space." Nor did he ever discuss the legacy of aerial photography to the conception of space he developed, even upon rejecting this technique. Chombart himself later remarked that he and Lefebvre had, in fact, promised to cite each other, but that in the end neither of them actually did. "We had

numerous discussions with Lefebvre," Chombart recalled in the 1990s. "In reality . . . we both continued as before."[41] In the 1960s, Chombart continued to participate in government-funded studies of the *grands ensembles*, sometimes with Lefebvre, and continually argued that the problem of the *grands ensembles* was tied to the division between centers and peripheries, i.e., the organization of urban social space.

Surprisingly, however, Chombart himself began to introduce a critique of technology into his own work, much like Lefebvre and Ledrut. At the end of a book published in 1976, for instance, Chombart discussed the ongoing "crisis" of Western civilization, and warned of two dangers: the struggle for profit under capitalism, which would increase inequality, and that of "the use of technological power, by those who possess it, to impose the models and structures of dominant groups." He criticized, in other words, not so much technology itself but how it was used. "Technology has no doubt not yet progressed far enough to meet the aspirations of individuals and groups," he wrote. "At its present stage of development, it brings undeniable material benefits but, by creating unbearable inequalities between countries and between social groups within individual countries, it reinforces the ways in which domination operates."[42]

RAYMOND LEDRUT: *L'ESPACE EN QUESTION*[43]

Lefebvre's friend and colleague Raymond Ledrut, based at the University of Toulouse-Le Mirail, was a member of the French Socialist Party who had studied at the École Normale Supérieure in Paris before moving to Toulouse during World War II. At the University of Toulouse, he created nuanced interdisciplinary groups and courses that aimed to integrate multiple academic perspectives and brought together sociologists, anthropologists, geographers, and economists. He also carried out numerous sociological studies for the Ministère de l'Équipement et du Logement and for other government planning organizations, the successes of which led to the creation of two new academic institutions devoted to this purpose, the Centre de Recherches Sociologiques and the Centre Interdisciplinaires d'Études Urbaines. Much like Chombart's Centre d'Études des Groupes Sociaux, the CIEU aimed to conduct interdisciplinary studies of urban environments for local and national governmental organizations. "The creation of the CIEU," Ledrut explained, "responds to the need to

give those in charge of these activities a point of contact and a framework, providing the ability to accept tasks collectively requiring the participation of several of them. It also responds to the necessity to offer to the entities claiming research or information a spokesman able to satisfy or direct them. Finally, it responds to the desire expressed already by numerous representatives of places outside of the university to see the organization of confrontations and exchanges."[44]

Yet, unlike Chombart, and very much in line with Lefebvre and Debord, Ledrut rejected the use of aerial photos in urban sociological research. For him, the "exterior view" (*vue extérieure*) of a city offered by the airplane was useless or, even worse, misleading; one could understand the complexity of everyday life only through ground-level exploration. In a phrase that directly counters the idea behind Auzelle's maquettoscope (that one could gain insight into the reality of urban environments on the ground by entering a model from above), Ledrut argued that "a city or a neighborhood is not a model [*maquette*] that one can see from above. . . . A neighborhood is almost never seen from a plane."[45] He did, however, utilize street-level photography. For instance, in *Images de la ville*, a work inspired by the work of the American urban planner Kevin Lynch, Ledrut showed residents of Toulouse and the neighboring town of Pau photographs of various places within the city and asked them to describe how they felt about the spaces depicted.[46] Using this combination of photography and language, Ledrut attempted to derive an "image" of everyday life in these areas.

Although Ledrut rejected the technique of aerial photography, he frequently employed the concept of social space in both his government-funded urban studies and his academic publications. "Social space" was particularly useful to Ledrut, as it was for Chombart, because it served three functions simultaneously: it opened up a new field of study, signified a new and more sociologically oriented approach to urban planning, and presented a new forum for discussing his left-wing political concerns. A literally vertical perspective, then, was transformed into a metaphorical one. The "social space" concept, engendered by the holistic view of the world offered by the airplane, now represented the distance that Ledrut, Lefebvre, and others perceived between their qualitative sociological approach and the quantitative authoritative approach of government officials and planners.

Much like Lefebvre, Ledrut's foray into social-scientific analysis of the "social space" of urban environments, which became central to his life's work, was sparked by his participation in government-sponsored studies of human habitation. Specifically, he began outlining his interest in the topic in an analysis of the *grands ensembles* of Toulouse, which he completed in the early 1960s. As we saw in the last chapter, the construction of these housing complexes was a point of much contention at the time; in response to public outcry, the Commission Urbanisme et Habitat du Comité d'Études pour l'Aménagement de la Région toulousaine, a local planning institution in Toulouse, commissionedthe Centre Interdisciplinaires d'Études Urbaines to carry out an interdisciplinary study of the situation. Participants inthis study, titled "La Vie dans les Grands Ensembles Toulousains,"[47] included sociologists and economists from the University of Toulouse, an engineer, and even a local priest.

In the report's introduction, one of the members of the research team stated that the social problems of the *grands ensembles* had become a national preoccupation: "Everybody is concerned with this new type of construction called the *grand immeuble* or the *grand ensemble*. If the *grands ensembles* do not have their own illness, there are still reasons for discontentment and difficulties that are their own."[48] The purpose of the study was to "scientifically" investigate the causes of the major ills that afflicted residents of these housing complexes in Toulouse, and then to propose solutions.

In the course of the research, Ledrut and his research group found that the problem was located not in the buildings themselves, but rather in their relationship to the center of the city. In other words, the problem was the city's "social space." "The *grand ensemble*," Ledrut wrote, "must never be judged or treated by itself." Rather, this housing form should always be evaluated "by its relationship with the city, in its multiple geographic, economic, social, cultural relationships. . . . It is the separation with respect to the city and the retrenchment of the insulated *grand ensemble* that certainly constitutes one of the most serious factors of perturbations."[49] The practical implication was that planners should address the deeper issue of spatial organization and the overall form of French cities by integrating these residential complexes into a holistic view (*vue d'ensemble*) of the city at hand.[50] Using the concept of social space, therefore, Ledrut helped to reconceptualize the problem of the *grands ensembles* as that of the modern *banlieue*.

Ledrut expanded upon this notion in two subsequent works, *L'Espace social de la ville* and *Sociologie urbaine*, both published in 1968, the year that students rioted in the streets of Paris and other French cities for their "right to the city."[51] Although an analysis of the *grands ensembles* was central to both of these works, Ledrut went much further. He now proposed that the current problems in all French cities reflected a more general crisis in French civilization: "The crisis of urbanism is . . . a real-life record, in space and in time, of the conflicts, oppositions, and contradictions of the social world. . . . The crisis of cities will end with the crisis of civilization."[52] Here Ledrut theorized, years before the publication of Lefebvre's own *Production of Space*, an attempt to go beyond specific urban problems and theorize socio-spatial relations.

In particular, Ledrut argued that the importance of the *quartier* or neighborhood in social life was disappearing, and with it not only social relations but the "collective soul" (*l'âme collective*) of French society. Whereas Griaule had argued that aerial photos revealed the spirit or "soul" of Dogon society, here Ledrut used the conception of "social space" to argue that the organization of French cities was not in line with the true "soul" of the metropole. With the increase in the number of automobiles on city streets, long commutes to work, and the appearance of American-style shopping malls, the importance of this traditional focal point of social life within French cities was diminishing rapidly. Though the *quartier* might remain a central administrative category, Ledrut explained, it was rapidly losing its sociological import.[53] The consequences of this shift went beyond any individual city, as the decline of this important sociological unit was accompanied by an overall decline in the dynamism and sociability of French cities and of French society more generally.

Ledrut contended that the sociologist's role was to intervene and try to awaken a "consciousness" within urban residents of how the spaces in which they lived and worked were shaped by government-sponsored planners, with little local input. In the midst of numerous erroneous notions of how urban environments served the needs of inhabitants, the sociologist offered government officials a more accurate view of the "reality" (*réalité*) of the "social space" of French cities. The sociologist's job was to help "users" of urban space to become conscious of this reality, so that they could find ways of transforming it. "The essential role of the sociologist," Ledrut wrote, "is to bring about an awareness in . . . urban reality . . .

and of thought-out urban planning practices. In other words, one of its functions is to lead urban society to self-consciousness."[54]

"Social space" was a crucial concept in this endeavor. For instance, a study Ledrut completed for the Ministère de l'Équipement et du Logement in 1970, titled "Analyse de l'espace social de la ville d'Albi,"[55] began with a discussion of decision making within Albi but ended with a general critique of government-sponsored planning practices. The aim of the study, according to Ledrut, was to obtain a realistic picture of the "social reality" (*réalité sociale*) of this city—that is, of hierarchies of power in urban affairs, from the mayor to local associations and individuals. This portrait of the city's "social space" would allow sociologists to determine the varying importance of different groups in "the urban mechanism of Albi."[56] "This research of the city practice," Ledrut wrote, "allowed us to draw a picture of the multiple social groups that interlace in the urban life, and that constitute the principal elements of the very complex set of social relationships."[57]

In other words, by investigating Albi's various actors, Ledrut and his research group hoped to locate opportunities for more local involvement in the planning process. What they found was that the social space of the city was organized around a few isolated nodes (*noyaux isolés*) that represented private interests rather than the needs of the collectivity as a whole. The political action of these nodes served to reinforce hierarchical relationships within the city, and thus prevented a true dialogue among local government officials, planners, and residents. Ledrut and his colleagues then recommended several strategies for overcoming this tendency, including holding discussions of future plans in which all affected parties could participate.[58] Increasing local awareness and participation was thus a crucial part of Ledrut's sociological studies of "social space."

QUALITATIVE ANALYSIS AND THE SOCIOLOGICAL STUDY OF THE BUILT ENVIRONMENT

Lefebvre and Ledrut's qualitative approach to the study of urban problems, which they promoted with the aid of the concept of "social space," played an important role in solidifying the place of sociologists within government-funded interdisciplinary urban research teams. The planner Françoise Dissard and other government officials saw sociologists as the true "experts"

of the built environment, because only they could provide a *vue d'ensemble* of the "reality" of social life in urban environments—a remedy to the *vue mutilée* of planners and architects, with their quantitative methods (aerial photography, cartography, statistics, demography). In the 1960s and the 1970s, as the vast social and psychological problems of the *grands ensembles* worsened, this was a view that government officials desperately sought.

Throughout the 1960s, sociologists were increasingly in demand at the Ministère de l'Équipement et du Logement. "At the same time as the Modernization and Equipment Programs were multiplying and that the design of the Plan d'Urbanisme was evolving," one MEL official commented, "sociology appeared more and more as an essential element to the accomplishment of urban studies and to the realization of projects."[59] The role of sociologists in urban planning was understood to be so important that the MEL and other government institutions funded research projects and conferences devoted to exploring the challenges involved in interdisciplinary collaboration. For instance, in 1965 the Ministère de la Construction awarded Raymond Ledrut and several others from the University of Toulouse funds to complete a study titled "Sociologie et Plans d'Urbanisme."[60] In the preface to the final report, Françoise Dissard argued that during the period of economic growth since the end of World War II urban planning in France had come to be directed, for the most part, by economic rather than social considerations. The time had now come, she argued, for a new type of planning that would take non-economic needs into consideration. This project required input from "experts" in the human and social sciences, especially sociologists:

If . . . urbanism must be the meeting point of human techniques and aspirations, and if our era would like to reach a new urban civilization where social relationships will have to be favored over constraints of economical profitability or a too rigid operation, it seemed desirable for the Direction de l'Aménagement Foncier et de l'Urbanisme to make room, among the studies and research that it had begun, for problems of urban sociology by calling for academic specialists of our faculties known as "Human Sciences."[61]

Dissard further justified the study in terms of the underdeveloped state of sociological theories of urban issues—despite the fact that since the 1950s sociologists had devoted themselves to the study of urban problems, and

especially those of the *grands ensembles*.[62] She thus urged sociologists to go beyond the study of *logement* and apply the methods and perspectives of their discipline to the much broader study of spatial organization.[63]

The aim of "Sociologie et plans d'urbanisme" was to promote sociologists' engagement with spatial problems by increasing contact between them and urban planners. Communication between the disciplines of urban planning and sociology, Dissard contended, was essential to developing new, sociologically oriented approaches to city management. "The door is today partially opened," the sociologist Jean-Paul Trystram wrote, expressing the optimism surrounding the potential for collaboration between sociologists and planners, "and we notice modifications both in the attitude of some and in the opinion of others. . . ."[64]

In the report, Trystram outlined the three primary contributions of sociologists to urban studies. First, urban planners only had a partial or fragmentary view (*vue mutilée*) of the city; sociologists would round out the perspective. Second, the complexity of urban problems in France at the time went beyond the confines of specific cities, and involved global trends and processes; sociologists could help place the problems of postwar French cities within a global perspective. Finally, according to Trystram, sociologists could help planners locate the specific problems of different cities in order to develop tailored plans to remedy them. In other words, sociologists were thought to be able to provide a global view of urban problems - rectifying the *vue mutilée* of planners with their (now metaphorical, not literal) *vue d'ensemble*. But they also, it was assumed, because of their qualitative research on the ground, had unique insight into local concerns.

For Trystram, as for Ledrut, the most important function for sociologists in urban planning was to help local residents become conscious of the spaces in which they lived and worked—that is, their "social space." Once aware of their "social space," residents could actively participate in the planning process:

The investigation is not an outside objective tool, it always more or less modifies the place that it touches, if only by forcing the interviewed people to answer, and that brings to the surface a lot of questions that had remained unconscious until then . . . the sociologist will act necessarily as an revealing agent, and this role shall not be underestimated.[65]

Many of these sentiments were echoed in other government-funded sociological studies completed around the same time. For instance, in an interdisciplinary report titled "Sociologie et développement urbaine," completed in 1965–1966, Dissard began by expressing yet again the commitment of the Ministère de l'Équipement et du Logement to correcting a world "devastated by technology," and the idea that sociologists were essential to this endeavor.[66] With great enthusiasm, she expressed hope that this study, completed just after the establishment of the MEL, would help create a "common language" (langage commun) for planners, sociologists, and other experts in the social and human sciences. Sociologists, Dissard explained, could help planners to correct their model of the city: "The urban planner rarely has the necessary elements available to compose and order the city. . . . The sociologist must then help him correct the model of the city and reposition the needs of the humankind in its totality before that of technology."[67] These "experts" of social life could aid planners in the decision-making process, keeping them focused on local needs rather than solely on economic considerations. Moreover, with the help of sociologists, planners could preserve the uniqueness and particularity of French cities, reversing the homogenization of urban life that appeared to be taking place all over France.[68]

The study of "social space" thus helped sociologists to gain authority within interdisciplinary government-funded research teams, and to define their role in the planning process. Unlike planners, who approached urban environments from the outside, students of "social space" focused on how the city operated on the ground, in everyday life, as well as on how decisions about space were made. Although Ledrut and others worked closely with geographers such as Pierre George and Bernard Kayser and pointed out the importance of location to understanding social trends, the study of "social space" went beyond the confines of topographical space. As both a new object of study and a novel approach to urban planning, "social space" embraced the perspectives of all disciplines involved in urban development. But it placed sociologists at the pinnacle of the entire endeavor, the goal of which was to understand the complexity of everyday life within urban environments.

This privileged position may have helped sociologists obtain funding from the government, but ultimately it presented problems for research teams that were supposed to be truly "interdisciplinary," with no one

academic field eclipsing the others. Coordinating geographers, sociologists, psychologists, economists, and planners proved extremely difficult in practice; many government-sponsored urban studies expressed both the necessity of good communication between specialists of different academic fields and the profound frustration researchers felt when this kind of communication could not be realized. Consider this passage in the introduction to a 1965 study written by Jean-Paul Trystram: "The efficiency of an interdisciplinary planning depends highly on the ability to create a dialog between specialists. Since the object of their study is the same and since the result must finally be a modification to make to this object, they must consider it together, that is, in a constant exchange of information and points of view."[69] If residents of the *grands ensembles* suffered from artificial dissections of urban space, social scientists, planners, and government officials were themselves divided over differing conceptions of space.

At the time, the goal of many of the studies funded by the Ministère de l'Équipement et du Logement and by other government institutions was to find ways of increasing communication and comprehension among these disparate groups. "Our goal in starting this," Françoise Dissard stated, "was to catch the attention of academia and to connect them to urban planners, thus creating a preamble association that seems indispensable to obtain efficient pluri-disciplinary teams. These will indeed run up against, firstly, the difficulties of an interdisciplinary dialog for which the different parties need to get used to convey through ordinary language and find methods of communication between themselves and public opinion as well."[70]

By 1968, the problem of interdisciplinary coordination had become so acute that the Ministère de l'Équipement et du Logement organized a conference devoted to exploring this issue and potential solutions to it.[71] In the preface to the conference report, Dissard expressed once again the need for a new "common language" that would help specialists from various fields work together to solve urban problems: "The importance of a clarification and a systematization of vocabulary appeared to us more and more obvious as the contacts between various disciplines were established."[72] Sociologists, Dissard explained, often complained that planners demanded too much or too little of them; either they were expected to provide the solution to all urban problems or they were simply ignored. Planners, in turn, protested the philosophical language that sociologists

often used in their reports, which made it difficult for them to utilize the social scientists' suggestions in practice. Although this was not the first time that Dissard and others from the MEL had expressed a desire to find a communal language or creole[73] for specialists working in different fields, her tone at the 1968 conference expressed complete exasperation:

The conference also brought to the surface—oh how many!—difficulties of language that were lying between disciplines and in particular when we tried to get out of the all too familiar dialogue between urban planners and sociologists in order to start the discussion with the people in charge of local bodies. The difficulties, not only of vocabulary, but even of methods of approaching subjects, proved how indispensable it was now to start an experience such as the one we attempted if we want some reality.[74]

By the end of the 1960s, the dream of interdisciplinary collaboration of the 1950s had broken down. Aerial photography no longer served as a medium common to planners and sociologists. On the contrary, sociologists such as Raymond Ledrut equated the use of aerial photos in urban planning with a technocratic and authoritarian approach that ignored the true needs of local residents. Moreover, while government officials such as Françoise Dissard emphasized their desire to work closely with sociologists and other "experts" in the human and social sciences, it remained unclear how all the groups involved would actually communicate effectively. With their street-level view of urban environments and the social problems that surrounded them, which was encapsulated in the idea of "social space," sociologists such as Ledrut and Lefebvre became critics of the entire profession of urban planning, of its effects on local populations and culture in France, and of the allegedly undemocratic nature of the planning process. In the 1970s, the analytical category of social space became the basis for a new spatially oriented social critique of capitalism.

THE "INTERNAL COLONIZATION" OF FRENCH CITIES

In the late 1960s, when Ledrut first published his reflections on urban space, Lefebvre began theorizing about urban society. The problem of habitation, Lefebvre suggested, could not be understood without reference to changes in the organization of space in French society more generally. At the center of his political analysis of urban space was the role of states,

which "attempt to homogenize, hierarchize, and to fragment social spaces."[75] Any analysis of urban planning, therefore, had to contend with the state and the capitalist modes of production it supported.

In a work titled *De L'État*, Lefebvre elaborated on this point by making specific reference to Griaule's work on Dogon society. He compared the morphological forms of habitation produced by Dogon social structures and cultural values to those produced in France by the capitalist modes of production and state dominance. In Dogon society, he wrote, "the head, limbs, male and female genital organs, and feet are represented by the grouping of huts: command huts, huts for socializing between men and women, huts for storing work tools, and so on."[76] By contrast, in Western capitalist society, with its emphasis on the abstract and the visual, spaces of human habitation and urban space more generally were disconnected from the human body. "The space of state control can also be defined as being optical and visual. The human body has disappeared into a space that is equivalent to a series of images."[77] Lefebvre used this and other examples in an effort to bring to light what he called the "internal colonization" of French cities by a domineering, centralized, and authoritarian state, of which the construction of the *grands ensembles* was a chief example.

On the one hand, "internal colonization" was intended to signify the authoritarian aspects of spatial management in Paris and other French cities, where capitalism, rather than the true needs of local users of urban space, drove the planning process. On the other hand, however, it was also intended to inspire urban residents to see urban space as a site of resistance. Urban space, in other words, was not only a place dominated or "colonized" by the state and urban planning but also the most promising domain for social and political change.

At a time when the French left was riddled with conflict, this was an especially inspiring idea. It connected Marxism to postwar French concerns, like housing, rather than blindly allying itself to Moscow. Founded in 1920, in the wake of the Bolshevik Revolution, the Parti Communiste Française had remained a relatively isolated political group until World War II, when it had gained prestige and new members throughthe Resistance effort. Its popularity peaked in 1945 and in the immediate postwar era. With the revelation of Stalin's crimes in 1956, scores of lifelong members turned away from the party and searched for new ways of expressing their

political concerns. One objection that many Marxists, including Lefebvre, had toward the PCF concerned its intransigent adherence to the Stalinist Party in Russia. This allegiance may have been due, in part, to the unavailability of many of Marx's works in French, especially his early writings.[78] The 1937 publication of Marx's *Paris Manuscripts of 1844* in French inspired a new leftist program, which came to be called the French New Left. Rather than focusing solely on class relationships, adherents of this program focused on three themes brought out in Marx's early study: alienation, objectification, and autogestion (self-management).

In 1956, Lefebvre and other French Communist intellectuals helped spearhead the French New Left by founding the journal *Arguments*, which provided a forum within which Lefebvre could criticize Stalinism and socialism while still illuminating the alienating characteristics of Western capitalist society. The journal's contributors called for a nuanced understanding of Marxism and its relevance in France. Lefebvre was particularly concerned with making abstract Marxist ideology more concrete by explaining how the three themes outlined in Marx's *Paris Manuscripts* influenced everyday life. "By expanding the analysis of alienation from the workplace to all aspects of everyday life," one historian explains, "Lefebvre brought to light arenas of oppression and dissatisfaction. . . . The transformation of everyday life became a more or less programmatic goal for the French New Left."[79]

The late 1960s were a heyday for the French New Left. The events of 1968 were inspired by its spirit and instigated by one of Lefebvre's students at Nanterre University, Daniel Cohn-Bendit. What began as a protest against the hierarchical nature of the universities spiraled into a more general workers' strike against capitalist bureaucracy and the feelings of alienation it produced. Among the protesters' slogans were "Consumer society must die a violent death," "Alienated society must die a violent death," and "We want a new and original world."[80] Guy Debord played a leading role in the student protests at the suburban university and helped to situate the hierarchical nature of the French educational system within the dual context of the growth of "consumer culture" in France and the urban problematic as articulated by Lefebvre.

If 1968 did not succeed in revolutionizing spatial relations in Paris, it did provoke a new era of theorizing (social) space. In a new journal, *Espaces et sociétés*, the first issue of which appeared in 1970, Lefebvre and Ledrut

outlined their spatially oriented left-wing program. In a report outlining the projected contributions of this new journal, Ledrut listed among the general points "Space: How to talk about it? How to represent it?"[81] The journal announced that it would publish articles exploring the process of urban planning, architecture, the "appropriation of space," and ecological issues. Ledrut anticipated articles on the "language" of the architect and ideology, representations of the city, and the varying "images" of the city formulated by inhabitants and by architects. The main goal of *Espaces et sociétés* was to provide a cross-disciplinary forum for theorizing the interrelationship between the social and the spatial, as well as the role of spatial relations in the reproduction of social relations within Western capitalist societies.

One of Lefebvre's first articles in *Espaces et Sociétés*, published in 1970, was titled "Réflexions sur la politique de l'espace."[82] In it, Lefebvre challenged the notion that "space" (rural, suburban, and urban) was neutral, and the notion that the practice of urban planning was a scientific endeavor. On the contrary, he argued, "space is political!"[83] Urban space might appear to be homogeneous and shaped by scientific management, yet it was, in fact, produced by social relations. Modern urban planning, which was tied to the French state, effectively disguised the political nature of space in order to perpetuate its practice of social control. A prime example of the political nature of space, Lefebvre argued, was the project of "decentralization" that, as we have seen, began in France at the end of World War II. In particular, Lefebvre found it contradictory that a centralized state was attempting to carry out such an ambitious project of decentralization: "How can the centralized State take responsibility for decentralization? This is a façade, a caricature."[84] The French state only appeared to support policies of decentralization; in reality, local regions and municipalities had very little power or autonomy.

Lefebvre proceeded to compare urban planning in postwar France with the process of colonization. The large-scale construction of the *grands ensembles* and new towns all over France under de Gaulle's Fifth Republic had, he asserted, resulted in the "internal colonization" of French cities. "There are no colonies in the old sense," he wrote, "but there is already a metropolitan semi-colonialism."[85] Lefebvre noted that he had first witnessed this process of internal colonization in his study of Lacq-Mourenx; his investigations of other areas of France, especially Paris and its

surrounding region, had confirmed its ubiquity. Like Ledrut, Lefebvre argued that the drastic changes occurring in cities across France were indicative of a major transformation in French society and culture. His call for a "politics of space," of which the journal *Espaces et sociétés* was to be a vehicle, was intended bring the significance of these spatial changes to light, not only for intellectuals, planners, architects, and government officials but also for the French public more generally.

In the 1970s, Lefebvre expanded upon his theoretical reflections on the politics of space in two works, *La révolution urbaine* and *La production de l'espace*.[86] In *La révolution urbaine*, Lefebvre used the terms "urban" and "urban society" to signify his theoretical approach. "The expression 'urban society,'" he wrote, "meets a theoretical need. It is more than simply a literary or pedagogical device, or even the expression of some form of acquired knowledge; it is an elaboration, a search, a conceptual formulation."[87] For Lefebvre, the project of theorizing the urban was to serve a practical function: to help promote an "urban revolution," by which he meant social revolution, by bringing to light the political practices embedded in the organization of space in French society.

La Production de l'espace (1974) explored the connection between the spatial and the social, and the role of space in social revolution, in more depth. In a chapter devoted to "social space," Lefebvre insisted that "space" was not a thing but rather "a social reality—a set of relations and forms."[88] The "social" and the "spatial" were inextricably linked, and therefore one could not discuss social relations without also analyzing spatial relations. Social relations, and especially relations of production, simultaneously produced space and were produced by it. With the concept of "social space" Lefebvre attempted to counteract the widely held notion that space was simply an empty container in which objects and people were placed; that view of space, he argued, was not only an "error" but an "ideology" promoted by those whose interests it served: the French state, urban planners, and architects.[89] On the contrary, Lefebvre contended, space was full—full of social relations, culture, and history. Any discussion of spatial form must therefore consider the effect on its content.

Just when Lefebvre was publishing his seminal works on the subject, Ledrut was putting forth his own theoretical works devoted to *L'Espace*. His most significant was *L'espace en question*, published in 1976.[90] Like Lefebvre, Ledrut began by lamenting the absence of a theoretical discourse

about "space": "We have too often been used to consider the space of the city outside of the most general and fundamental question, that of the space itself and its meaning, of its position, of its role, in the life of its people."[91] What remained to be investigated thoroughly, he argued, was "space" itself, and the relationship of urban inhabitants to the spaces in which they lived and worked. An investigation of "space" was fundamentally, Ledrut argued, an examination of social relations, and the latter should be called "into question." Contemporary cities, he explained, were dominated by capitalism and colonized by the spectacle of consumerism; as a result, they were becoming places of exclusion rather than centers of democracy. The only remedy was to return to the model of the city not as a place of consumption but as a true reflection of the "cultural personality" (*personnalité culturelle*) of the people who lived there.[92]

A few years after the publication of *L'espace en question*, Ledrut published *La Révolution cachée*, in which he returned to many of the same themes of his 1976 book but added an analysis of the organization of space in Western and non-Western societies.[93] Like Chombart and other ethnographers, Ledrut argued that spatial organization in non-Western societies was more in line with those societies' social morphology. Drawing on Marcel Mauss, he noted that there was a direct correlation between spatial organization and social organization in Eskimo society. No such correlation existed in the West, where spatial organization—and especially the construction of housing—was dominated by a technocratic logic predicated on economic rather than social needs. In contrast to non-Western societies such as Amazonia, where space was arranged according to the symbols, meanings, and ways of life of the tribe, urban space in Western society was homogeneous and organized at random, and "one can do anything anywhere."[94] Ledrut called for the creation of a new society through the creation of a new space that would be more in line with local needs and cultural values.

Here, then, our story comes full circle. Colonialism, the point where our narrative began, eventually became central to Lefebvre's urban critique in the 1960s and the 1970s. In *La révolution urbaine*, Lefebvre returned to the notion of "internal colonization" that he had referred to in his first article for *Espaces et sociétés*. Urban space had been colonized, he wrote, "through the image, through publicity, through the spectacle of objects."[95] During the Urban Revolution, according to Lefebvre, the political nature

of space would finally be uncovered: "Space reveals its true nature as . . . a political space, the site and object of various strategies."[96] Any move to transform politics and social relations in France and elsewhere, therefore, must include a corresponding emphasis on the organization of urban space. "If there is a connection between social relationships and space, between places and human groups, we must, if we are to establish cohesion, radically modify the structures of space."[97]

Lefebvre's work on the social dimensions of urban space remains the canon in numerous social-scientific fields, from urban planning, urban studies, architecture, sociology, anthropology, and geography to literary theory. Conferences at top universities have been devoted entirely to his work, and numerous books have concentrated on his writings and his biography. The enormous renewed interest in his work today can be attributed largely to the translation of *La Production de l'espace* into English in 1991; more recent translations of his most important works on the state and spatial organization will surely inspire new analyses.[1]

Yet, as this book has shown, the idea that spatial and social relations are inextricably linked did not emerge, full-blown, in Lefebvre's writings. On the contrary, this way of understanding socio-spatial relations has a rich and complex genealogy and is closely connected with various quantitative techniques of vision and representation. In other words, this notion, which was so integral to a critique of state power and colonization in numerous works by Foucault, Lefebvre, Ledrut, and many other scholars, had its origins in exactly the same techniques, institutions, and colonial past that these figures claimed so vehemently to oppose.

Recounting this story, then, places the commonplace division between "top-down" urban planning and its "bottom-up" critique into question. That dichotomy, in both theory and in practice, was clearly never as vivid as Lefebvre and others often alleged. Unlike Lefebvre and Ledrut, as we have seen, Gourou, Griaule, and other interwar social scientists had no conception of the "top-down." Their interest in everyday life did not preclude the use of aerial photography, but was bolstered by it. Only aerial photos, they often proclaimed, could make their investigation of social life on the ground more "objective" and scientific. For these figures, aerial

photos did not mask the complexity of social life on the ground. On the contrary, only with this "scientific" instrument were they able to penetrate the topographical surface and gain insight into deep social and psychological trends that existed below the surface.

Chombart himself embodied the inseparability of these two approaches. He used a top-down technique to develop a bottom-up approach that, in turn, helped to promote sociological perspectives in government and planning circles in postwar Paris. Aerial photos, for him and other "experts" working within a historical moment when faith in technology was at its height but confidence in capitalism was at its lowest point, were absolutely crucial to understanding sociological phenomena. In this sense, recovering Chombart's life and work should inspire a post-dichotomous moment in urban planning, in architecture, and in social-scientific research.

In view of the fact that Lefebvre's critique of urban space and French society emerged from within the system of state-sponsored urban planning programs, it is no wonder that his ideas have become somewhat institutionalized in France since the 1970s. They have been utilized, in particular, to analyze the "problem" of the suburb, which is considered one of the most important political issues in France today. In 1973, for instance, Minister of Public Works Olivier Guichard issued a declaration calling for an end to the construction of large-scale *grands ensembles* in order to address housing discrimination in France. In an address to the Chamber of Deputies he argued, drawing on Lefebvre's 1968 book *Le droit a la ville*, that architects and planners had a duty to ensure the "beauty" of the built environment for all French citizens. Living in comfort should not be reserved for only the wealthiest members of French society; like *egalité*, *libérté*, *fratérnité*, it should be a basic human right. Cities must be planned for humans, not for machines. "Generally," Guichard noted, "one may say that urbanism in France is impoverished, and thus impoverishing for mankind. . . . Housing blocks are strung together; blocks without beauty, alignment without life. One made them functional . . . forgetting that the beauty of the decor of everyday life is also a function that the architect must ensure."[2]

Various groups followed Guichard's lead and began arguing for more participatory urban planning in order to improve everyday life within the *grands ensembles*. For instance, in 1977, the Club Habitat et Vie Sociale, which had been formed to promote ways of increasing levels of sociability

within *grands ensembles* complexes across France, proposed the creation of athletic facilities, churches, and other amenities to provide residents with leisure activities and social outlets. Further reforms under the general policy of "la politique de la ville" followed in the 1980s, with the election of François Mitterrand and the Socialist Party. In the wake of a violent outbreak in the suburban area of Les Minguettes, outside Lyon,[3] Mitterrand proposed a series of new initiatives to target the impoverished state of peripheral areas throughout France. Two of the most important of these initiatives were the creation of the National Commission for the Social Development of Neighborhoods (Commission Nationale pour le Développement Social des Quartiers) and the implementation of Banlieues 89, a program aimed to rehabilitate the suburbs and restore not only order but also "beauty" to these areas.[4]

One might claim, remaining true to the rhetoric behind these reforms, that the creation of this commission signaled a completely new, and more positive, approach to urban policy. The chairman of this committee was a locally elected and popular public official, Hubert Dubedout, the mayor of Grenoble, rather than a technocrat appointed by the state.[5] The 1983 Dubedout Report,[6] which became one of the founding texts of French urban policy in the late twentieth century, criticized the narrow-minded approach of the Club Habitat et Vie Sociale and called for more attention to the social and economic conditions of entire neighborhoods rather than just housing complexes. It also made a strong plea for local participation, asserting that "no progress can be accomplished without a real appropriation by inhabitants of their environment."[7] In making this argument, Dubedout and his colleagues on the commission, much like Guichard ten years earlier, adopted the language of Lefebvre's book *Le droit a la ville*. In the quest for the "democraticization of the management of the city," for instance, the report stated that "there are no privileged professions, no monopoly of knowledge, no hierarchical level, no command centers. Meeting this challenge requires a mobilization of all those who want to give access to the right to the city to all those from whom it is withheld."[8] In published interviews conducted in recent years, members of Dubedout's commission indicated that the use of the phrase "right to the city," and the document as a whole, had been directly inspired by Lefebvre. Committee member Pierre Saragoussi once even remarked that "this democraticization [was] about participating in everyday life. . . . Personally,

I was, steeped in Lefebvre's ideas, Henri Lefebvre, about everyday life, about . . . all those things . . . well, I'd read, I'd devoured."[9]

In the present story, however, these and other reforms appear as simply the product of a much longer history of the application of various types of "expertise" to the construction of the suburb as an object of scientific research and social reform. The outcome of the social-scientific critique of the *grands ensembles*—which centered on the notion of "social space"— was, as the sociologist Sylvie Tissot has shown, a new set of urban reforms that focused on the so-called *quartiers sensibles*—reforms that gained momentum under the leftist government of François Mitterand in the 1980s.[10] More recently, urban policy concerning the *grands ensembles* in France and other countries has shifted to blaming architecture, rather than the organization of space, for the social problems prevalent in large housing estates, and this has resulted in the destruction of numerous units constructed in the 1950s and the 1960s. Yet the focus on spatial organization, as the Grand Paris project indicates, remains strong.

And so does the perceived need for a "holistic" perspective or *vue d'ensemble* on the world's social, environmental, and urban problems, both literally and figuratively. Long after the full development of the technique of aerial photography in World War I, techniques of observation such as aerial and satellite photography are applied in areas far removed from the realm of the urban. Remote sensing, for instance, has become increasingly important to climate science; environmental scientists use satellite technology to document, analyze, and publicize the various impacts of climate change, from desertification to flooding, which in turn shapes public policy. In addition, in the wake of numerous environmental catastrophes over the last few decades, the notion that ecological systems all over the world are interconnected, and that our activities and behavior in one location can profoundly affect those living in other parts of the world, has never been more relevant.

There has, perhaps, never been a better time to resurrect the need for a global view of the effects of consumer capitalism on social, environmental, and urban developments. Though this seems to be a twenty-first-century concern, Chombart expressed a similar sentiment back in the mid 1970s, in a work dedicated to reflecting upon social and environmental transformation on a global scale.[11] Appearing closer to Marxism than social Catholicism than ever before, Chombart argued in this article that social

injustice was no longer limited to the struggle between classes; inequality was located in geographical regions across the entire world. Revising his earlier faith in the use of technology for humanistic purposes, Chombart suggested that technology contributed to the worldwide condition of social and economic disequilibrium by bolstering rich nations and holding poorer ones back. Nevertheless, he held onto the metaphorical value of aerial vision, which reminded us of the need for a view of the whole. What was needed, he contended, was recognition of the *global* consequences of capitalism. "It is necessary," Chombart remarked, "to have a *vue d'ensemble* of the world situation."[12]

INTRODUCTION

1. Paul-Henry Chombart de Lauwe et al., *La Découverte aérienne du monde* (Horizons de France, 1948).

2. Marcel Griaule, "L'Homme et le milieu naturel," in *La Découverte aérienne du monde*, ed. Paul-Henry Chombart de Lauwe (Horizons de France, 1948), p. 177.

3. This notion might be compared to the notion of "habitus" developed by the French philosopher Pierre Bourdieu. See Bourdieu, *Outline of a Theory of Practice*, tr. Richard Nice (Cambridge University Press, 1977). For more on the social-scientific study of "everyday life," see Ben Highmore, *Everyday Life and Cultural Theory: An Introduction* (Routledge, 2002); Ben Highmore, ed., *The Everyday Life Reader* (Routledge, 2002); Darrow Schecter, "The Revolt against Conformism and the Critique of Everyday Life: From Surrealism and Situationism to 1968 and Beyond," in Schecter, *The History of the Left from Marx to the Present: Theoretical Perspectives* (Continuum, 2007).

4. Henri Lefebvre, *The Production of Space* (Blackwell, 1991).

5. Henri Lefebvre, "L'Espace et l'état," quoted in Henri Lefebvre, *State, Space, World: Selected Essays*, ed. Neil Brenner and Stuart Elden (University of Minnesota Press, 2009), pp. 226–227. See also Lefebvre, *The Production of Space* (Blackwell, 1991); Michel de Certeau, *The Practice of Everyday Life*, tr. Steven Rendall (University of California Press, 1984); Edward Soja, "The Socio-Spatial Dialectic," *Annals of the Association of American Geographers* 70, no. 2 (1980): 207–225; Anthony Giddens, *A Contemporary Critique of Historical Materialism* (Macmillan, 1981); and numerous works by the social geographer David Harvey, especially *Consciousness and the Urban Experience: Studies in the History and Theory of Capitalist Urbanization* (Johns Hopkins University Press, 1985).

6. Lefebvre, *State, Space, World*, p. 228.

7. Ibid.

8. Ibid.

9. Lefebvre, *The Production of Space*, p. 286, emphasis added.

10. Antoine Picon, "Nineteenth-Century Urban Cartography and the Scientific Ideal: The Case of Paris," *Osiris* 18 (2003): 135–149.

11. See Sylvie Tissot, *L'État et les quartiers. Genèse d'une catégorie de l'action publique* (Seuil, 2007). I thank Sylvie Tissot for numerous insightful discussions on this matter.

CHAPTER I

1. Arthur Batut, *La Photographie aérienne par cerf-volant* (Gauthier-Villars, 1890).

2. Albert Garcia Espuche, *Cities: From the Balloon to the Satellite*, exposition at Centra de Cultura Contemporània de Barcelona, February–May 1994 (Electa, 1994), p. 25. See also Robert Wohl, *The Spectacle of Flight: Aviation and the Western Imagination, 1920–1950* (Yale University Press, 2005); Jean-Louis Cohen, *Above Paris: The Aerial Survey of Roger Henrard* (Princeton University Press, 2006); Antoine Picon, "Nineteenth-Century Urban Cartography and the Scientific Ideal: The Case of Paris," *Osiris* 18 (2003): 135–149; Rupert Martin, ed., *The View from Above: 125 Years of Aerial Photography* (Photographer's Gallery, 1983); Beaumont Newhall, *Airborne Camera: The World from the Air and Outer Space* (Hastings House, 1969); Alex Maclean, *Designs on the Land: Exploring America from the Air* (Thames & Hudson, 2003).

3. Denis Cosgrove and William L. Fox, *Photography and Flight* (Reaktion Books, 2010), p. 23.

4. Ibid., pp. 23–24.

5. G. Béthuys, *Les Aérostiers militaires* (H. Lecène et H. Oudin, 1889), p. 8.

6. Captain Eugène Pépin, "Lecture on the Study and Interpretation of Aerial Photographs," quoted in Colonel Terrence J. Finnegan, *Shooting the Front: Allied Aerial Reconnaissance and Photographic Interpretation on the Western Front* (Government Printing Office, 2006), p. 448.

7. Charles Christianne et al., *Histoire de l'aviation militaire française* (Charles-Lavauzelle, 1980), p. 83.

8. Alain Dégardin, "Un Observateur de la guerre 1914–1918: Eugène Pépin," in *Vues d'en haut. La Photographie aérienne pendant la guerre de 1914–1918*, exposition du 20 octobre 1988 au 31 janvier 1989, Hôtel nationale des invalides (Musée de l'armée; Nanterre: BDIC-Musée d'histoire contemporaine, 1988), pp. 17–24.

9. Peter Sloterdijk, *Terror From the Air* (MIT Press, 2009), p. 14.

10. Christianne and Lissarrague, *Histoire de l'aviation française*, p. 59.

11. Ibid., pp. 197–198.

12. Finnegan, *Shooting the Front*, pp. 194, 197.

13. André-H. Carlier, *La Photographie aérienne pendant la guerre* (Delagrave, 1921), p. 138.

14. Ibid., p. 139.

15. P.O. Le Chef d'État-Major, "Note sur l'utilisation de la photographie aérienne," 20 septembre 1916. Reproduced in Carlier, *La Photographie aérienne pendant la guerre*, pp. 102–104.

16. "Explication, traduction (par une représentation graphique), et commentaire critique," in Carlier, *La Photographie aérienne pendant la guerre*, p. 128.

17. Ibid.

18. Finnegan, *Shooting the Front*, p. 183.

19. Carlier, *La Photographie aérienne pendant la guerre*, pp. 59–60.

20. "L'interpréteur tactique devra éviter de disperser son attention dans l'étude des détails . . . Il tâchera d'obtenir une impression d'ensemble." Carlier, *La Photographie aérienne pendant la guerre*, p. 5.

21. "L'image exacte du terrain." Carlier, *La Photographie aérienne pendant la guerre*, p. 198.

22. Carlier, *La Photographie aérienne pendant la guerre*, p. 132.

23. Ibid., p. 131.

24. Ibid.

25. Ibid., p. 5.

26. Joseph Corn, *The Winged Gospel: America's Romance with Aviation, 1900–1950* (Oxford University Press, 1983), p. 12.

27. Ibid.

28. Rupert Martin, "A New Perspective," in *The View from Above: 125 Years of Aerial Photography* (Photographer's Gallery, 1983), pp. 19–23.

29. Ibid.

30. Laszlo Moholy-Nagy, *Painting, Photography, Film* (Lund Humphries, 1969), 61, quoted in Rupert Martin, "A New Perspective," in *The View from Above: 125 Years of Aerial Photography* (Photographer's Gallery, 1983), p. 21.

31. Ibid.

32. Corn, *The Winged Gospel*, pp. 17, 23, 73.

33. For more on the humanistic dimension of Nadar's work, see Stephen Bann, "When I Was a Photographer: Nadar and History," *History and Theory* 48 (December 2009): 95–111.

34. Wohl, *The Spectacle of Flight*, p. 49.

35. James Scott, *Seeing Like A State: How Certain Schemes to Improve the Human Condition Have Failed* (Yale University Press, 1998), p. 89.

36. Cosgrove and Fox, *Photography and Flight*, p. 17.

37. Cosgrove has argued, for instance, that the illusion of spatial control made possible by this process of abstraction helped to engender a new way of thinking about the natural world. Viewing the landscape from afar, humans imagined the world as capable of being fragmented, parceled up, and ultimately sold for monetary profit. See Denis Cosgrove, *Social Formation and Symbolic Landscape* (University of Wisconsin Press, 1984).

38. Picon, "Nineteenth-Century Urban Cartography and the Scientific Ideal: The Case of Paris," p. 136.

39. Ibid., p. 7.

CHAPTER 2

1. See Gavin Bowd and Daniel Clayton, "Tropicality, Orientalism, and French Colonialism in Indochina: The Work of Pierre Gourou, 1927-1982." *French Historical Studies* 28, no. 2 (2005): 297-327.

2. Pierre Gourou, *The Peasants of the Tonkin Delta: A Study in Human Geography*, tr. by Richard R. Miller. (Human Relations Area Files, 1955). Originally published as *Les Paysans du delta tonkinois. Étude de geographie humaine* (Éditions d'art et d'histoire, 1936), p. 237.

3. Ibid.

4. Of course "capitalism" is not monolithic. I am referring here to the particular brand of capitalism that was in evidence in the 1930s, which was largely characterized by a lack of government regulation.

5. Paul Vidal de la Blache, *Tableau de la Géographie de la France* (Hachette, 1911), p. 4.

6. Ibid., p. 1.

7. Lorraine Daston and Peter Galison, *Objectivity* (Zone Books, 2007).

8. Emmanuel de Martonne, *Traité de géographie physique*, volume 1: Notions générales, climat-hydrographie (Colin, 1927), p. 22.

9. Emmanuel de Martonne, "Jean Brunhes," *Annales de géographie* 39, no. 221 (1930): 549–553, p. 549.

10. See Paula Amad, *Counter-Archive: Film, the Everyday, and Albert Kahn's Archives de la Planète* (Columbia University Press, 2010).

11. Mariel Jean-Brunhes Delamarre et al., *Jean Brunhes autour du monde: Regards d'un géographe, regards de la géographie* (Musée Albert Kahn, 1993), p. 91.

12. Ibid., p. 92.

13. In *Counter-Archive*, Amad has focused on the influence of Bergson on this project.

14. Brunhes, *Leçons de Géographie: Cours Moyen* (Maison A. Mame, 1926), p. 1.

15. Ibid., p. 4.

16. Bowd and Clayton, "Tropicality, Orientalism, and French Colonialism in Indochina: Reflections on Pierre Gourou's *Les Paysans du delta tonkinois*, 1936," p. 148.

17. Pierre Gourou, *Terres de bonne espérance. Le monde tropical* (Plon, 1982), p. 14, quoted in Gavin Bowd and Daniel Clayton, "Tropicality, Orientalism, and French Colonialism in Indochina: The Work of Pierre Gourou, 1927–1982," *French Historical Studies* 28, no. 2 (2005): 297–329, p. 303. Bowd and Clayton note that Nazi officials confiscated Gourou's papers in Brussels in 1941, and therefore very little is known about his actual experience during World War I.

18. Bowd and Clayton, "Fieldwork and Tropicality in French Indochina: Reflections on Pierre Gourou's *Les Paysans du delta tonkinois,* 1936," p. 150.

19. Gourou, *Les Paysans du delta tonkinois.*

20. Ibid., p. 237.

21. Ibid., pp. 237–238.

22. Ibid.

23. Pierre Gourou, "Le Tonkin," Exposition colonial internationale, Paris 1931 (Protat frères, 1931), pp. 5–6.

24. Gourou, *Les Paysans du delta tonkinois*, pp. 14–15.

25. Ibid., p. 662.

26. Ibid., p. 225.

27. Carole Fink, *Marc Bloch: A Life in History* (Cambridge University Press, 1989), p. 69.

28. Ibid., p. 125.

29. Marc Bloch, *French Rural History: An Essay on Its Basic Characteristics*, tr. Janet Sondheimer (University of California Press, 1966), p. 45. Originally published as *Les Caractères originaux de l'histoire rurale française* (Harvard University Press, 1931).

30. Ibid., p. 45.

31. Albert Demangeon, *La Plaine picardie* (Colin, 1905) and Jules Sion, *Les Paysans de la Normandie orientale* (Colin, 1909).

32. Susan W. Friedman, *Marc Bloch, Sociology, and Geography* (Cambridge University Press, 1996), p. 146.

33. Ibid., p. 144.

34. Marc Bloch, "Plans Parcellaires," *Annales* 1 (1929): 60–70, pp. 60–61.

35. Marc Bloch, "Une nouvelle image de nos terroirs: la mise à jour du cadastre," *Annales* 7, no. 32 (1935): 156–159, p. 158.

36. Cecil E. Curwen, *Air-Photography and Economic History: The Evolution of the Corn Field* (Economic History Society, no date but probably 1927–1929). Marc Bloch, "Les Plans Parcellaires: L'Avion au Service de l'Histoire Agraire," *Annales* 2 (1930): 557–558.

37. Ibid., p. 557.

38. Ibid., pp. 557–558.

39. For more on the history of anthropology, see, for instance, Claude Blanckaert, ed., *Les Politiques de l'anthropologie: Discours et practiques en France (1860–1940)* (L'Harmattan, 2001); George Stocking, *The Ethnographer's Magic and Other Essays in the History of Anthropology* (University of Wisconsin Press, 1992). For an overview of aerial photography in anthropological fieldwork, see Evon Vogt, ed., *Aerial Photography in Anthropological Fieldwork* (Harvard University Press, 1974).

40. For a detailed analysis of this trend in anthropology, see Marion Segaud, *Anthropologie de l'espace. Habiter, Fonder, Distribuer, Transformer* (Colin, 2008).

41. Marcel Mauss (with the assistance of Henri Beuchat), "Essai sur les variations saisonnières des sociétés eskimos. Étude de morphologie sociale," *L'Année sociologique* 9 (1904–1905): 39–102.

42. Marcel Griaule, "Cinq Missions Ethnographiques en Afrique Tropicale," *Académie des Sciences Coloniales*, Compte rendu des séances des 3 et 17 décembre 1943: 680–692, p. 684.

43. Griaule often stated that he distrusted information obtained from local informants, and therefore resorted to military techniques, such as teamwork and aerial photography, to verify information given to him by local collaborators. See James Clifford, *The Predicament of Culture: Twentieth-Century Ethnography, Literature, and Art* (Harvard University Press, 1988).

44. Marcel Griaule, *Méthode de l'ethnographie* (Presses Universitaires de France, 1957), pp. 91–92.

45. Claude Blanckaert, ed., *Les Politiques de l'anthropologie: Discours et practiques en France, 1870–1940* (L'Harmattan, 2001), p. 9.

46. Marcel Griaule, "Rapport sur la Mission Sahara-Cameroun, 1936–37," *La Géographie* 68, no. 3 (March 1937): 166–67, p. 166.

47. Musée de l'Homme, *Les Collections du Tchad. Guide pour leur exposition*. Unpublished catalogue, Bibliothèque du Musée de l'Homme (Paris), 1937.

48. Jean-Paul Lebeuf, "La Mission Sahara-Cameroun," *Actes de la Société de Géographie* 69 (January–June 1938): 225–230, p. 225.

49. The Dogon are currently located in Mali, a republic founded in 1959.

50. Marcel Griaule, "Blasons totémiques des Dogon," *Journal de la Société des Africanistes* 7 (1937): 69–79, p. 71.

51. This research was published in *Les Saô légendaires* (Gallimard, 1943).

52. Élisabeth Pradoura, "Entretien avec Paul-Henri Chombart de Lauwe," 21 janvier 1986 (http://www.histcnrs.fr/).

53. Élisabeth Pradoura, "Entretien avec Paul-Henri Chombart de Lauwe," 21 janvier 1986 (http://www.histcnrs.fr/).

54. Paul-Henry Chombart de Lauwe, "Chez les Fali. Mission ethnographique Griaule-Sahara-Cameroon," *La géographie* 68, no. 2–3 (August–September 1937): 97–104, p. 98.

55. Ibid., pp. 103–104.

56. Ibid., p. 100.

57. J. Deboudaud and P.-H. Chombart de Lauwe, "Carte schématique des populations du Cameroun," *Journal de la société des africanistes* 9 (1939): 197–204.

58. Ibid., p. 197.

59. Paul-Henry Chombart de Lauwe, "Chez les Fali. Mission ethnographique Griaule-Sahara-Cameroon," *La géographie* 68, no. 2–3 (1937): 97–104, p. 99.

60. Paul-Henry Chombart de Lauwe, *Chronique d'un pilote ordinaire* (Félin, 2007), p. 23.

61. Tyler Stovall, *The Rise of the Paris Red Belt* (University of California Press, 1990), p. 36.

62. Colin Jones, *Paris: Biography of a City* (Allen Lane, 2004), pp. 408–409.

63. Georges Lacombe, *La Zone. Au pays des chiffoniers*. La Société des films Charles Dullin (silent, black and white, 28 minutes), 1928.

64. Marc Desportes and Antoine Picon, *De L'Espace au Territoire: L'Aménagement en France XVIe–XXe Siècles* (Presses de l'école nationale des ponts et chaussées, 1997), p. 134.

65. The Cornudet Law of 1919 required all large cities (of over 10,000 inhabitants) across France to develop urban plans. The Sarraut and Loucher Laws of 1928 introduced building regulations and government support for mortgages.

66. Desportes and Picon 1997, p. 120.

67. Jones 2004, p. 405.

68. Pieter Uyttenhove, *Marcel Lods: Action, architecture, histoire* (Verdier, 2009), p. 163.

69. Ibid., p. 151.

70. Ibid.

71. Marcel Lods, "La Crasse de Paris, ou les hommes enfumés," *L'Architecture d'Aujourd'hui* 9, no. 6 (1938): 82–89.

72. Pieter Uyttenhove, "L'Oeil discusif: Pour le constat, l'analyse et la critique, ou pour l'exemple, la petite boîte noire obéissait au doigt comme à l'oeil de Marcel Lods," *L'Architecture d'aujourd'hui* 277 (October 1991): 72–74, p. 73.

73. Nicole Toutcheff, "L'Objectif Lods," in Marcel Lods, *Marcel Lods, 1891–1978. Photographies d'architect* (Centre Georges Pompidou, 1991), p. 2.

74. F. Gutheim and J. McAndrew, "Houses and Housing," in *Art in Our Time: An Exhibition to Celebrate the Tenth Anniversary of the Museum of Modern Art and the Opening of Its Building, Held at the Time of the New York World's Fair*, exhibition catalog (Museum of Modern Art, 1939): 288–331, p. 323. Quoted in Uyttenhove 2009, p. 18, emphasis added.

75. Desportes and Picon 1997, p. 121 and 170.

76. Le Corbusier, *The Athens Charter*, tr. Anthony Eardley (Grossman, 1973; originally published as *La Charte d'athènes*, (Plon, 1943). Of course, as Eric Mumford, Giorgio Ciucci, and many others have noted, the CIAM and Le Corbusier should not be equated with a single and unproblematic notion of a "Modern Movement" in architecture, the idea of which may have been created only after-the-fact. See Eric Mumford, *The CIAM Discourse on Urbanism, 1928–1960* (MIT Press, 2000) and Giorgio Ciucci, "The Invention of the Modern Movement," in *Oppositions* 24 (1981): 69–91.

77. Pieter Uyttenhove, "The Failure of Modernism: Illusions and Desillusions of Marcel Lods," in *Tra guerre e pace: Società, cultura e architettura nel secondo dopoguerra*, ed. Patrizia Bonifazio (Franco Angeli, 1998), pp. 231–241.

78. Anthony Sutcliffe, "A Vision of Utopia: Optimistic Foundations of Le Corbusier's *Doctrine d'urbanisme*," in *The Open Hand: Essays on Le Corbusier*, ed. Russell Walden (MIT Press, 1977): 217–242, p. 219. For a general overview of Le Corbusier, see Kenneth Frampton, *Le Corbusier: Architect of the Twentieth Century* (Abrams, 2002); Mary McLeod, Urbanism and Utopia: Le Corbusier from Regional Syndicalism to Vichy, Ph.D. dissertation, Princeton University, 1985; Mary McLeod, "'Architecture or Revolution': Taylorism, Technocracy, and Social Change," *Art Journal* 43, no. 2 (1983): 132–147; Mary McLeod, "Le Corbusier and Algiers," *Oppositions*, no. 19–20 (1980): 55–80.

79. James Scott, *Seeing Like A State How Certain Schemes to Improve the Human Condition Have Failed* (Yale University Press, 1998), p. 115.

80. Sutcliffe, "A Vision of Utopia," p. 220.

81. Robert Hughes, *The Shock of the New* (Knopf, 1981).

82. Le Corbusier, *Precisions on the Present State of Architecture and City Planning*, tr. Edith Schrieber Aujame (MIT Press, 1991).

83. Ibid., p. 5.

84. McLeod, "Le Corbusier and Algiers," p. 56.

85. Ibid., p. 59.

86. Le Corbusier, *Poésie sur Alger* (Falaize, 1942), p. 11.

87. "This would be for a series of books to which we have tentatively given the general title of 'The New Vision.' We propose that each book in the series should be devoted to one characteristic section of contemporary design in industry, dealing with the new forms that have been created as the result of the efforts of engineer, architect, designer, and technician. We should, for example, devote one such book to aeroplanes, another to locomotives and so on, and we thought of beginning with a book on the aeroplane." Unpublished letter from The Studio, Ltd. in London to Le Corbusier, January 16, 1935. Le Corbusier Foundation Archives (Paris), B3-14-1.

88. Unpublished letter from Le Corbusier to The Studio, Ltd., 22 January 1935. Le Corbusier Foundation Archives (Paris), B3-13-3.

89. Le Corbusier, *Aircraft* (Studio Publications, 1935).

90. Ibid., p. 11.

91. Ibid., p. 13.

92. "Circle over London, Berlin, New York, or Chicago in an airplane. . . . What is the shape of the city and how does it define itself? As the eye stretches toward the hazy periphery one can pick out no definite shape, except that formed by nature: a banked river or a lakefront: one beholds rather a shapeless mass, here bulging or ridged with buildings, there broken by a patch of green or the separate geometric shapes of a gas tank or a series of freight sheds. The growth of a great city is amoeboid: failing to divide its social chromosomes and split up into new cells, the big city continues to grow by breaking through the edges and accepting its sprawl and shapelessness as an inevitable by-product of its physical immensity." Lewis Mumford, *The Culture of Cities* (Harcourt Brace Jovanovich, 1970), pp. 233–234.

93. Jean-Louis Cohen, "Henri Prost and Casablanca: The Art of Making Successful Cities," *New City* (fall 1996): 106–121, p. 188.

94. Gwendolyn Wright, "Tradition in the Service of Modernity: Architecture and Urbanism in French Colonial Policy, 1900–1930," *Journal of Modern History* 59, no. 2 (1987): 291–316, p. 295.

95. Cohen, "Henri Prost and Casablanca: The Art of Making Successful Cities," p. 115.

96. Ibid.

97. Rosemary Wakeman, "Nostalgic Modernism and the Invention of Paris in the Twentieth Century," *French Historical Studies* 27, no. 1 (2004): 115–144, p. 125.

98. Ibid.

99. J. Marrast and André Vois, *L'Oeuvre de Henri Prost* (Académie d'Architecture, 1960), p. 153.

100. Ibid., p. 158.

101. François Laisney, "Réglementer la banlieue? L'exemple du Plan Prost," *Cahiers de la recherche architecturale* 38/29 (1996): 117–130, p. 120.

102. For more on the role of the airplane in the migration of theories from ecology to zoology, botany, and sociology, see Peder Anker, *Imperial Ecology: Environmental Order in the British Empire, 1895–1945* (MIT Press, 2001).

CHAPTER 3

1. Hereafter, Uriage.

2. Paul-Henry Chombart de Lauwe, "A la recherche de la terre de France," *Jeunesse . . . France!* June 8, 1940, pp. 10–11, p. 10.

3. Maxime Weygaud, speech delivered in Lille on June 5, 1939. Quoted in Saul K. Padover, "France in Defeat: Causes and Consequences," *World Politics* 2, no. 3 (April 1950): 305–337, p. 307.

4. Quoted in Jeremy D. Popkin, *A History of Modern France* (Prentice-Hall, 2001), p. 232.

5. Marc Bloch, *Strange Defeat: A Statement of Evidence Written in 1940*, tr. Gerard Hopkins (Octagon Books, 1968).

6. Quoted in Marc Desportes and Antoine Picon, *De l'Espace au territoire. L'Aménagement en France, XVIe-XXe siècles* (Presses de l'École National des Ponts et Chaussées, 1997), p. 124.

7. Ian Ousby, *Occupation. The Ordeal of France, 1940–1944* (Pimlico, 1999), p. 93.

8. As John Hellman and others have pointed out, these youth camps were based on the model of the Hitlerjugend. See John Hellman, *The Knight-Monks of Vichy France. Uriage, 1940–1945* (McGill University Press, 1993). For more on Chombart's work at Uriage, see W. Brian Newsome, *French Urban Planning 1940– 1968: The Construction and Deconstruction of an Authoritarian System* (Peter Lang, 2009).

9. "Projet de présentation de l'École Nationale des Cadres," Archives Départementales de l'Isère, 102 J 157, p. 2.

10. Ibid., p. 3.

11. Ibid.

12. Paul-Henry Chombart de Lauwe, "Les Zones et L'Unité Française," *Jeunesse . . . France!* 29 (March 1942): 49–52, p. 51.

13. Paul-Henry Chombart de Lauwe, "A Propos de l'apprentissage intellectuel," *Jeunesse . . . France!* May 22, 1941: 2.

14. Report titled "L'École Nationale des Cadres de la Jeunesse: Uriage," Archives Départementales de l'Isère, 102 J 157, p. 4.

15. Pierre Deffontaines, *Le Petit guide du voyageur actif* (Labourrer, 1938).

16. Paul-Henry Chombart de Lauwe, "A la recherche de la terre de France," *Jeunesse . . . France!* June 8, 1941): 10–11, 10.

17. Ibid.

18. Ibid.

19. Letter from Joffe Dumazidier to Monsieur Le Veugle, May 9, 1942. Archives Départementales de l'Isère, 102 J 159.

20. "Promenade Deffontaines," September 7, 1941. Archives Départementales de l'Isère, 102 J 103.

21. Ibid., p. 4.

22. H. Bouchet et J. Fauvel, *Fiche-Plans pour enquêtes régionales. I. La Vie d'un village* (1941). Archives Départementales de l'Isère, 102 J 102. Emphasis added.

23. Paul Delouvrier, "Uriage: L'École Nationale des Cadres de la Jeunesse," *Gazette de l'Inspection* 7 (October 1941): 11–14, p. 12.

24. Ibid., pp. 12–14.

25. See Isabelle Couzon, "La Place de la ville dans le discours des aménageurs du début des années 1920 à la fin des années 1960," *Cybergeo* 37 (November 1997): 1–30, p. 8.

26. Danièle Voldman, *La Reconstruction des villes françaises de 1940 à 1954. Histoire d'une politique* (L'Harmattan, 1997), p. 59.

27. Jean-François Gravier, *Régions et Nation* (Presses Universitaires de France, 1942), 3–4, p. 7.

28. Alfred Sauvy, *Richesse et population. Avec 38 graphiques* (Payot, 1943), p. 86.

29. Ibid., pp. 301–303.

30. *Rapports et travaux sur la décongestion des centers industriels* (Délégation Générale à l'Équipement National, 1944), p. 3. Hereafter cited as *Rapports.*

31. It is interesting to note that, like the ethnographers discussed in chapter 1, J. Weulersse carried out his fieldwork in Africa in the 1930s. His first book was titled *L'Afrique noire. Vue d'ensemble sur le Continent Africain* (Fayard, 1934). Griaule's name is not in the index.

32. *Rapports.*

33. "Bien que proche de la géographie, elle s'en distingue car elle est de l'ordre de la practique." Marie-Claire Robic, "Des Vertus de la Chaire à la Tentation de l'Action," *La Géographie Française à l'Époque Classique (1918–1968)* (L'Harmattan, 1996), p. 48.

34. As Rouge explained, "Organiser l'espace, c'est lui donner la meilleure fin possible en fonction de l'homme, en fonction aussi bien de ses besoins spirituels ou esthétiques que ses besoins matériels, c'est en trouver, au profit de l'homme, la meilleure utilisation possible." Maurice-François Rouge, *La Géonomie, ou, l'organization de l'espace* (Librairie générale de droit et de jurisprudence, 1947).

35. "Le problème de la localisation se lie à tous les autres problèmes généraux concernant l'importance et la structure de l'industrie d'une part, et l'état social des travailleurs industriels d'autre part." *Rapports*, p. 6.

36. Ibid., p. 17.

37. Ibid., p. 20.

38. Ibid., p. 19.

39. Ibid., p. 34.

40. Ibid., p. 51.

41. Voldman, *La Reconstruction des villes françaises de 1940 à 1954*, p. 110.

42. It is important to note, as the architectural historian Ciucci has pointed out, that the CIAM did not have the defined form that many writers after-the-fact would have us believe. In fact, according to Ciucci, the notion of the CIAM as a defined group developed largely in the postwar period with the formation of the opposition group Team X.

43. Rémi Baudouï, "Raoul Dautry: La Conscience du Social," *Vingtième siècle. Revue d' histoire* 15 (July–September 1987): 45–58, 45. See also Rémi Baudouï, *Raoul Dautry 1880–1951: Le Technocrat de la République* (Balland, 1992).

44. Eugène Claudius-Petit, *Pour un plan national d'aménagement du territoire. Communication du ministère de la reconstruction et de l'urbanisme au conseil des ministres*, February 1950, p. 3.

45. Ibid., p. 27.

46. Jean-François Gravier, *Paris et le désert français: décentralization, équipement, population* (Portulan, 1947).

47. Benoît Pouvreau, "La Politique d'aménagement du territoire d'Eugène Claudius-Petit," *Vingtième Siècle, Revue d'Histoire* 79 (July–September 2003): 43–52.

48. Antoine Picon, "Nineteenth-Century Urban Cartography and the Scientific Ideal: The Case of Paris," *Osiris* 18, Science and the City (2003): 135–149. See also Paul Rabinow, "Middling Modernism: The Socio-Technical Environment," in *French Modern: Norms and Forms of the Social Environment* (MIT Press, 1989), pp. 320-359.

49. Desportes and Picon, *De l'Espace au territoire,* pp. 11, 13.

50. B. Dubuisson, "La photographie aérienne au service de l'Urbanisme," *Urbanisme* 1–2 (1952): 44–47, p. 47. See also Danièle Voldman, *La Reconstruction des villes françaises de 1940 à 1954.*

51. From 1945 to 1951, the MRU took 13,140 images at a scale of 1/1,500, 46,316 images at 1/5,000, and 1,754 images at 1/10,000. Dubuisson, "La photographie aérienne au service de l'Urbanisme," p. 47.

52. Ministère de la Reconstruction et de l'Urbanisme, Direction de l'Amenagement du Territoire, Groupes Techniques Topographiques, "Communication du Ministere de la Reconstruction et de l'Urbanisme Francais sur ses procedes nouveaux d'exploitation des photographies aeriennes dans l'etablissement des plans aux grandes echelles de l'Amenagement du Territoire," VII Congres Internationale de Photogrammatrie, Washington 1952. CAC 19770690/1.

53. Burger, *Photographies aériennes et aménagement du territoire*, p. 20.

54. "La matière urbaine en autant d'éléments que l'on désire et de sélectionner les renseignements pour mieux les mettre en valeur." A. Burger, *Photographies aériennes et aménagement du territoire* (Dunod, 1957), p. 20.

55. Eugène Claudius-Petit, *Pour un plan national d'aménagement du territoire*, pp. 7, 9.

56. Paul-Henry Chombart de Lauwe, *Photographies aériennes: méthode, procédés, interprétation. L'Etude de l'homme sur la terre* (Colin, 1951).

57. Robert Auzelle, "Principes et méthodes d'aménagement du territoire," Exposé au Centre des Intellectuels Catholiques, April 6, 1954, 4. IFA archives, RA36.

58. Max Sorre, *Les Fondements de la géographie humaine*, volume III: *L'Habitat. Conclusion générale* (Colin, 1952).

59. Pierre Bigot, "L'architecture et l'urbanisme au Congrès national de l'aviation française," *Techniques et architecture* (1945): 157–159, p. 159.

60. Ibid., p. 158.

61. Marcel Griaule, "La géographie au Congrès national de l'aviation française de 1946," *Annales de Géographie* 301 (January–March 1947): 55–58, p. 57.

62. Ibid., p. 57.

63. Claude Lévi-Strauss, *Tristes Tropiques* (Plon, 1955).

64. Claude Lévi-Strauss, "Social Structure," in *Anthropology Today: Selections*, ed. Sol Tax (University of Chicago Press, 1962), p. 331.

65. For more on the history of the École Nationale des Ponts et Chaussees and its national significance, see Antoine Picon, *L'Invention de l'ingénieur moderne: L'École nationale des ponts et chaussées, 1747–1851* (Presses de l'École nationale des ponts et chaussées, 1992); *French Architects and Engineers in the Age of Enlightenment*, tr. Martin Thom (Cambridge University Press, 1992).

66. "Institut Géographie Nationale, *Collection de Stéréogrammes pour l'entraînement à l'identification des détails sur les photographies aériennes à axe vertical* (1947), p. 1.

67. René Danger, *Cours d'Urbanisme* (Eyrolles, 1947), pp. 22–23.

68. Chombart de Lauwe, ed., *La Découverte aérienne du monde.*

69. Ibid., p. 14.

70. Ibid., p. 31.

71. Ibid., pp. 32, 101.

72. Ibid., p. 408.

73. Ibid., pp. 409, 411. Emmanuel de Martonne echoed Morazé's philosophical statement in his 1948 aerial photography manual, *Géographie aérienne*, when he wrote: "The terrible wartime machine . . . may become an instrument of peace, bringing together men of countries far removed and activating exchanges thanks to the conquest of the third element of our planet."

CHAPTER 4

1. Chombart et al., *Paris et l'agglomération parisienne. L'Étude de l'espace social dans une grande cité* (Presses Universitaires de France, 1952), p. 106. Also see Anthony Vidler, "Photourbanism: Planning the City from Above and from Below," in *A Companion to the City*, ed. G. Bridges and S. Watson (Blackwell, 2000); Vidler, "*Terres Inconnues*: Cartographies of a Landscape to Be Invented," *October* 115 (winter 2006): 13-30; Vidler, "Airwar and Architecture," in *Ruins of Modernity*, ed. J. Hell and A. Schönle (Duke University Press, 2009).

2. Ibid., p. 21.

3. Paul-Henry Chombart de Lauwe, "Vingt-cinq ans de sociologie urbaine," *Urbanisme* 156 (1976): 61–63.

4. Danièle Voldman, "Aménager la région parisienne (février 1950–août 1960)," *Cahiers de l'Institut d'histoire du temps présent*, no. 17 (1990): 49–54.

5. Geneviève Chauveau, "Logement et habitat populaires de la fin de la deuxième guerre mondiale aux années soixante," in *Un Siècle de banlieue parisienne (1859–1964): Guide de recherche*, ed. Annie Fourcaut (L'Harmattan, 1988), pp. 130–131.

6. Norma Evenson, *Paris: A Century of Change, 1878–1978* (Yale University Press, 1979), p. 236; Jean-Paul Flamand, *Loger le peuple. Essai sur l'histoire du logement social* (Découverte, 1989), p. 251.

7. Evenson, *Paris: A Century of Change,* p. 237.

8. Christine Mengin, "La Solution des grands ensembles," *Vingtième Siècle. Revue d'histoire* 64. Numéro spécial: Villes en crise? (October–December 1999): 105–111, p. 106.

9. W. Brian Newsome, "The Rise of the *Grands Ensembles: Government, Business, and Housing in Postwar France*," *The Historian* 66, no. 4 (2004): 793–816, pp. 800–801.

10. Ibid., p. 810.

11. Ibid., pp. 808, 810.

12. Fourcaut, "Les premiers grands ensembles en région parisienne," p. 206.

13. Ibid., p. 212.

14. Marc Cantagrel, *Se Loger* (14 minutes), 1948.

15. Ibid.

16. Evenson, *Paris: A Century of Change*, p. 241.

17. Marc Bernard, *Sarcellopolis* (Flammarion, 1964). As Evenson points out, the term "Sarcellitis" was used to describe the growing rates of depression, suicide, and juvenile delinquency in the Sarcelles housing project, but Sarcelles became a

symbol of the emptiness and inhuman scale of the *grands ensembles* more generally (*Paris: A Century of Change, 1878–1978*, p. 247).

18. Kristin Ross, *Fast Cars, Clean Bodies: Decolonization and the Reordering of French Culture* (MIT Press, 1995), p. 13.

19. CAC 19770816, art. 6.

20. Ibid., p. 1.

21. Ibid., p. 1.

22. The Cité Daste was created in Toulouse between 1950 and 1955. Expansion of this large housing complex continued after 1956 with the aid of the municipal HLM program. In a poll conducted in 1953, 80 percent of local residents said they would prefer to live in a *pavillon isolé* rather than a *grand ensemble*. As Rosemary Wakeman writes, "It was a difficult dream to square with the *immeubles collectifs* rising around the city." Wakeman, *Modernizing the Provincial City: Toulouse, 1945–1975* (Harvard University Press, 1997), p. 86. See also Rosemary Wakeman, *Paris: The Heroic City, 1945–1975* (University of Chicago Press, 2010).

23. Ibid., pp. 88–89.

24. Robert Auzelle, *Documents d'urbanisme, présentés à la même échelle, réunis et commentés* (Vincent Fréal, 1948).

25. The role of aerial photography in obtaining an holistic view of an urban environment is even more pronounced in Auzelle's *Documents d'Urbanisme, présentés à la même échelle, réunis et commentés* (Vincent Fréal, 1948).

26. Robert Auzelle, *Techniques de l'urbanisme* (Presses Universitaires de France, 1953), pp. 9–10.

27. Fernand Lot, "L'Urbanisme peut voir ce que sera son oeuvre dans la réalité," *Le Figaro litteraire*, May 12, 1956.

28. H. and J. Vulmière, "Description et exposé technique," *Études et informations* 2 (février 1954): 23–27, p. 23.

29. Lot, "L'Urbanisme peut voir ce que sera son oeuvre dans la réalité."

30. Robert Auzelle, "Le Maquettoscope: Un appareil destiné à l'examen des maquettes," *Études et informations* 2 (February 1954): 21–22, p. 22.

31. H. and J. Vulmière, "Description et exposé technique," *Études et informations* 2 (février 1954): 23–27.

32. Ibid., p. 23.

33. Ibid.

34. Ibid., p. 25.

35. Chombart et al., *Paris et l'agglomération parisienne*, p. 25.

36. For a more thorough discussion of Roger Henrard and his postwar project of documenting the spaces of Paris using aerial photography, see Jean-Louis Cohen, *Above Paris: The Aerial Survey of Roger Henrard* (Princeton Architectural Press, 2006).

37. Chombart et al., *Paris et l'agglomération parisienne*, p. 106.

38. Ibid., pp. 105–106.

39. Ibid., p. 21.

40. Ibid., p. 253.

41. Ibid., p. 250.

42. For an analysis of the importance of statistics in the nineteenth century and its connection to notions of collectivity, see Theodore M. Porter, *The Rise of Statistical Thinking, 1820–1900* (Princeton University Press, 1986).

43. The Institut d'Urbanisme de Paris, created in 1924 at the Sorbonne in Paris, was formerly known as L'École des Hautes Études Urbaines. Its first directors were Marcel Poëte and Henri Sellier, and its mission was to develop new and interdisciplinary approaches to the study of "urbanisme," which was tied to social issues such as affordable housing for working-class individuals and families. The IUP still publishes an interdisciplinary journal, *La Vie Urbaine*. It is currently located at the University of Paris-XII-Créteil. Source: "Histoire de l'Institut d'urbanisme de Paris" (available at http://urbanisme.univ-paris12.fr).

44. For more on the importance of this group, see Denis Pelletier, *Économie et humanisme: De l'utopie communautaire au combat pour le Tiers Monde (1941–1966)* (Cerf, 1996).

45. Gaston Bardet, *Le Nouvel Urbanisme* (Dunod, 1948), p. 123.

46. Bardet once stated: "It was when I had to deal with a completely destroyed urban center, Louviers, that I came to understand that this urban fabric was made up simply of the interweaving of human activities on the land and that on a map I had to represent *them*, and not the resulting structures. Out of this was born the principle of *social topography*." Gaston Bardet, "Social Topography: An Analytico-Synthetic Understanding of the Urban Texture," *Town Planning Review* 22, no. 3 (1951): 237–260, p. 238.

47. Albert Demangeon, *Paris, la ville et sa banlieue* (Bourrelier, 1934).

48. Bardet, "Social Topography," p. 238.

49. Ibid., p. 245.

50. Ibid., p. 246.

51. Rouge, *Introduction à un urbanisme experimentale*, p. 18.

52. Ibid.

53. Paul-Henry Chombart de Lauwe, *Paris: Essais de Sociologie, 1952–1964* (Ouvrières, 1965), p. 10.

54. The CEGS became the Centre de Sociologie Urbaine in 1958.

55. Centre des Archives Contemporaines (CAC) 20000459, art. 2: "Rapports d'activité et gestion du CEGS (1955–1988)."

56. Paul-Henry Chombart de Lauwe, "Les Enquêtes sociologiques et leur utilisation par l'urbaniste," report completed for the Ministère de la Reconstruction et de l'urbanisme, Direction de l'aménagement du territoire, Centre d'études, Juin 1952. Centre de documentation de l'urbanisme (CDU), Paris, 40281, p. 1.

57. Ibid., p. 3.

58. Paul-Henry Chombart de Lauwe et al., "Les Comportements et les besoins des parisiens en relation avec les structures de l'agglomération." Rapport réalisé pour le Commissariat général du plan d'équipement et de la productivité et le Délégation générale au District de la Région de Paris, 1963. Centre de documentation d'urbanisme (Paris) 10667.

59. Jacques Jenny, Louis Couvreur, et Paul-Henry Chombart de Lauwe, "Sociologie du logement: Logement et comportement des ménages dans trois cités

nouvelles de l'agglomération bordelaise," *Cahiers du Centre Scientifique et Techniques du Bâtiment* (winter 1956–1957), p. 80.

60. P. Chombart de Lauwe et L. Couvreur, eds., "Ménages et catégories sociales dans les habitations nouvelles," *Informations Sociales* 5 (May 1958), p. 84.

61. Paul-Henry Chombart de Lauwe et al., *Famille et Habitation*, two volumes (CNRS, 1959–1960).

62. Ibid., p. 206.

63. Ibid., p. 39.

64. Ibid., p. 207.

65. Chombart also made this argument in the introduction to an earlier work, *Les Photographies aériennes. Méthode, procédés, interprétations. L'Étude de l'homme sur la terre* (Colin, 1951).

66. Ibid., p. 212.

67. L'Institut National de la Statistique et des Études Économiques (l'INSEE) is a statistical agency created in 1946; L'Institut National d'Études Démographiques (l'INED) is a demographic institute founded in 1945 by Alfred Sauvy and Robert Debré. l'INED and the work of Sauvy were central to the emergence of the French school of demography in the late 1940s and the 1950s. For more on the history of demography in France, see Jacques Dupâquier, *Histoire de la Démographie: la statistique de la population des origines à 1914* (Perrin, 1985); Christophe Bergouignan, ed., *La Population de la France: évolutions démographiques depuis 1946* (CUDEP, 2005); Françis Ronsin, Hervé Le Bras, and Elizabeth Zucker-Rouvillois, eds., *Demographie et Politique* (Éditions Universitaires de Dijon, 1997). For more on Alfred Sauvy, see Michel Louis Lévy, *Alfred Sauvy, compagnon du siècle* (Manufacture, 1990).

68. Paul-Henry Chombart de Lauwe, "Le Rôle de l'observation en sociologie," *Revue de l'Institut de Sociologie* 33, no. 1 (1960): 27–43, p. 41.

69. For a thorough discussion of the role of statistics in this trend, see Porter, *The Rise of Statistical Thinking*.

70. Chombart et al., *Famille et Habitation*, volume 2, p. 270.

71. Ibid., p. 272.

72. For a history of the ENPC, see Antoine Picon, *L'Invention de l'ingénieur moderne: L'École Nationale des Ponts et Chaussées, 1747–1851* (ENPC, 1992).

73. A. Burger, *Photographies aériennes et aménagement du territoire* (Dunod, 1957).

74. In the introduction to this work, Burger expressed special appreciation to Robert Auzelle, then a professor at the IUP and an urbanist at the MRU, for assistance. He also thanked Bernard Dubuisson, an ingénieur en chef at the MRU, who extolled aerial photography's benefits to humanism in the early 1950s and who completed a doctoral thesis on aerial photography in the early 1940s. Burger, *Photographies aériennes*, VIII.

75. Burger, *Photographies aériennes*, pp. 63, 71.

76. Ibid., pp. 66–71.

77. Paul-Henry Chombart de Lauwe, *Un Anthropologue dans le siècle: entretiens avec Thierry Paquot* (Descartes & Cie, 1996), p. 71.

78. Paul-Henry Chombart de Lauwe, "Social Evolution and Human Aspirations," *American Catholic Sociological Review* 23, no. 4 (1962): 294–309, p. 309.

79. Chombart, "Vingt-cinq ans de sociologie urbaine," *Urbanisme* 156 (1976): 61–63.

CHAPTER 5

1. Robert Gilpin, *France in the Age of the Scientific State* (Princeton University Press, 1968), p. 278.

2. For more on urban policy and modernization under de Gaulle, see Peggy Phillips, *Modern France: Theories and Realities of Urban Planning* (University Press of America, 1987); Rosemary Wakeman, *Modernizing the Provincial City: Toulouse, 1945–1975* (Harvard University Press, 1997); Rosemary Wakeman, *Paris: the Heroic City, 1945-1975* (University of Chicago, 2010); Olivier Guichard, *Aménager la France* (Laffont-Gauthier, 1965); Pierre Randet, *L'Aménagement du territoire. Genèse et étapes d'un grand dessein* (La Documentation Française, 1994).

3. Evenson, *Paris: A Century of Change,* p. 208. Evenson notes that between 1955 and 1960 seventeen urban renewal projects were carried out in Paris, covering 89.7 hectares.

4. Jacques Brun and Marcel Roncayolo, "Formes et paysages," in *La ville aujourd'hui, croissance urbaine et crise du déclin*, volume 5: *Histoire de la France urbaine*, ed. by Marcel Roncayolo (Seuil, 1985), p. 349.

5. Desportes and Picon 1997, p. 151.

6. Pierre Randet, *L'Aménagement du territoire: Genèse et étapes d'un grand dessein* (DATAR, 1994), p. 34.

7. Ibid.

8. Roncayolo, *La ville aujourd'hui, croissance urbaine et crise du déclin*, p. 113.

9. Wakeman, *Modernizing the Provincial City*, p. 119.

10. The historian Larry Busbea notes that in 1962 Delouvrier sent out a letter to cultural figures such as Michel Ragon requesting their input into future plans for the Paris region. "It is clear," Busbea writes, "that the administration in Paris wanted at the very least to keep its finger on the pulse of the avant-garde in preparing what would become the city's most controversial master plan since the Haussmann era." Larry Busbea, *Topologies: The Urban Utopia in France, 1960–1970* (MIT Press, 2007), p. 119.

11. Paul Delouvrier, *Schéma Directeur d'Aménagement et d'Urbanisme de la Région de Paris* (District de la Région de Paris, 1965).

12. The 1960s saw a drastic increase in car ownership in France. By 1965 there were more than 2 million automobiles in the city of Paris alone. Busbea, *Topologies*, p. 120.

13. Ibid., p. 121.

14. Ibid., p. 120; Evenson, *Paris: A Century of Change*, p. 283.

15. Delouvrier, *Schéma Directeur*, p. 47.

16. Ibid., p. 212.

17. Lefebvre, *State, Space, World*, p. 243.

18. Ibid., p. 234.

19. See, especially, Peter Galison, "War Against the Center," *Grey Room* 4 (summer 2001): 5–33.

20. Henri Lefebvre, *The Production of Space*, tr. Donald Nicholson-Smith (Blackwell, 1991), p. 286, emphasis added.

21. For more on Debord's critique of visuality and maps, see Simon Sadler, *The Situationist City* (MIT Press, 1998); Kan Knabb, ed., *The Situationist International Anthology* (Bureau of Public Secrets, 2006); Tom McDonough, ed., *Guy Debord and the Situationist International: Texts and Documents* (MIT Press, 2002).

22. The literature on Henri Lefebvre is immense. Among the most important works are Andy Merrifield, *Henri Lefebvre: A Critical Introduction* (Routledge, 2006); Stuart Elden, *Understanding Henri Lefebvre: Theory and the Possible* (Continuum, 2004); Rémi Hess, *Henri Lefebvre et L'Aventure du Siècle* (Métailié, 1988); Bud Burkhard, *French Marxism between the Wars: Henri Lefebvre and the "Philosophies"* (Humanity Books, 2000);; Henri Lefebvre, *State, Space, World: Selected Essays*, ed. Neil Brenner and Stuart Elden, tr. Gerald Moore, Neil Brenner, and Stuart Elden (University of Minnesota Press, 2009); Lukasz Stanek, *Henri Lefebvre on Space: Architecture, Urban Research, and the Production of Theory* (University of Minnesota, 2011); and Kaishka Goonewardena et al., *Space, Difference, and Everyday Life: Reading Henri Lefebvre* (Routledge, 2008). On his critique of Chombart, see Anthony Vidler, *Scenes of the Street and Other Essays* (Monacelli, 2011).

23. Henri Lefebvre, *La Vallée de Campan, étude de sociologie rurale* (Presses Universitaires de France, 1963).

24. Henri Lefebvre, *Le Temps de Méprises* (Stock, 1975), p. 218.

25. Edward Soja, *Postmodern Geographies. The Reassertion of Space in Critical Social Theory* (Verso, 1989), p. 50.

26. Specifically, Lille-Roubaix-Tourcoing, Lyon-Saint-Etienne-Grenoble, Marsaille-Aix-en-Provence, Nancy-Metz, Strasbourg, Bordeaux, Nantes-Saint-Nazaire, and Toulouse. Wakeman, *Modernizing the Provincial City*, p. 116.

27. Henri Lefebvre, *Pyrénées* (Éditions Rencontre, 1965), 116–117, quoted in Andy Merrifield, *Henri Lefebvre: A Critical Introduction* (Routledge, 2006), p. 60.

28. Merrifield, *Henri Lefebvre*, p. 65.

29. Henri Lefebvre, "Utopie expérimentale: Pour un Nouvel Urbanisme," *Revue française de sociologie* II, no. 3 (1961): 191–199.

30. Ibid., p. 193.

31. Ibid.

32. "Note succincte sur l'organisation de l'enseignement et de la recherche pour le Ministère de l'Équipement," Archives du MEL, CAC 19790664, art. 6, p. 1.

33. CAC 19770685, article 10. ENPC/STCAU, 1967–1969, 10.

34. Ibid., p. 2.

35. Ibid, p. 5.

36. ENPC, "Note sur l'organisation de l'enseignement et de la formation dans le domaine du Ministère de l'Equipement et du Logement," 5 avril 1968. Archives of ENPC, 19790664, art. 6 enseignement et recherche, ENPC, 1966–71.

37. For more on the MEL, its internal organization, and its collaboration with social scientists, see Pierre Lassave, *Les sociologues et la recherche urbaine dans la France contemporaine* (Presses Universitaires de Mirail, 1997).

38. Henri Lefebvre, *State, Space, World: Selected Essays*, ed. Neil Brenner and Stuart Elden, tr. Gerald Moore, Neil Brenner, and Stuart Elden (University of Minnesota Press, 2009), p. 228.

39. Ross, *Fast Cars, Clean Bodies*.

40. Shields, *Lefebvre, Love, and Struggle*, p. 68.

41. Paul-Henry Chombart de Lauwe, *Un anthropologue dans le siecle: Entretiens avec Thierry Paquot* (Descartes & Cie, 1996), pp. 93–94.

42. Paul-Henry Chombart de Lauwe, "Technical Domination," 1986, p. 107.

43. Raymond Ledrut, *L'Espace en question: ou, Le nouveau monde urbaine* (Anthropos, 1976).

44. Raymond Ledrut, "Le Centre Interdisciplinaire d'Études Urbaines," report for Faculté des lettres et sciences humaines, Université de Toulouse. Papers of Raymond Ledrut, n.d.

45. Raymond Ledrut, *Sociologie urbaine* (Presses Universitaires de France, 1968), p. 165.

46. Raymond Ledrut, *Les Images de la Ville* (Anthropos, 1973).

47. M. Lucas, J. Coppolani, Père Ducos, Raymond Ledrut, and P. Pariselle, "La Vie dans les Grands Ensembles Toulousains," Premiers résultats d'une enquête de la Commission Urbanisme et Habitat du Comité d'Études pour l'Aménagement de la Région toulousaine. Unpublised report, papers of Raymond Ledrut, 1963.

48. Ibid., p. 7.

49. Ibid., pp. 62–63.

50. Ibid, p. 64.

51. Raymond Ledrut, *L'Espace social de la ville. Problèmes de sociologie appliqué à l'aménagement urbaine* (Anthropos, 1968) and *Sociologie urbaine* (Presses Universitaires de France, 1968).

52. Raymond Ledrut, "La Crise de l'urbanisme," unpublished manuscript, n. d.

53. For example, l'INSEE, the main statistical agency in France, still used the category of *quartier* in its reports. Ledrut, *L'Espace Social de la Ville*, p. 155.

54. Ledrut and Christian Roy, "Toulouse, sociologie, et planification urbaine," *Urbanisme* 93 (1966): 50–63, p. 59.

55. Raymond Ledrut, Jacqueline Giami, and Christian Roy, "Analyse de l'espace social de la ville d'Albi. Étude de sociologie urbaine," compte rendu d'une recherche financée par le Ministère de l'Équipement, Juin 1970. Papers of Raymond Ledrut, University of Toulouse-Le Mirail.

56. Raymond Ledrut, Jacqueline Giami, and Christian Roy, "Analyse de l'espace social de la ville d'Albi. Étude de sociologie urbaine," compte rendu d'une recherche financée par le Ministère de l'Équipement, Juin 1970. Papers of Raymond Ledrut, University of Toulouse-Le Mirail, p. 3.

57. Ibid., p. 4.

58. Ibid., pp. 70–71.

59. Archives of MEL, CAC 19770685, art. 11.

60. Jean-Paul Trystram, ed., *Sociologie et Plans d'Urbanisme: Aix-en-Provence, Toulouse, Le Havre*, report for the Ministère de la Construction, Direction de l'Aménagement Foncier et de l'Urbanisme, Service des Études et des Programmes de Développement Urbain, Septembre 1965.

61. Trystram, *Sociologie et Plans d'Urbanisme*, p. 1.

62. It is important to remember here that the entire field of urban sociology in France was still relatively new; its emergence can be traced to the appearance of Chombart's study of Paris in 1952. See Chombart, *Un Anthropologue dans le siècle*.

63. Trystram, *Sociologie et Plans d'Urbanisme,* p. 2.

64. Ibid.

65. Ibid., p. 12.

66. Jean-Paul Trystram, ed., *Sociologie et développement urbain*, report for the Ministère de l'Équipement et du Logement, 1965–66. Archives of MEL, CAC 19770685, art. 12 (études sociologiques), volume 1, p. 3.

67. Ibid., volume 1, pp. 7–8.

68. Ibid.

69. Trystram, *Sociologie et Plans d'Urbanisme*, p. 11.

70. Ibid., p. 2.

71. Jean-Paul Trystram, ed., *Sociologie et urbanisme*, Colloque des 1, 2, 3 Mai 1968 (Fondation Royaumont, 1970).

72. Ibid., p. 11.

73. In *Image and Logic* (University of Chicago Press, 1997), Peter Galison, drawing on anthropological theory, compares the creation of an interdisciplinary language to that of a creole.

74. Trystram, *Sociologie et urbanisme*, p. 14.

75. Lefebvre, *State, Space, World*, p. 223.

76. Ibid., p. 230.

77. Ibid., p. 234.

78. Arthur Hirsh, *French New Left* (Black Rose Books, 1982), p. 12.

79. Ibid., pp. 104–105.

80. Ibid., p. 140.

81. Raymond Ledrut, "Projet de Revue 'Espaces et Sociétés': Contributions envisagées," Papers of Raymond Ledrut, University of Toulouse-Le Mirail, n. d.

82. Henri Lefebvre, "Réflexions sur la politique de l'espace," *Espaces et sociétés* 1 (Novembre 1970): 3–13.

83. Ibid., p. 10.

84. Ibid.

85. Ibid., p. 11.

86. Henri Lefebvre, *The Urban Revolution*, tr. Robert Bononno (University of Minneapolis Press, 2003); *The Production of Space*, tr. Donald Nicholson-Smith (Blackwell, 1991).

87. Lefebvre, *The Urban Revolution*, p. 5.

88. Lefebvre, *The Production of Space*, p. 116.

89. Ibid., p. 94.

90. Raymond Ledrut, *L'Espace en Question* (Anthropos, 1976).

91. Ibid., p. 7.

92. Ibid., pp. 271–273.

93. Raymond Ledrut, *La Révolution Cachée* (Casterman, 1979).

94. Ibid., p. 125.

95. Lefebvre, *The Urban Revolution*, p. 21.

96. Ibid., p. 44.

97. Ibid., p. 92.

CONCLUSION

1. In view of the continuing concerns about spatial organization and social life in urban environments, a translation of Raymond Ledrut's sociological studies and theoretical explorations is certainly long overdue.

2. Olivier Guichard, "Déclaration sur les orientations de la politique urbaine," Assemblée nationale, 17 mai 1973, *Journal officiel de la République française*, 1973.

3. The incident of Les Minguettes wasn't the first suburban riot in France, and therefore it is probably not accurate to point to this event as the instigator of these policies. See Mustafa Dikeç, *Badlands of the Republic* (Blackwell, 2007), pp. 39–40.

4. One of the slogans of the Banlieues 89 project was "Democracy through Beauty." Dikeç, *Badlands of the Republic*, p. 56. The project was widely criticized for being merely a media stunt upon the part of Mitterand and his administration.

5. Ibid., p. 49.

6. Hubert Dubedout, "Ensemble, Refaire la Ville," *rapport au premier ministre du président de la commission nationale pour le développement social des quartiers* (La Documentation Française, 1983).

7. Dubedout, "Ensemble, Refaire la Ville," p. 75. Quoted in Dikeç, *Badlands of the Republic,* p. 54.

8. Ibid., emphasis added.

9. Dikeç, *Badlands of the Republic*, p. 54, n. 15.

10. Sylvie Tissot, *L'État et les quartiers: Genèse d'une catégorie de l'action politique* (Seuil, 2007).

11. Paul-Henry Chombart de Lauwe et al., *Transformations de l'environement, des aspirations et des valeurs* (CNRS, 1976).

12. Ibid., p. 222.

BIBLIOGRAPHY

ARCHIVES

Archives départementales de l'Isère (Grenoble)

Archives de l'École Nationale des Ponts et Chaussées (Paris)

Archives de l'Institut français d'architecture (Paris)

Archives nationales (Paris)

Centre des archives contemporaines (Fontainebleau)

Fondation Le Corbusier (Paris)

Fonds Marcel Griaule

Université de Toulouse-Le Mirail (Toulouse)

PUBLISHED SOURCES

Alvarenga, Antonio. La notion d'espace social dans la sociologie française actuelle. Essai de généalogie d'un concept et analyse de sa portée opératoire. Thèse de doctorat, Université de Toulouse-II, 1989.

Amad, Paula. *Counter-Archive: Film, the Everyday, and Albert Kahn's Archives de la Planète*. Columbia University Press, 2010.

Amiot, M. *Contre l'état, les sociologues*. EHESS, 1986.

Anker, Peder. *Imperial Ecology: Environmental Order in the British Empire, 1895–1945*. Harvard University Press, 2001.

Aronowitz, Stanley. The Theory of Social Space in the Work of Henri Lefebvre. In *Urban Political Economy and Social Theory. Critical Essays in Urban Studies*, ed. Ray Forrest, Jeff Henderson, and Peter Williams. Gower, 1982.

Auzelle, Robert. *Documents d'urbanisme, présentés à la même échelle, réunis et commentés.* Vincent Fréal, 1948.

Auzelle, Robert. *Techniques de l'urbanisme*. Presses Universitaires de France, 1953.

Auzelle, Robert. Le Maquettoscope: Un Appareil destiné à l'examen des maquettes. *Études et informations* 2 (February 1954): 21–22.

Bann, Stephen. When I was a Photographer: Nadar and History. *History and Theory* 48 (December 2009): 95–111.

Bardet, Gaston. *Problèmes de l'urbanisme*. Dunod, 1941.

Bardet, Gaston. *Pierre sur pierre: Construction du nouvel urbanisme*. L.C.B, 1945.

Bardet, Gaston. *Le Nouvel urbanisme*. Dunod, 1948.

Bardet, Gaston. Social Topography: An Analytico-Synthetic Understanding of the Urban Texture. *Town Planning Review* 22 (3) (October 1951): 237–260.

Bardet, Gaston. *L'Urbanisme*. Presses Universitaires de France, 1963.

Batut, Arthur. *La Photographie aérienne par cerf-volant*. Gauthier-Villars et cie, 1890.

Baudelle, Guy, Marie-Vic Ozouf-Marignier, and Marie-Claire Robic, eds. *Géographes en practiques (1870–1914). Le terrain, le livre, la cité*. Presses Universitaires de Rennes, 2001.

Baudouï, Rémi. Planification territoriale et reconstruction, 1940–1946. Thèse de cycle, Université de Paris, 1984.

Baudouï, Rémi. Raoul Dautry: La Conscience du social. *Vingtième siècle. Revue d'histoire* 15 (July–September 1987): 45–58.

Baudouï, Rémi. Marcel Poëte et Le Corbusier, l'histoire dans le projet d'urbanisme. *Annales de la recherche urbaine* 37 (1988): 46–54.

Baudouï, Rémi. *Raoul Dautry 1880–1951: Le Technocrat de la République*. Éditions Balland, 1992.

Bergouignan, Christophe, ed. *La Population de la France: Évolutions démographiques depuis 1946*. CUDEP, 2005.

Bernard, Marc. *Sarcellopolis*. Flammarion, 1964.

Bethuys, G. *Les Aerostiers militaires*. H. Lecène et H. Oudin, 1889.

Bigot, Pierre. L'Architecture et l'urbanisme au Congrès national de l'aviation français. *Techniques et architecture* (1945): 157–159.

Bitoun, P. *Les Hommes d'Uriage*. La Découverte, 1988.

Blanckaert, Claude, ed. *Les Politiques de l'anthropologie: Discours et practiques en France, 1860–1940*. L'Harmattan, 2001.

Bloch, Marc. Plans parcellaires. *Annales* 1 (1929): 60–70.

Bloch, Marc. Les plans parcellaires: L'avion au service de l'histoire agraire. *Annales* 2 (1930): 557–558.

Bloch, Marc. *French Rural History: An Essay on Its Basic Characteristics*, tr. Janet Sondheimer. University of California Press, 1966. Originally published as *Les caractères originaux de l'histoire rurale française*. Harvard University Press, 1931.

Bloch, Marc. Une Nouvelle image de nos terroirs: La mise à jour du cadastre. *Annales* 7 (32) (1935): 156–159.

Bloch, Marc. *Strange Defeat: A Statement of Evidence written in 1940*, tr. Gerard Hopkins. Octagon Books, 1968.

Bonillo, Jean-Lucien, Claude Massu, and Daniel Pinson, eds. *La Modernité critique: Autour du CIAM 9 d'Aix-en-Provence, 1953*. Imbernon, 2006.

Bourdelais, P., and B. Lepetit. Histoire et espace. In *Espaces, jeux et enjeux*, ed. R. Brunet and F. Auriac. Fayard–Fondation Diderot, 1986.

Bourdieu, Pierre. *Outline of a Theory of Practice*, tr. Richard Nice. Cambridge University Press, 1977. Originally published as *Esquisse d'une théorie de la practique* (Droz, 1972).

Bourdieu, Pierre. Social Space and the Genesis of Groups. *Theory and Society* 14 (1985): 723–744.

Bourg, Julien. *From Revolution to Ethics: May 1968 and Contemporary French Thought.* McGill–Queens University Press, 2007.

Bowd, Gavin, and Daniel Clayton. Fieldwork and Tropicality in French Indochina: Reflections on Pierre Gourou's *Les Paysans du delta tonkinois, 1936. Singapore Journal of Tropical Geography* 24 (2) (2003): 147–168.

Bowd, Gavin, and Daniel Clayton. Tropicality, Orientalism, and French Colonialism in Indochina: The Work of Pierre Gourou, 1927–1982. *French Historical Studies* 28 (2) (spring 2005): 297–329.

Braudel, Fernand. Georges Gurvitch et la discontinuité du social. *Annales* 12 (1953): 347–361.

Braudel, Fernand. Lucien Fèbvre et l'histoire. *Cahiers Internationaux de Sociologie* 22 (1957): 15–20.

Braudel, Fernand. Personal Testimony. *Journal of Modern History* 44 (1972): 448–467.

Brunhes, Jean. Une Géographie nouvelle: La géographie humaine. *Revue des Deux Mondes* (June 1906): 543–574.

Brunhes, Jean. *Human Geography: An Attempt at a Positive Classification, Principles, and Examples,* tr. T. C. Le Compte. Rand McNally, 1920. Originally published *as La Géographie humaine. Essai de classification positive, principes et exemples.* Alcan, 1910.

Brunhes, Jean. *Leçons de géographie: Cours moyen.* Maison Alfred Mame et Fils, 1926.

Burger, Alexandre. *Photographies aériennes et aménagement du territoire. L'Interprétation des photographies aériennes appliquée aux études d'urbanisme et d'aménagement du territoire.* Dunod, 1957.

Burguière, André. *L'École des Annales: une histoire intellectuelle.* Jacob, 2006.

Burke, Peter. *The French Historical Revolution: The Annales School, 1929–89.* Polity, 1990.

Burkhard, Bud. *French Marxism between the Wars: Henri Lefebvre and the "Philosophies.* Humanity Books, 2000.

Busbea, Larry. *Topologies: The Urban Utopia in France, 1960–1970*. MIT Press, 2007.

Buttimer, Anne. *Society and Milieu in the French Geographic Tradition*. Rand McNally, 1971.

Buttimer, Anne. Social space and the planning of residential areas. *Environment and Behavior* 4 (3) (1972): 279–318.

Buttimer, Anne. Social Space in Interdisciplinary Perspective. In *Surviving the City*, ed. John Gabree. Ballantine, 1973.

Carlier, André-H. *La Photographie aérienne pendant la guerre*. Librairie Delagrave, 1921.

Casey, Edward. *The Fate of Place: A Philosophical History*. University of California Press, 1997.

Centre de Recherche d'Urbanisme. *Photographie aérienne et urbanisme*. CRU, 1969.

Chevallier, Raymond. Photographie aérienne et histoire de l'urbanisme. *La vie urbaine* 4 (October–November 1963): 253–270.

Chevallier, Raymond. Panorama des applications de la photographie aérienne. *Annales* 18, no. 4 (1963): 677–698.

Chevallier, Raymond. *La Photographie aérienne*. Colin, 1971.

Chombart de Lauwe, Paul-Henry. Chez les Fali. Mission ethnographique Griaule, Sahara-Cameroun. *La géographie* 68, no. 2–3 (1937): 97–104.

Chombart de Lauwe, Paul-Henry. A Propos de l'apprentissage intellectuel, *Jeunesse . . . France!* (May 1941): 2.

Chombart de Lauwe, Paul-Henry. A la Recherche de la terre de la France. *Jeunesse . . . France!* (June 1941): 10–11.

Chombart de Lauwe, Paul-Henry. Les Zones et l'unité française. *Jeunesse . . . France!* (March 1942): 49–52.

Chombart de Lauwe, Paul-Henry. *Pour Retrouver la France: Enquêtes sociales en équipes*. Ecole nationale des cadres, 1943.

Chombart de Lauwe, Paul-Henry. *Pour Comprendre la France*. Presses d'Ile-de-France, 1947.

Chombart de Lauwe, Paul-Henry, et al. *La Découverte aérienne du monde*. Horizons de France, 1948.

Chombart de Lauwe, Paul-Henry, et al. *Photographies aériennes. Méthode. Procédés. Interprétation*. Colin, 1951.

Chombart de Lauwe, Paul-Henry. *Paris et l'agglomération parisienne*. 2 vols. Presses Universitaires de France, 1952.

Chombart de Lauwe, Paul-Henry, and L. Couvreur. Ménages et catégories sociales dans les habitations nouvelles. *Informations sociales* 5 (May 1958).

Chombart de Lauwe, Paul-Henry, and L. Couvreur. *Famille et habitation*. Two volumes. Centre Nationale de la Recherche Scientifique, 1959–1960.

Chombart de Lauwe, Paul-Henry, and L. Couvreur. Le Rôle de l'observation en sociologie. *Revue de l'Institut de Sociologie* 33 (1) (1960): 27–43.

Chombart de Lauwe, Paul-Henry, and L. Couvreur. Social Evolution and Human Aspirations. *American Catholic Sociological Review* 23 (4) (winter 1962): 294–309.

Chombart de Lauwe, Paul-Henry, and L. Couvreur. *Paris: Essais de sociologie, 1952–1964*. Ouvrières, 1965.

Chombart de Lauwe, Paul-Henry, and L. Couvreur. Vingt-cinq ans de sociologie urbaine. *Urbanisme* 156 (1976): 61–63.

Chombart de Lauwe, Paul-Henry, and L. Couvreur. *Transformations de l'environnement, des aspirations et des valeurs*. CNRS, 1976.

Chombart de Lauwe, Paul-Henry, and L. Couvreur. Technical Domination and Cultural Dynamism. *OECD Center for Educational Research and Innovation* 107 (1986): 105–115.

Chombart de Lauwe, Paul-Henry, and L. Couvreur. *Les hommes, leurs espaces et leurs aspirations: Hommage à Paul-Henry Chombart de Lauwe*. L'Harmattan, 1994.

Chombart de Lauwe, Paul-Henry, and L. Couvreur. *Un Anthropologue dans le siècle: Entretiens avec Thierry Paquot*. Descartes & Cie, 1996.

Chombart de Lauwe, Paul-Henry, and L. Couvreur. *Chronique d'un pilote ordinaire.* Félin, 2007.

Ciucci, Giorgio. The Invention of the Modern Movement. *Oppositions* 24 (1981): 69–91.

Clarke, Stuart, ed. *The Annales School.* Routledge, 1999.

Claudius-Petit, Eugène. *Pour un plan national d'aménagement du territoire.* Communication du Ministère de la reconstruction et de l'urbanisme au conseil des ministres. Paris, February 1950.

Claval, Paul. *Essai sur l'évolution de la géographie humaine.* Annales Littéraires de l'Université de Besançon, 1976.

Claval, Paul, ed. *Autour de Vidal de la Blache. La formation de l'école française de géographie.* CNRS, 1993.

Claval, Paul, and André-Louis Sanguin, eds. *La Géographie française à l'époqie classique (1918–1968).* L'Harmattan, 1996.

Clifford, James. *The Predicament of Culture: Twentieth-Century Ethnography, Literature, and Art.* Harvard University Press, 1988.

Cohen, Jean-Louis. Henri Prost and Casablanca: The Art of Making Successful Cities. *New City* (fall 2006): 106–121.

Cohen, Jean-Louis. *Above Paris. The Aerial Survey of Roger Henrard.* Princeton Architectural Press, 2006.

Comte, Bernard. *Une Utopie combattante. L'École des cadres d'Uriage, 1940–1942.* Fayard, 1991.

Condominas, George. *L'Espace social à propos de l'Asie du Sud-est.* Flammarion, 1980.

Coing, Henri. *Rénovation urbaine et changement social, l'ilôt no. 4 (Paris 13th).* Paris: Éditions ouvrières, 1966.

Corn, Joseph J. *The Winged Gospel: America's Romance with Aviation, 1900–1950.* Oxford University Press, 1983.

Cosgrove, Denis. *Social Formation and Symbolic Landscape.* Barnes & Noble Books, 1985.

Cosgrove, Denis. *Mappings*. Reaktion, 1999.

Cosgrove, Denis, and William L. Fox. *Photography and Flight*. Reaktion, 2010.

Couzon, Isabelle. La place de la ville dans le discours des aménageurs du début des années 1920 à la fin des années 1960. *Cybergeo* 37 (November 1997): 1–30.

Crary, Jonathan. *Techniques of the Observer: On Vision and Modernity in the Nineteenth Century*. MIT Press, 1990.

Crary, Jonathan. Géricault, the Panorama, and Sites of Reality in the Early Nineteenth Century. *Grey Room* 9 (fall 2002): 5–25.

Cristianne, Charles, et al. *Histoire de l'aviation militaire française*. Charles-Lavauzelle, 1980.

Curwen, Cecil E. *Air-Photography and Economic History: The Evolution of the Corn Field*. London: Economic History Society, 1927–30.

Danger, René. *Cours d'urbanisme*. Eyrolles, 1947.

Daston, Lorraine, and Peter Galison. *Objectivity*. Zone Books, 2007.

Dautry, Raoul. 1945 doit être l'année de l'urbanisme. *Urbanisme* 103–104 (1945).

De Barros, Françoise. Des 'Français musulmans d'Algérie' aux 'immigrés:' L'importation de classifications coloniales dans les politiques du logement en France (1950–1970). *Actes de la Recherche en Sciences Sociales* 159 (2006): 26–45.

Deboudaud, J. and Paul-Henry Chombart de Lauwe. Carte schématique des populations du Cameroun. *Journal de la société des africanistes* 9 (1939): 197–204.

De Certeau, Michel. *The Practice of Everyday Life*, tr. Steven Rendall. University of California Press, 1984. Originally published as *L'Invention du quotidien*. Union général d'éditions, 1980.

Débord, Guy. *La Société du spectacle*. Buchet/Chastel, 1967.

Deffontaines, Pierre. En Avion au-dessus de Rio de Janeiro. *La Vie Urbaine* 38 (March–April 1937): 67–71.

Deffontaines, Pierre. *Le Petit guide du voyageur actif*. Labourrer, 1938.

Deffontaines, Pierre, and Mariel Jean-Brunhes Delamarre. *Atlas aérien*. Gallimard, 1955.

Delamarre, Mariel Jean-Brunhes, et al. *Jean Brunhes autour du monde: regards d'un géographe, regards de la géographie*. Musée Albert Kahn, 1993.

Délégation Générale à l'Équipement National (DGEN). *Rapports et travaux sur la décongestion des centres industriels.* . DGEN, 1944.

Délégation Générale à l'Équipement National (DGEN). *Premier rapport de la Commission nationale de l'aménagement du territoire. Commissariat Général du Plan d'Équipement et de la productivité*. DATAR, 1964.

Delestre, Antoine. *Uriage, une communauté et une école dans la tourmente, 1940–1945*. Presses Universitaires de Nancy, 1989.

Delouvrier, Paul. Uriage, École nationale des cadres de la jeunesse. *Gazette de l'Inspection* (October 1941): 11–14.

Delouvrier, Paul. *Schéma directeur d'aménagement et d'urbanisme de la Région de Paris*. District de la Région de Paris, 1965.

Demangeon, Albert. *La Plaine Picardie*. Colin, 1905.

Demangeon, Albert. *Paris, la ville et sa banlieue*. Bourrelier et cie, 1934.

Demangeon, Albert. *Problèmes de géographie humaine*. Colin, 1942.

De Martonne, Emmanuel. *Notions générales, Climat. Hydrographie*, volume 1: Traité de geographie physique. Colin, 1927.

De Martonne, Emmanuel. Jean Brunhes. *Annales de Geographie* 39 (221) (September 1930): 549–553.

De Martonne, Emmanuel. *La Géographie aérienne*. Albin Michel, 1948.

Desportes, Marc, and Antoine Picon. *De l'Espace au territoire: l'aménagement du territoire en France, XVIe–XXe siècles*. Presses de l'École nationale des ponts et chaussées, 1997.

Dikeç, Mustafa. *Badlands of the Republic: Space, Politics, and Urban Policy*. Blackwell, 2007.

Dubedout, Hubert. Ensemble, refaire la ville. Rapport au premier ministre du président de la commission nationale pour le développement social des quartiers. Paris: La Documentation français, 1983.

Dubuisson, Bernard. La Photographie aérienne au service de l'urbanisme. *Urbanisme* 1–2 (1952): 44–47.

Dufaux, Frédéric, and Annie Fourcaut, eds. *Le Monde des Grandes Ensembles*. Créaphis, 2004.

Dufournet, Paul. *Les plans d'organisation de l'espace*. C.R.U, 1969.

Dupâquier, Jacques, and Michel Dupâquier. *Histoire de la démographie. La statistique de la population des origines à 1914*. Perrin, 1985.

Durkheim, Émile. *Les formes élémentaires de la vie religieuse*. Librairie Félix Alcan, 1913.

Elden, Stuart. *Understanding Henri Lefebvre: Theory and the Possible*. Continuum, 2004.

Espuche, Albert Garcia. Cities: From the Balloon to the Satellite. In *Exposition at the Centra de Cultura Contemporània de Barcelona, February–May 1994*. Electa, 1994.

Evenson, Norma. *Paris: A Century of Change, 1878–1978*. Yale University Press, 1979.

Fiemeyer, Isabelle. *Marcel Griaule, Citoyen Dogon*. Actes Sud, 2004.

Fink, Carole. *Marc Bloch: A Life in History*. Cambridge University Press, 1989.

Finnegan, Colonel Terrence J. *Shooting the Front. Allied aerial reconnaissance and photographic interpretation on the Western Front—World War I*. Center for Strategic Intelligence Research, National Defense Intelligence College, 2006

Flamand, Jean-Paul. *Loger le Peuple. Essai sur l'histoire du logement social*. Découverte, 1989.

Fourcaut, Annie, ed. *Un Siècle de banlieue parisienne (1859–1964): Guide de recherche*. L'Harmattan, 1988.

Fourcaut, Annie. Les premiers grands ensembles en région parisienne: Ne pas refaire la banlieue?" *French Historical Studies* 27 (1) (winter 2004): 195–218.

Frampton, Kenneth. *Modern Architecture: A Critical History*. Oxford University Press, 1980.

Frampton, Kenneth. *Le Corbusier: Architect of the Twentieth Century*. Abrams, 2002.

Frémont, Armand, R. Hérin, and J. Chevalier. *Géographie sociale*. Masson, 1984.

Friedmann, George. *Villes et campagnes*. Colin, 1953.

Friedman, Susan W. *Marc Bloch, Sociology, and Geography*. Cambridge University Press, 1996.

Fritzsche, Peter. *A Nation of Fliers: German Aviation and the National Imagination*. Harvard University Press, 1992.

Galison, Peter L. The Ontology of the Enemy: Norbert Wiener and the Cybernetic Vision. *Critical Inquiry* 21 (1) (autumn 1994): 228–266.

Galison, Peter L. *Image and Logic: A Material Logic of Microphysics*. University of Chicago Press, 1997.

Galison, Peter L. War Against the Center. *Grey Room* 4 (summer 2001): 5–33.

Galison, Peter L. *Einstein's Clocks, Poincaré's Maps: Empires of Time*. Norton, 2003.

George, Pierre. *Sociologie et géographie*. Presses Universitaires de France, 1966.

Giacone, Alessandro. *Paul Delouvrier: Un Demi-siècle au service de la France et de l'Europe*. Descartes & Cie, 2004.

Giddens, Anthony. *A Contemporary Critique of Historical Materialism* Macmillan, 1981.

Giedion, Sigfried. *Space, Time, and Architecture. The Growth of a New Tradition*. Harvard University Press, 1962.

Gildea, Robert. *France since 1945*. Oxford University Press, 2002.

Gilpin, Robert. *France in the Age of the Scientific State*. Princeton University Press, 1968.

Goonewardena, Kaishka, et al. *Space, Difference, and Everyday Life: Reading Henri Lefebvre*. Routledge, 2008.

Gottmann, Jean. French Geography in Wartime. *Geographical Review* 36 (1) (January 1946): 80–91.

Gottmann, Jean. De la méthode d'analyse en géographie humaine. *Annales de Geographie* (1947): 1–12.

Gottmann, Jean. De l'organisation de l'espace: Considérations de géographie et d'économie. *Révue économique* 1 (1950): 60–71.

Gottmann, Jean. *Essais sur l'aménagement de l'espace habité*. La Haye, 1966.

Gourou, Pierre. Le Tonkin. In *Exposition coloniale internationale*. Protat Frères, 1931.

Gourou, Pierre. *Les Paysans du delta tonkinois. Étude de géographie humaine*. Éditions d'art et histoire, 1936.

Gravier, Jean-François. *Régions et nation*. Presses Universitaires de France, 1942.

Gravier, Jean-François. *Paris et le désert français. Décentralisation, équipement, population*. Portulan, 1947.

Gravier, Jean-François. *L'Aménagement du territoire et l'avenir des régions françaises*. Flammarion, 1964.

Griaule, Marcel. Rapport sur la Mission Sahara-Cameroun, 1936–37. *La Géographie* 68 (3) (March 1937): 166–167.

Griaule, Marcel. Blasons totémiques des Dogon. *Journal de la Société des Africanistes* 7 (1937): 69–79.

Griaule, Marcel. Cinq missions ethnographiques en Afrique Tropicale. Académie des Sciences Coloniales, Compte rendu des séances des 3 et 17 décembre 1943, 680–692.

Griaule, Marcel. La géographie au Congrès national de l'aviation française de 1946. *Annales de Geographie* 301 (January–March 1947): 55–58.

Griaule, Marcel. *Méthode de l'ethnographie*. Presses Universitaires de France, 1957.

Guichard, Olivier. *Aménager la France*. Editions Gonthier, 1965.

Guichard, Olivier. Déclaration sur les orientations de la politique urbaine," Assemblé nationale, 17 mai 1973, Journal officiel de la République française, 1973.

Haffner, Jeanne. Historicizing the View from Below: Aerial Photography and the Emergence of a Social Conception of Space. In Proceedings of Spaces of History / Histories of Space: Emerging Approaches to the Study of the Built Environment, University of California, Berkeley, 2010.

Halbwachs, Maurice. *Morphologie sociale*. Colin, 1938.

Harvey, David. *Consciousness and the Urban Experience: Studies in the History and Theory of Capitalist Urbanization*. Johns Hopkins University Press, 1985.

Harvey, David. Space as a Keyword. In *David Harvey. A Critical Reader*, ed. Noel Castree and Derek Gregory, 270–293. Blackwell Publishing, 2006.

Hecht, Gabrielle. *The Radiance of France: Nuclear Power and National Identity after World War II*. MIT Press, 1998.

Hellman, John. *The Knight-Monks of Vichy France. Uriage, 1940–1945*. McGill University Press, 1993.

Hess, R. *Henri Lefebvre et l'aventure du siècle*. Éditions A. M. Métaillé, 1988.

Highmore, Ben. *Everyday Life and Cultural Theory: An Introduction*. Routledge, 2002.

Highmore, Ben, ed. *The Everyday Life Reader*. Routledge, 2002.

Hirsh, Arthur. *The French New Left*. South End Press, 1981.

Horne, Janet R. *A Social Laboratory for Modern France: The Musée Social & The Rise of the Welfare State*. Duke University Press, 2002.

Hughes, Jonathan, and Simon Sadler, eds. *Non-Plan: Essays on Freedom Participation and Change in Modern Architecture*. Architectural Press, 1999.

Hughes, Robert. *The Shock of the New*. Knopf, 1981.

Institut Géographique National (I.G.N.). *Collection de stéréogrammes pour l'entraînement à l'identification des détails sur les photographies aérienne à axe vertical*. I.G.N, 1947.

Institut d'urbanisme de Paris. Histoire de l'Institut d'urbanisme de Paris. http://urbanisme.univ-paris12.fr. Accessed June 11, 2007.

Jameson, Fredric. *Postmodernism, or the Cultural Logic of Late Capitalism*. Duke University Press, 1991.

Jay, Martin. *Downcast Eyes: The Denigration of Vision in Twentieth-Century French Thought*. University of California Press, 1993.

Jenny, Jacques, Louis Couvreur, and Paul-Henry Chombart de Lauwe. Sociologie du logement: Logement et comportement des ménages dans trois cités nouvelles de l'agglomération bordelais. *Cahiers du Centre Scientifique et Techniques du Bâtiment* (winter 1956–1957).

Jones, Colin. *Paris: Biography of a City*. Allen Lane, 2004.

Judt, Tony. *Past Imperfect: French Intellectuals, 1944–1956*. University of California Press, 1992.

Judt, Tony. *Marxism and the French Left. Studies in Labour and Politics in France, 1830–1981*. Oxford University Press, 1986.

Kelly, Michael. *Modern French Marxism*. Johns Hopkins University Press, 1982.

Kern, Stephen. *The Culture of Time and Space, 1880–1914*. MIT Press, 1983.

Knabb, Kan, ed. *The Situationist International Anthology*. Bureau of Public Secrets, 2006.

Knorr-Cetina, Karin. *Epistemic Cultures: How the Sciences Make Knowledge*. Harvard University Press, 1999.

Laisney, François. Réglementer la banlieue? L'Exemple du Plan Prost. *Les Cahiers de la Recherche Architecturale* 28/29 (1996): 117–130.

Lassave, Pierre. *Les sociologues et la recherche urbaine dans la France contemporaine*. Presses Universitaires de Mirail, 1997.

Latour, Bruno. *Laboratory Life: The Construction of Scientific Facts*, tr. Steve Woolgar. Princeton University Press, 1986.

Latour, Bruno. *Science in Action: How to Follow Scientists and Engineers through Society*. Harvard University Press, 1987.

Latour, Bruno. *We Have Never Been Modern*, tr. Catherine Porter. Harvard University Press, 1993.

Latour, Bruno. *Reassembling the Social: An Introduction to Actor-Network Theory.* Oxford University Press, 2005.

Laurent, Sébastien, and Jean-Eudes Roullier. *Paul Delouvrier: Un grand commis de l'État.* Presses Universitaires de Sciences Po, 2005.

Lebeuf, Jean-Paul. La Mission Sahara-Cameroun. *Actes de la Société de Géographie* 69 (January–June 1938): 225–230.

Lebovics, Herman. *True France: The Wars Over Cultural Identity, 1900–1945.* Cornell University Press, 1992.

Le Corbusier. *Aircraft.* Studio Publications, 1935.

Le Corbusier. *Sur les quatre routes.* Gallimard, 1941.

Le Corbusier. *Poésie sur Alger.* Falaize, 1942.

Le Corbusier. *The Athens Charter*, tr. Anthony Eardley. Grossman, 1973. Originally published as C.I.A.M., *La Charte d'Athènes.* Plon, 1943.

Le Corbusier. *New World of Space.* Reynal & Hitchcock, 1948.

Le Corbusier. *Precisions on the Present State of Architecture and City Planning*, tr. Edith Schrieber Aujame. MIT Press, 1991.

Le Corbusier. *Toward a New Architecture* tr. John Goodman. Getty Research Institute, 2007.

Ledrut, Raymond. Sociabilité d'habitat et structure urbaine. *Cahiers Internationaux de Sociologie* 34 (January–June 1963): 113–124.

Ledrut, Raymond. *L'Espace social de la ville. Problèmes de sociologie appliquée à l'aménagement urbain.* Anthropos, 1968.

Ledrut, Raymond. *Sociologie urbaine.* Presses Universitaires de France, 1968.

Ledrut, Raymond. *Les images de la ville.* Anthropos, 1973.

Ledrut, Raymond. *L'espace en question.* Anthropos, 1976.

Ledrut, Raymond. *La Révolution cachée.* Casterman, 1979.

Ledrut, Raymond, and Christian Roy. Toulouse, sociologie, et planification urbaine. *Urbanisme* 93 (1966): 50–63.

Lefebvre, Henri. *Critique de la vie quotidienne*. Grasset, 1947.

Lefebvre, Henri. Les nouveaux ensembles urbains: Un cas concret, Lacq-Mourenx et les problèmes urbains de la nouvelle classe ouvrière. *Revue Francaise de Sociologie* 1 (2) (1960): 186–202.

Lefebvre, Henri. Utopie expérimentale: Pour un nouvel urbanisme. *Revue Francaise de Sociologie* 3 (3) (1961): 191–199.

Lefebvre, Henri. *La Vallée de Campan, étude de sociologie rurale*. Presses Universitaires de France, 1963.

Lefebvre, Henri. Henri Lefebvre (né en 1905). In *Les philosophes français d'aujourd'hui par eux-mêmes: Autobiographie de la philosophie française contemporaine*, ed. G. Deledalle and D. Huisman, 282–301. CDU, 1963.

Lefebvre, Henri. *Pyrénées*. Éditions rencontre, 1965.

Lefebvre, Henri. *La droit à la ville*. Anthropos, 1968.

Lefebvre, Henri. Réflexions sur la politique de l'espace. *Espaces et Sociétés* 1 (1970): 3–12.

Lefebvre, Henri. *La somme et le reste*. Belibaste, 1973.

Lefebvre, Henri. *The Production of Space*, tr. Donald Nicholson-Smith. Blackwell, 1991. Originally published as *La Production de l'espace*. . Anthropos, 1974.

Lefebvre, Henri. *Le Temps de méprises*. Stock, 1975.

Lefebvre, Henri. *De L'État*. Union générale des éditions, 1976–1978.

Lefebvre, Henri. *The Urban Revolution*, tr. Robert Bononno. University of Minneapolis Press, 2003.

Lefebvre, Henri. In *State, Space, World: Selected Essays*, ed. Neil Brenner et al. University of Minneapolis Press, 2009.

Lepetit, Bernard, and Christian Topalov. Histoire urbaine et espace. *L'Espace Geographique* 1 (1980): 43–54.

Lepetit, Bernard, and Christian Topalov. *La ville des sciences sociales*. Belin, 2001.

Lévi-Strauss, Claude. Social Structure. In *Anthropology Today: An Encyclopedic Inventory*. University of Chicago Press, 1953.

Lévi-Strauss, Claude. *Tristes Tropiques*. : Plon, 1955.

Lévi-Strauss, Claude. *Anthropologie structurale*. Plon, 1958.

Lévi-Strauss, Claude. French Sociology. In *Twentieth Century Sociology*, ed. George Gurvitch and Wilbert E. Moore (Philosophical Library, 1945).

Lévy, Louis. *Alfred Sauvy, compagnon du siècle*. Manufacture, 1990.

Light, Jennifer S. *From Warfare to Welfare. Defense Intellectuals and Urban Problems in Cold War America*. Johns Hopkins University Press, 2003.

Lods, Marcel. La crasse de Paris, ou les hommes enfumés. *L'Architecture d'aujourd'hui* 9, no. 6 (1938): 82–89.

Lods, Marcel. *Marcel Lods, 1891–1978. Photographies d'architecte. Exposition au Centre Georges Pompidou, Paris, 2 octobre 1991–6 janvier 1992*. Éditions Georges Pompidou, 1991.

Lot, Fernand. L'urbanisme peut voir ce que sera son oeuvre dans la réalité. *Le Figaro littéraire*, Saturday, May 12, 1956.

Maclean, Alex. *Designs on the Land: Exploring America from the Air*. Thames & Hudson, 2003.

Marrast, J., and André Vois. *L'Oeuvre de Henri Prost*. Paris: Académie d'Architecture, 1960.

Martin, Reinhold. *The Organizational Complex: Architecture, Media, and Corporate Space*. MIT Press, 2003.

Martin, Rupert, ed. *The View from Above. 125 Years of Aerial Photography*. London: The Photographers' Gallery, 1983.

Marzorati, Jean-Louis. *La France en 1968*. Hoëbeke, 2007.

Mauss, Marcel. Essai sur les variations saisonnaires des sociétés eskimos. Étude de morphologie sociale (with the assistance of Henri Beuchat). *L'Annee Sociologique* 9 (1904–1905).

McDonough, Tom, ed. *Guy Debord and the Situationist International: Texts and Documents*. MIT Press, 2002.

MacLean, Alex. *Designs on the Land: Exploring America from the Air*. Thames & Hudson, 2003.

McLeod, Mary. "Architecture or Revolution": Taylorism, Technocracy, and Social Change. *Art Journal* 43 (2) (summer 1983): 132–147.

McLeod, Mary. Urbanism and Utopia: Le Corbusier from Regional Syndicalism to Vichy. Ph.D. dissertation, Princeton University, 1985.

McLeod, Mary. Le Corbusier and Algiers. *Oppositions* 19–20 (winter/spring 1980): 55–80.

Mengin, Christine. La Solution des grands ensembles. *Vingtième siècle. Revue d'histoire* 64 (October–December 1999): 105–111.

Merrifield, Andy. *Henri Lefebvre: A Critical Introduction*. Routledge, 2006.

Moholy-Nagy, László. *Painting, Photography, Film*. Lund Humphries, 1969.

Montigny, Gilles. *De la ville à l'urbanisation. Essai sur la genèse des études urbaines françaises en géographie, sociologie et statistique sociale*. L'Harmattan, 1992.

Mumford, Eric. *The CIAM Discourse on Urbanism, 1928–1960*. MIT Press, 2000.

Mumford, Lewis. *The Culture of Cities*. Harcourt Brace Jovanovich, 1970.

Musée de l'armée (Paris). *Vues d'en haut. La Photographie aérienne pendant la guerre de 1914–1918*. Exposition du 20 octobre 1988 au 31 janvier 1989, Hôtel nationale des invalides. Paris: Musée de l'armée and Nanterre: BDIC-Musée de l'histoire contemporaine, 1988. Newhall, Beaumont. *Airborne Camera: The World from the Air and Outer Space*. Hastings House, 1969.

Newsome, W. Brian. The Struggle for a Voice in the City: The Development of Participatory Architectural and Urban Planning in France, 1940–1968. Ph.D. dissertation, University of South Carolina, 2002.

Newsome, W. Brian. The Rise of the Grands Ensembles: Government, Business, and Housing in Postwar France. *Historian* 66 (4) (winter 2004): 793–816.

Newsome, W. Brian. *French Urban Planning 1940-1968: The Construction and Deconstruction of an Authoritarian System.* Peter Lang, 2009.

Ostrowetsky, Sylvia, ed. *Sociologues en ville.* L'Harmattan, 1996.

Ousby, Ian. *Occupation. The Ordeal of France, 1940–1944.* Pimlico, 1999.

Padover, Saul K. France in Defeat: Causes and Consequences. *World Politics* 2 (3) (April 1950): 305–337.

Parin, Paul, Fritz Morgenthaler, and Aldo van Eyck. Dogon: Basket, House, Village, Universe. *Forum* 3 (1963): 30–55.

Pelletier, Denis. *Économie et humanisme. De l'Utopie communautaire au combat pour le Tiers Monde (1941–1966).* Éditions du Cerf, 1996.

Picon, Antoine. *Architects and Engineers in the Age of Enlightenment*, tr. Martin Thom. Cambridge University Press, 1992.

Picon, Antoine. *L'Invention de l'ingénieur moderne: L'École nationale des ponts et chaussées, 1747–1851.* Paris: Presses de l'Ecole nationale des ponts et chaussées, 1992.

Picon, Antoine. *Le Dessus des cartes: Un Atlas parisien, with Jean-Paul Robert.* Pavillon de l'Arsenal, 1999.

Picon, Antoine. *Les Saint-Simoniens: Raison, imaginaire et utopie.* Belin, 2002.

Picon, Antoine. Nineteenth-Century Urban Cartography and the Scientific Ideal: The Case of Paris. *Osiris* 18 (2003): 135–149.

Phillips, Peggy. *Modern France: Theories and Realities of Urban Planning.* University Press of America, 1987.

Popkin, Jeremy D. *A History of Modern France.* Prentice-Hall, 2001.

Porter, Theodore M. *The Rise of Statistical Thinking, 1820–1900.* Princeton University Press, 1986.

Poster, Mark. *Existential Marxism in Postwar France: From Sartre to Althusser.* Princeton University Press, 1975.

Pouvreau, Benoît. La Politique d'aménagement du territoire d'Eugène Claudius-Petit. *Vingtième siècle. Revue d'histoire* 79 (July–September 2003): 43–52.

Pradoura, Élizabeth. Entretien avec Paul-Henry Chombart de Lauwe," January 21, 1986 (http://picardp1.ivry.cnrs.fr/CdL.html).

Quoist, Michel. *Les villes et l'homme. Rouen, étude sociologique d'un secteur proletarien, suivie de conclusions pour l'action.* Paris: Éditions ouvrières, 1952.

Rabinow, Paul. *French Modern: Norms and Forms of the Social Environment.* MIT Press, 1989.

Randet, Pierre. *L'Aménagement du territoire. Genèse et étapes d'un grand dessein.* DATAR, 1994.

Riefenstahl, Leni, dir. *Triumph des Willens.* Leni-Riefenstahl-Produktion, 1935.

Risselada, Max, and Dirk van den Heuvel. *Team 10: 1953–1981.* Rotterdam: NAi, 2005.

Robic, Marie-Claire. Des Vertus de la chaire à la tentation de l'action. In *La Géographie française à l'époque classique (1918–1968).* L'Harmattan, 1996.

Robic, Marie-Claire. Organisation de l'espace. Contribution à l'étude de l'introduction et des significations de l'expression en France, depuis la seconde guerre mondiale. *Documents pour l'histoire du vocabulaire scientifique*, no. 3, 69–101.

Robic, Marie-Claire, et al. *Couvrir le monde: Un grand XXe siècle de géographie française.* Association pour la diffusion de la pensée française-Ministère des Affaires étrangères, 2006.

Roncayolo, Marcel. *Les grammaires d'une ville: Essais sur la genèse des structures urbaines à Marseille.* EHESS, 1996.

Roncayolo, Marcel. *Les Villes et ses territoires.* Gallimard, 1990.

Roncayolo, Marcel, ed. *La Ville aujourd'hui, croissance urbaine et crise du déclin*, volume 5: Histoire de la France urbaine. Seuil, 1985.

Roncayolo, Marcel, and Thierry Paquot. *Villes et civilisation urbaine, XVIIIe-XXe siècles.* Larousse, 1992.

Ronsin, Françis, Hervé Le Bras, and Elizabeth Zucker-Rouvillois, eds. *Demographie et politique.* Éditions Universitaires de Dijon, 1997.

Ross, Kristin. *Fast Cars, Clean Bodies: Decolonization and the Reordering of French Culture*. MIT Press, 1995.

Ross, Kristin. *May '68 and Its Afterlives*. University of Chicago Press, 2002.

Rotival, Maurice. Les Grands ensembles. *Architecture d'aujourd'hui* 6 (June 1935): 57–87.

Rouge, Maurice-François. *La Géonomie, ou, l'organisation de l'espace*. Librairie générale de droit et de jurisprudence, 1947.

Rouge, Maurice-François. *Introduction à un urbanisme experimentale*. Librairie générale de droit et de jurisprudence, 1951.

Sadler, Simon. *The Situationist City*. MIT Press, 1998.

Sauvy, Alfred. *Richesse et population*. Payot, 1943.

Schecter, Darrow. *The History of the Left from Marx to the Present: Theoretical Perspectives*. Continuum, 2007.

Scott, James C. *Seeing Like a State. How Certain Schemes to Improve the Human Condition Have Failed*. Yale University Press, 1998.

Segaud, Marion. *Anthropologie de l'espace. Habiter, fonder, distribuer, transformer*. Colin, 2007.

Sert, José Luis. *Can Our Cities Survive?* Harvard University Press, 1942.

Shapiro, Ann-Louise. *Housing the Poor of Paris, 1850–1902*. University of Wisconsin Press, 1985.

Shepard, Todd. *The Invention of Decolonization: The Algerian War and the Remaking of France*. Cornell University Press, 2007.

Shields, Rob. *Lefebvre, Love, and Struggle: Spatial Dialectics*. Routledge, 1999.

Sies, Margaret. *Planning the Twentieth-Century American City*. Johns Hopkins University Press, 1996.

Sion, Jules. *Les Paysans de la Normandie orientale*. Colin, 1909.

Sloterdijk, Peter. *Terror from the Air*. MIT Press, 2009.

Smithson, Alison, ed. *Team 10 Primer*. MIT Press, 1968.

Sobieszczanski, Marcin, ed. *Spatialisation en art et sciences humaines*. Peeters, 2004.

Soja, Edward. The Socio-Spatial Dialectic. *Annals of the Association of American Geographers. Association of American Geographers* 70 (2) (June 1980): 207–225.

Soja, Edward. *Postmodern Geographies: The Reassertion of Space in Critical Social Theory*. Verso, 1989.

Sorre, Maximillian. *Les Fondements biologiques de la géographie humaine* (3 vols.). Colin, 1943–1952.

Sorre, Maximillian. *Rencontres de la géographie et de la sociologie*. Marcel Rivière et Cie, 1957.

Sorre, Maximillian. *L'Homme sur la terre*. Hachette, 1961.

Stanek, Lukasz. *Henri Lefebvre on Space: Architecture, Urban Research, and the Production of Theory*. University of Minnesota Press, 2011.

Stocking, George. *The Ethnographer's Magic and Other Essays in the History of Anthropology*. University of Wisconsin Press, 1992.

Stovall, Tyler. French Communism and Suburban Development: The Rise of the Paris Red Belt. *Journal of Contemporary History* 24 (1989): 437–460.

Stovall, Tyler. *The Rise of the Paris Red Belt*. University of California Press, 1990.

Sutcliffe, Anthony. A Vision of Utopia: Optimistic Foundations of Le Corbusier's Doctrine d'urbanisme. In *The Open Hand: Essays on Le Corbusier*, ed. Russell Walden, 217–242. MIT Press, 1977.

Tchernia, Pierre. Les Grands Ensembles" (1960) (http://www.dailymotion.com/video/x8ozzwz_les-grands-ensembles_creation).

Tissier, Jean-Louis. Rendez-vous à Uriage (1940–1942). La fonction du terrain au temps de la Révolution nationale. In *Géographes en practiques (1870–1945). Le Terrain, le livre, la cité*, ed. Guy Baudelle, Marie-Vic Ozouf-Marignier, and Marie-Claire Robic. Presses Universitaires de Rennes, 2001.

Tissot, Sylvie. *L'État des quartiers. Genèse d'une catégorie de l'action publique*. Seuil, 2007.

Topalov, Christian. *Le Logement en France: Histoire d'une marchandise impossible.* Presses de la Fondation national des sciences politiques, 1987.

Topalov, Christian. A History of Urban Research: The French Experience since 1965. *International Journal of Urban and Regional Research* 13 (1989): 625–651.

Topalov, Christian. *Laboratoires du nouveau siècle: La nébuleuse réformatrice et ses réseaux en France.* EHESS, 1999.

Topalov, Christian. Traditional Working-Class Neighborhoods": An Inquiry into the Emergence of a Sociological Model in the 1950s and 1960s. *Osiris* 18 (2003): 212–233.

Toutcheff, Nicole. L'Objectif Lods. In *Marcel Lods, Marcel Lods, 1891–1978. Photographes d'un architect.* Centre Georges Pompidou, 1991.

Trystram, J. P., ed. *Sociologie et plans d'urbanisme: Aix-en-Provence, Toulouse, Le Havre,* report for the Ministère de la Construction, Direction de l'Aménagement Foncier et de l'Urbanisme, Service des Études et des Programmes de Développement Urbain, September 1965.

Trystram, J. P., ed. *Sociologie et urbanisme.* Colloque des 1, 2, 3 mai 1968. Paris: Fondation royaumont, 1970.

Uyttenhove, Pieter. L'Oeil discursif: Pour le constat, l'analyse et la critique, ou pour l'exemple, la petite boîte noire obéissait au doigt comme à l'oeil de Marcel Lods. *L'Architecture d'aujourd'hui* 277 (October 1991): 72–74.

Uyttenhove, Pieter. The Failure of Modernism: Illusions and Desillusions of Marcel Lods. In *Tra Guerre e pace: Società, cultura e architettura nel secondo dopoguerra,* ed. Patrizia Bonifazio. FrancoAngeli, 1998.

Uyttenhove, Pieter. *Marcel Lods: Action, architecture, histoire.* Verdier, 2009.

Vago, Pierre. L'Urbanisme française," *Architecture d'Aujourd'hui* (September–October 1946): 16–18.

Vera, André. Opportunité de l'urbanisme. *Urbanisme* 103–104 (1945): 33–44.

Vidal de la Blache, Paul. *Tableau de la géographie de la France.* Hachette, 1911.

Vidal de la Blache, Paul. *Principes de géographie humaine.* Colin, 1922.

Vidler, Anthony. "Photourbanism: Planning the City from Above and from Below." In *A Companion to the City*, ed. Gary Bridges and Sophie Watson. Blackwell, 2000.

Vidler, Anthony. "*Terres Inconnues*: Cartographies of a Landscape to Be Invented." *October* 115 (winter 2006): 13–30.

Vidler, Anthony. "Airwar and Architecture." In *Ruins of Modernity: Politics, History, and Culture*, ed. Julia Hell and Andreas Schönle. Duke University Press, 2009.

Vidler, Anthony. *Scenes of the Street and Other Essays*. Monacelli, 2011.

Violeau, Jean-Louis. *Les architects et mai 1968*. Recherches, 2005.

Vogt, Evon, ed. *Aerial Photography in Anthropological Fieldwork*. Harvard University Press, 1974.

Voldman, Danièle. Urban Reconstruction in France after World War II. *Planning History Bulletin* 11 (1988): 13–17.

Voldman, Danièle. Aménager la région parisienne (février 1950–août 1960). *Cahiers de l'Institute d'histoire du temps présent*, no. 17 (1990): 49–54.

Voldman, Danièle. *La Reconstruction des villes françaises de 1940 à 1954: Histoire d'une politique*. L'Harmattan, 1997.

Voldman, Danièle. Sur les 'crises' urbaines. *Vingtième siècle. Revue d'histoire* 64 (October–December 1999): 5–10.

Vulmière, H., and J. Vulmière. Description et exposé technique. *Études et informations* 2 (February 1954): 23–27.

Wakeman, Rosemary. La Ville en Vol: Toulouse and the Cultural Legacy of the Airplane. *French Historical Studies* 17 (3) (spring 1992): 769–790.

Wakeman, Rosemary. *Modernizing the Provincial City: Toulouse, 1945–1975*. Harvard University Press, 1997.

Wakeman, Rosemary. Nostalgic Modernism and the Invention of Paris in the Twentieth Century. *French Historical Studies* 27 (1) (winter 2004): 115–144.

Wakeman, Rosemary. *The Heroic City: Paris, 1945–1975*. University of Chicago Press, 2010.

Walden, Russell, ed. *The Open Hand: Essays on Le Corbusier*. MIT Press, 1977.

Waquet, Jean-Claude, Odile Goerg, and Rebecca Rogers. *Les Espaces de l'historien: Études d'historiographie*. Presses Universitaires de l'Université de Strasbourg, 2000.

Weulersse, Jacques. *L'Afrique noire: Vue d'ensemble sur le Continent Africain*. Fayard, 1934.

Wohl, Robert. *A Passion for Wings: Aviation and the Western Imagination, 1908–1918*. Yale University Press, 1994.

Wohl, Robert. *The Spectacle of Flight: Aviation and the Western Imagination, 1920–1950*. Yale University Press, 2005.

Wright, Gwendolyn. Tradition in the Service of Modernity: Architecture and Urbanism in French Colonial Policy. *Journal of Modern History* 59 (1987): 291–316.

Wright, Gwendolyn. *The Politics of Design in French Colonial Urbanism*. University of Chicago Press, 1991.